Encouraging the Artist in Your Child

in Your Child

(Even If You Can't Draw)

Encouraging the Artist in Your Child

(Even If You Can't Draw)

101 failure-proof,
home-tested projects for kids age 2–10

Sally Warner

Line illustrations by Sally Warner

Kids' illustrations by Alex, Andrew, Cassandra,
Evan, Nico, and Anna

Photographs by Claire Henze

St. Martin's Press
New York

Library of Congress Cataloging-in-Publication Data

Warner, Sally.
 Encouraging the artist in your child (even if you can't draw) /
Sally Warner.
 p. cm.
 ISBN 0-312-03331-1
 1. Children as artists. 2. Art—Study and teaching (Elementary)
 I. Title.
 N351.W37 1989
 700—dc20 89-34849

10 9 8 7 6 5 4 3 2

This book is dedicated to my sons,

Alex and Andrew

(or)

Andrew and Alex

Contents

Acknowledgments

First, I thank William Strunk, Jr., E. B. White, and William Zinsser for helping an art major.

I thank my family for their generosity and encouragement: my sons, Alex and Andrew; my father, Stuart Warner; my sister, Todd Jackson; and my brother, Todd Warner. (When we find a name we like, we stick with it.)

Next, I thank the best neighbors anyone could ever have: the Chambers family—Patrick, Tina, Cassandra, and Evan. Moving next door to another family of artists has been one of the nicest things ever to happen to us.

And I thank my friends, especially Claire Henze. Claire and her children, Nico and Anna, are part of our family in California. It has been a pleasure to have Claire's photographs help express the spirit of this book.

I thank all of the children whose artwork appears in this book: Alex, Andrew, Cassandra, Evan, Nico, and Anna.

I thank the many gifted teachers I've had throughout my life. I may have forgotten the metric system, but I'll never forget the unspoken example these men and women set. (In case they've forgotten me, I was the one with red hair. I was sitting in the back row, looking out of the window or drawing in my notebook . . . I was the one who turned in the heavily illustrated reports.)

Finally, I thank my students, from whom I've learned

so much, especially my students at Pasadena City College. (Most of them are working teachers.) I thank them for bringing in projects and ideas, for helping me tinker with materials and methods, and for telling me their own art histories. And I thank them for asking me to write this book!

Foreword

Art at home! Do these words send a chill down your spine? I know that they scare many parents.

I am an artist who has taught art to many hundreds of preschool teachers over the past ten years. They often tell me that parents are desperate for easy art projects that their children (preschool and older) can do at home. But as a parent I know from hard experience that there are a number of things we secretly dread:

- that we will have to *teach* our child art

- that we will have to sit down and do art, too

- that the house will be trashed by art

- that we will have to buy (and store) an easel

None of these worries is necessary!

This book presents a realistic, easel-less approach to art at home. I am writing it from three points of view:

- as an artist

- as a parent

- as a teacher

As an artist, I am fascinated by the creative process. When we watch very young children make art, we are struck by how natural this process seems to them. A two-year-old child doesn't wait to be "in the mood" to play with playdough. A three-year-old doesn't say "I can't draw!" A four-year-old doesn't worry that he or she is not "talented" enough to paint.

As an artist, I want to encourage parents to respect and nurture the artist and the "art spirit" that lives in each child—not the things a child makes or the skills a child learns, but the artist in him- or herself. That is the primary purpose of this book.

As a parent, I know that this is asking a lot. I sympathize with you. Everyone is so busy, for one thing. Everything is so expensive, for another. And more and more we comfort ourselves by leaving things to specialists, to "the experts." Art? He'll get art in school! Or maybe, if she's any good, she can have special lessons.

Please don't leave art only to the experts. It's not an activity that should be isolated from our everyday lives; give it a chance at home. We parents are game to give everything else a try for the sake of our children—camping, long car trips, amusement parks, ice-skating. Then why not art?

Art is for every child, and it's easy. Don't wait. Don't try to buy the experience for your child. Do it yourself. Do it at home. This book will provide a foundation.

As a parent, I know that art at home is a unique gift that only we as parents can give. It enables each child to see that his or her own creativity is something that is valued by the family and is an integral part of who that child is.

As a teacher, I know that you can learn. You can learn about art materials and ways of using them. You can learn about which projects suit a particular age and why. You can then use that knowledge to create an individualized family art program. And you will learn about the creative process just by watching your child thrive in a supportive art environment.

I also know that most of us panic when confronted with The Unknown, especially when it's The Known to someone else. How we hate exposing our ignorance to an "expert"! Art is The Unknown to many parents. This can create art panic.

Art panic makes it hard to hear for some reason. "Did

I understand correctly?" "Am I doing this right?" It's crucial, therefore, that art instructions be simple and clear. This book suggests a basic program to follow, tells you exactly what art supplies you'll need, and explains how to proceed with each project.

My teaching approach is to go through a small number of projects thoroughly. I know that a lot of questions come up when people are trying something new. Art panic makes things seem harder than they really are. Don't panic!

As a teacher, I feel that most parents will gain enough confidence and knowledge from this thorough approach to begin to feel at home with art again.

It may surprise you that a teacher would put the teachable things about art after the intangibles—"art spirit" and self-esteem. I would like to say that I consider the "teachables" extremely important; they can and should be taught in our schools by teachers trained in art. The "teachables" can be taught sequentially and should be taught in a professional manner.

But there are many art educators who will concentrate on that. I can best approach the subject from the point of view of being both artist and parent. I feel that this approach is the most important one for parents to understand. *Will I have to teach my child art?*

No. You will provide the time, the space, and some simple, easily purchased materials. You will keep your child company if he or she wants you to. You will assist your child with any procedures that are beyond his or her present grasp. You will help your child overcome distractions and learn to work for longer periods of time. You will encourage your child to talk about his or her art. But you won't have to teach your child art.

Will I have to sit down and do the projects, too?

No. In fact, I think that this is usually a bad idea. We often end up showing our child the "right" way to do a project. Even if we can resist this urge, our child may try to copy our way of working.

Occasionally it's okay to sit down and join in. I'll tell you when. Otherwise, just being in the vicinity is enough.

Will the house be trashed by art?

No! There's no reason for this to happen. Many of us have an image of an artist's studio as chaos, drifts of paper, and splashes of paint. "That's creativity," we think (but not in my house).

It won't be like that. Your child will learn where to work and how to use the materials. He or she will help set up each project and help clean up afterward. It will take some extra effort, but it'll be worth it. And your house will survive.

Will I have to buy an easel?

Nope!

Here are some guidelines that apply to all ages in doing art at home.

A Place to Work

The two criteria for choosing a primary place to make art are:

1. that the floor be uncarpeted (this will cut down on nagging)

2. that the place not be isolated from family life

For most families, this describes the *kitchen.*

If you have a *kitchen table,* that will be where your child works. Otherwise he or she will probably work on the floor. If your kitchen floor is bumpy, buy a piece of *Masonite* at the lumberyard. Have it cut to a reasonable size (say 2' by 4') and store it in a closet or under a bed.

It's possible for your child to work at the kitchen counter, but not ideal. Not only might he or she feel understandably edgy about toppling off the kitchen stool, but also it cuts down on mobility. You want your child to be able to move around, to look at things from different angles, to stretch out.

So I would suggest that your child's primary workplace be the kitchen. Here are three additional places to work from time to time.

1. *In the bedroom* (age 2+)

Sometimes, children like to be alone when they work. Encourage your child to work in his or her bedroom occasionally. If it is carpeted or if the floor is bumpy, slip a piece of Masonite under the bed. This can be used to provide a smooth work surface.

Some projects are more practical for a child to do alone than others. Some good ones are:

Drawing with crayons (2+)

Drawing with markers (4+, if the child understands to draw only on the paper and not on walls, floor, or him- or herself)

Cutting construction paper (3+)

Folding and cutting (4+)

Cutting and pasting (4+, if the child uses paste rather than white vinyl glue and can keep it off the floor pretty well)

Sewing cards (3½+)

Berry basket weaving (4+) with shoelaces

I would discourage allowing your child to work alone with food color, paint, yarn needles, or white vinyl glue. We don't want any nasty scenes.

2. *At a desk* (age 4+)

Four-year-olds often like to work small. Provide your four-year-old with a box of small materials such as un-lined 3" by 5" cards, 5" blunt-nosed scissors, markers, a hole punch, stickers, stars, and some tape. Don't include hard pencils and ballpoint pens, unless your child is "playing school."

3. *Outside* (age 2+)

Your child can work on the front porch, the back porch, the patio, the driveway, in the garden, in the sandbox, in the park. But encourage him or her to work outside whenever possible.

If you don't have a yard, go for walks and then work with sticks and leaves collected *on* walks. Open a window, at least!

A Time to Work

"Timing is everything," especially when children are working in the kitchen. Children will always want to spread projects out on the kitchen table right before a meal—you already know that. But there are other, more convenient times, when art can be made with little disruption to your normal kitchen schedule.

Very Early Morning

If your child is three and a half or older, this is a good age to work on a safe, nonmessy art project.

Midmorning (weekends, probably)

The kitchen table should be free now. Making and/or playing with playdough is a good activity for this energetic period. All other projects are good midmorning, too.

After Lunch (weekends or after preschool)

Choose a quiet activity. If your child still naps, he or she can do a quiet bedroom art project upon arising.

If your child doesn't nap, a quiet period is still a good idea. After it's over, he or she can work on a collage at the kitchen table. Yarn, magazine, or nature collages are good bets. Later in the afternoon, if you are able to help out, your child can try a more ambitious collage or painting project.

Before Dinner

Forget it! This must be the hardest time of day for everyone. Don't even try making art right before dinner.

After Dinner

This can be a surprisingly good work time. Clean off the kitchen table first, and your young child can putter and

chatter as you do the dishes. Choose a project that doesn't require much more than companionship from you.

How Much Time Should You Allow for a Project?

Ideally you should always allow enough time for your child to work in a relaxed atmosphere and to decide for him- or herself when to stop. Tack on enough time for your child to help with the cleanup even if it's easier for you to do it yourself. That's the ideal.

Try to stick as close to the ideal as you can. Don't let your child start a project right before a meal, or before you have to go out. Respect the child's effort enough not to say "you're done!" as you whisk away the art supplies. If you anticipate a last-minute rush, suggest that your child draw in his or her room.

Rather than complain that their child spends too long on an art project, though, many parents complain that their child doesn't spend long enough. And after all that preparation. It hardly seems worthwhile.

But it *is* worthwhile. This reminds me of museums and why so many children dread them. They anticipate the outing with excitement. They enjoy it tremendously—for about ten minutes. Then they have to stay. And stay. Museum fatigue is born.

Even if you have to drive half an hour each way, it's better to leave after ten minutes if that's your child's limit. Leave *before* he or she starts to glaze over. Go outside and let your child run around on the grass.

It's like that with art. Don't try to "get your money's worth" by attempting to wring every drop out of the project. Let your child decide how long to spend.

A two- or three-year-old may only spend five minutes on an art project. A four- or five-year-old may spend five, ten, or maybe fifteen minutes working. Some of this has to do with age, and some of it has to do with the nature of the child, or how much he or she likes the project.

A six- or seven-year-old child usually spends a little longer on a project. Allow fifteen or twenty minutes, and plan some projects he can come back to the next day. An eight-, nine-, or ten-year-old can often work for long periods of time, and can easily return to a project the next day for more work.

With an older child, explain in advance if he or she won't have more than half an hour to work on a project (allow time for cleanup). Then announce the start of the last ten minutes of work time. Assure the child that he or she will be able to return to the project in the near future, if that's the case.

Although your child determines when to stop, you can encourage additional work if your child seems uncertain that he or she is really done.

- Help your child overcome distractions **that occur while he or she is working:** doorbells ringing, dogs barking, brothers and sisters charging through the room. Gently draw your child's attention back to what he or she was doing.

- Help your child recall artwork he or she has done before. Your child may then think of art materials or methods that could be used again.

- Encourage your child to be flexible and experimental as he or she works.

But remember the amount of time spent on a project doesn't determine its value.

How often "should" your child do art at home? Well, anything is better than nothing. But here is what I consider a good, basic home art program.

- Drawing: Encourage your child to do this every day. It's easy, it's fairly neat, and it is the most valuable part of the program for all ages.

- Painting: Aim for a painting project every week or so—more often if possible.

- Collage: Encourage your child to do collage work a couple of times a week. These can be simple cut-and-paste collages. Try to let your child do a more complex collage project once or twice a month.

- Yarn: Offer your child the opportunity to work with yarn (in collage, stitching, weaving, or sculpture) a couple of times a month.

- Sculpture: Try to let your child do this weekly. It could be playdough, assemblage, woodworking, or a number of outdoor activities.

A Way to Work

Good work habits are good work habits—they apply to art as well as to less creative endeavors. Making art isn't synonymous with making a mess. You're not murdering creativity if you expect some measure of tidiness.

I'm not talking about tidiness in the art itself. We don't want cautious, inside-the-lines, by-the-numbers art. I'm talking about work *habits,* especially the preparation for and cleanup after art projects.

I know it's easier to do these tasks yourself—that's not the point. The point is to involve your child in the entire process. Art materials don't come from thin air. We buy them, then we take them home and put them away. When it's time to use them, we get out all the right materials and (sometimes) cover the kitchen table with newspaper. We prepare.

We take care of the materials. We don't leave brushes soaking or glue sticks lying around. Taking good care of art materials is a way of anticipating the next art project.

Children participate more in activities they are involved in, and they appreciate them more.

Don't worry so much about neatness while your child is working. A lot of that is in your hands, anyway. Does he or she knock over the paint? Use a shallow container, and fill it only one-third full. Does your child get glue all over the place? Again, use a shallow container, and try coloring the white glue so he or she can keep better track of it. Does your child trail paint smudges all the way to the sink? Put a small basin one-third full of soapy water right on the kitchen table. You get the idea.

Don't make your child wear special clothes to make art; old play clothes will do. Don't wrap your child in plastic garbage bags when he or she paints. How would that make you feel?

Don't swathe the work area with drop cloths. This is art, not brain surgery. Anything that makes doing art harder should be avoided. Art is not a chore; it's fun!

When I first started teaching art, I had the romantic fantasy that the ideal classroom would be loaded with supplies available to everyone all the time. There wouldn't even be projects, really; children would just come in and "create."

I still cherish that fantasy, but for the most part it doesn't work. People don't seem to feel free when faced with virtually unlimited art supplies. They feel overwhelmed.

Now, if you were to say to two- to five-year-olds, "Here are the supplies! Make art!" they'd probably manage. But the older we get, the harder it seems to get. When I started teaching art to self-avowed "non-artists" in college, I tried the "Here are the supplies! Make art!" approach. There were short circuits everywhere. Anxiety levels zoomed. In other words, it didn't work.

Most people feel comfortable working with limited choices, and this is especially true for two- to five-year-olds. Eight marker colors are enough to choose from. Eight colors of watercolor are enough. Would you like black paper, red paper, or white paper? Would you like glue or paste? Would you like to color the glue?

Once, I gave up at the supermarket. Every week my four-year-old and I would go through the Cereal Aisle Ordeal. I would offer him a choice of two or three fairly nutritious cereals, and he would loudly campaign for a write-in, always some heavily advertised, lurid concoction. So one day I thought, "Why not? Let *him* choose the cereal for one week." (This was primarily a fatigue-based decision.)

The announcement that for this one week he could choose any cereal at all electrified him. He chugged up and down the cereal aisle, trying to decide. Five minutes later, he was a wreck and so was I. He just couldn't decide—I had inadvertently reduced him to tears. That retaught me a vivid lesson about limiting choices.

With art, even if children can cope with your lavishness, most of them use what is handiest anyway. If you put out a crate filled with 3,000 crayons, children usually choose the ones on top. If you put out a shoe box full of magazine pictures, they usually choose the ones on top. Just put out a limited choice to begin with.

But make sure you do offer a choice. Art is about making decisions, even if they are small ones. Help your child build his or her own decision-making capabilities through art.

Let your child work at his or her own pace. Some people are quick when they work and some people are slow. That doesn't mean they are "smart" or "stupid"; it's just their natural pace, and it's best not to fight it. If your child tends to work slowly, allow extra time. Don't try to rush your child or "improve" his or her pace. This isn't a race.

Let your child decide when the project is done. This means that he or she may walk away from some projects that you feel could use more work, and that he or she may "wreck" some wonderful work by going "too far." Let your child decide anyway. It's important.

Your child may get sidetracked and want to switch to some other activity. If it is a related art activity, be flexible. But if it is a completely different activity, encourage your child to finish what he or she is working on first. If your child says he or she is done, start right away with the cleanup. Do not leave everything out for "later," whatever you do. Remember:

- The project never looks as inviting "later."

- It's twice as hard to clean up "later."

When it's cleanup time, wash the brushes first. Your child can do this at the kitchen table in a basin one-third full of soapy water. Next, throw away any trash. Then put the art supplies away one at a time. Finally, your child can wipe the kitchen table with a damp cloth. Finished!

Now is a good time for a cuddle, a story, or a back rub. Make the end of the activity a happy time. Don't spring any quizzes on your child: "Now, what did we learn?" Just enjoy being together.

Always end up on a positive note. Allow enough time so that you don't end up nagging or scolding your child during cleanup. Unfortunately the scolding is what your child will remember from the art experience. Most children are pretty slow when it comes to cleaning up. Rather than try to change human nature, I suggest that you adapt to it!

What to Work With

Everyone hates feeling stupid in stores, and the more specialized the store the greater the danger is. Art stores can seem like the worst.

A salesperson in an art store once argued with me about an art material I use for many hours every day. I can imagine how hard it must be if you're a little unsure about what you're asking for to begin with. In the Appendix 1: A List of Art Materials I tell you just what to ask for, by name.

You may still have trouble with salespeople, though. Just don't let it get you down. You'll be relieved to know that many of the supplies you'll use in your home art program will be bought in places other than an art supply store. Most supermarkets carry things you can use: markers, crayons, food color, stiff paper plates, foil, tape. Lumberyards carry Masonite and wood scraps. Hardware stores and building supply stores carry white vinyl glue and hot-glue guns. Craft catalogs supply varied paper, paints, pipe cleaners, and other collage supplies. Fabric stores carry yarn needles and felt. Once you start your art program, you will see supplies all around you.

Some art materials should be always accessible to your child once he or she can resist drawing on walls. (I drew with cold cream on a linen wall covering once. Who needed crayons?) Here are a few ideas:

- Age 2½: crayons and paper
- Age 3: small blunt-nosed scissors
- Age 3½: markers and paper
- Age 4½: skinny markers, 3" by 5" cards or small blank books, colored pencils, tape, clips, etc.

These suggestions should be based on your own common sense, of course. If your three-year-old is liable to shred his or her clothes with the scissors or is apt to feel peckish and eat the paste, make a few changes.

None of the art materials your child will use is dangerous, but some are better to use only with permission, under closer supervision. These include paint, yarn (you'll know why once you've untangled it), yarn needles, and white vinyl glue. Please refer to the Appendix 1: List of Art Materials for more specific advice.

These materials are not expensive, but they do cost something. Build up your art supplies gradually, beginning with drawing materials. Buy only one or two colors of temp-

era paint if buying more creates a problem. But buy the right two colors—check Appendix 2: The Color Wheel for "related color" suggestions. Scrounge materials when you can—computer paper is good for many projects. If possible, buy larger quantities of a few supplies such as white vinyl glue and inexpensive drawing paper. Sometimes I buy one project material each week at the supermarket—either markers or construction paper or tape or paper clips.

Don't buy art kits for your children. You want to have useful quantities of the supplies your children really enjoy using. You don't want your child given kit projects to copy. If you assemble your own art supplies with some forethought and assistance from your child, you can be assured that, for once, the supplies will actually be used up!

As your children get older, you will want to provide them with higher-quality art materials if you can—better paper, more colors, varied collage supplies. Older children are usually more concerned with the appearance of the finished project than are younger children. Do what you can to give them a head start by upgrading materials. I give you more specific suggestions in the Appendix 1: List of Art Materials and in Part Two: Introduction.

Every parent wants the best for his or her child, and art is one of the best things there is. It's time to feel at home with art again; it's time to start making art at home!

Before Your Child Begins a Long Project: Advice to Parents

Before your child begins any of the longer projects, read through all of the instructions for that project. Then paraphrase or read the instructions to your child one section at a time as he or she works.

Reading the instructions from start to finish not only helps you see what materials and methods are used but also helps you foresee common pitfalls and places where your help is needed.

And I hope that a thorough reading of a project gives you an idea of some of the things that make a project "failure-proof":

- **Choices** are available to your child, even within structure.

- **Flexibility** is encouraged during the creative process.
- There is an openness as to what the finished project will look like.

If you feel that your older child (eight and above) can work alone from the book, I suggest that he or she:

- read the entire project through before beginning
- always ask permission before beginning a long project
- do any messy work only in the agreed-upon art area
- come and get you for any "parents only" help
- always clean up thoroughly when finished for the day, with your help (or final inspection) if necessary

Once these ground rules are established, both you and your child can relax and enjoy the art.

Part One
Age 2–5

Introduction for Parents of Children Age 2–5

Young children are natural, unself-conscious artists. We watch them with a mixture of awe, nostalgia, and even a little jealousy. Did we ever have that confidence with art, that freedom? When did we lose it? A little sadness may creep in—will our children lose that freedom too?

Children certainly won't lose their art if they are allowed (1) to succeed when they make art and (2) to have fun when they make art.

Too often we booby-trap our child's efforts at art by making it impossible for him or her to succeed. We do this out of ignorance: Don't scribble! Don't waste materials! Tell me when you're ready to make *real* art! But don't ask *me* what to use, because I don't know! Sometimes we do it out of vanity: Do it my way! Do it better! Make me look good!

Sometimes we sabotage our young child's art out of insecurity: What is "normal" for my child's age? Can he or she compete? How can I teach my child art when I can't do it myself? What *is* art, anyway?

And as for fun, how often do we take something that is naturally enjoyable (art), slap a label on it ("culture"), and proceed to bash ourselves over the head with it? Pretty often. We wheel our small children off to galleries and museums, and talk about the art in loud and irritating voices.

We lecture. We sign up our toddlers for art classes when they should be drawing on their own, or pasting at the kitchen table, or looking at the sky. We turn everything into a lesson—we drain the joy out of art.

But we don't want to do this, and we don't mean to do it. I hope that Part One gives you the confidence to let your child be the creator he or she naturally is.

What is art to your child? It is not about "things," the finished objects he or she may end up with. It is about making, about the act of creating. This is especially true for a two- or three-year-old child. In fact, the child often doesn't recognize his or her own "art object" the next day.

"My three-year-old only spends a minute on a drawing." (It's still worthwhile.)

"But she scribbles!" (It's especially worthwhile.)

"She can't cut, she piles things up, she uses too much glue." (So do other children her age. It's still worth doing.)

"But when she paints, she slops all the colors together and it's a big mess!" (Not to her. It was a valuable process to her.)

A four- or five-year-old will probably spend longer on his or her art, but it's still hard sometimes to understand what's going on.

"He draws fine, but he still paints like a chimp!" (Painting is different from drawing. Don't expect him to draw when he paints.)

"He loves to cut, but it's so ragged." (This is normal. Show him how to move the paper he's cutting, rather than move the scissors.)

"He sometimes makes things and then smashes them!" (So do other children. Think of it as some weird performance piece.)

Just *assume* that your young child likes to make art. If it's obvious that he or she doesn't, ask yourself some questions:

- Am I letting my child make art often enough?

- Am I letting my child make art where he or she likes to be (outdoors, with other family members, alone)?

- Am I taking the fun out of making art (telling your child to do it, telling him or her *how* to do it, turning it into a lesson)?

- Am I making art at home failure-proof (suggesting the right project for your child's age, the right materials for the project)?

- Am I accepting the kind of art my child is interested in making?

After you have done what you can to make art at home possible for your child, relax. It's only natural that some children like making art more than other children do. If you've made it available, they'll do it from time to time if you let them get bored enough. (Hint: Turn off the TV! And when they say "What'll I do?" say "Gee, I don't know." Then slip out the art supplies.)

Even the most avid child artist has periods when he or she is busy with other things. Expect enthusiasm to come in irregularly spaced waves. It's still genuine enthusiasm.

I have given age suggestions for each project. The notation "3+" means that most three-year-olds could do the project, and so could four- or five-year-olds. (Even older children might often enjoy the project.)

You might have a two and a half-year-old who could do that project. Fine! (It doesn't mean your child is especially gifted, though; these things have a way of evening out.)

You might have a three- or three and a half-year-old who can't do the project yet or who needs more help than the instructions indicate. That's fine, too, and it certainly doesn't mean your child is "slow" or bad at art.

The ages given are intended merely as guidelines. That's the best way to use them. But don't try to go *much* younger than the age recommended. Don't try to push your two-year-old to do a project recommended for a four-year-old. Don't try to teach your child through art or improve

him or her with art. Each year is precious and unique—help your child live fully and happily in each year.

The art projects in the book are for boys and girls; the "boy" and "girl" designations I have given are just to make the projects easier to read.

As your child grows up, you will find yourself reliving these early years each time you look at the art he or she made once, when everything was new.

1
Drawing For Children Age 2–5

"What are you drawing?"

"It's just a buzzine!"

Drawing delights more children—and scares more adults—than any other art activity. Don't let your own fears about drawing affect what should be the heart of your child's art.

Have you noticed how naturally your child draws? She doesn't worry about whether she is "good" at it or whether she "knows how" to draw something. She just does it!

The good news about drawing at home is that *you don't have to teach anything.* Just provide drawing materials and time. That's it. But if you do it consistently and without interfering, you will provide your child with the strongest possible art experience.

Scribbling

Until your child is three or four, he will "scribble" when he draws. (We call it scribbling when *we* don't recognize what it represents. When the first wobbly tadpole-man appears, we breathe a sigh of relief and call it "drawing.") Here is what scribbling is not:

Example of scribbling, age 3½

"Sky Ride," age 3½

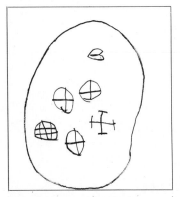

Intersecting lines inside a circle
are similar to ancient designs
called mandalas. Age 4.

● *It is not meaningless.* It is the child's different way of responding to things.

Imagine that you, an adult, are describing your home to someone. How do you represent it? Maybe it's with a photograph, a floor plan, or a drawing of your home. But perhaps you just write down your address, or even get out a map and point. Does the address look like your home? Does the map?

Imagine that you, an adult, are asked to draw the Fourth of July. Most of us would respond by drawing a copied symbol or two: the flag, a firecracker, a watermelon. But a child might choose to draw a feeling of excitement, the action of fireworks bursting in the night sky, or the lines of a sparkler zigzagging in the dark. That drawing might even look like scribbling.

● *It is not practicing for "real" drawing, or for writing.* It's already real.

● *It is not a waste of paper.* Junk mail is a waste of paper. Drawing never is.

Your youngest "scribbler" will probably start with long back-and-forth lines. Later the lines will be more controlled, and he will spend more time on a drawing. Dots often show up, and circles. Look for intersecting lines inside the circle—this is similar to a beautiful, ancient design called a mandala.

Scribbling is so important that I'm going to strongly suggest a few "nevers":

● Never ask your child to copy what you draw.

● Never "help" your child with his drawings.

● Never "correct" his drawings.

● Never push your child's own natural drawing development.

When we do this, we are sacrificing something precious and unique in each child to our own vanity.

Symbols

The first symbol your three- or four-year-old child will probably draw is tadpole-man (or tadpole-woman). This

creature has one leg; if it has two, it looks more like what we call a stick figure. (Most of us still draw something like a stick figure when we try to draw a person.) It's a symbol because we all recognize what it stands for (on its wobbly leg) immediately, although it doesn't look like anyone we know personally.

Children quickly develop many drawn symbols, and each symbol undergoes changes over time. These symbols have more to do with thinking than with specific observation. For example, if your four-year-old daughter wants to draw a tree, don't suggest the elm tree in the front yard. She already knows how to draw a tree—her own tree symbol. She will draw it at the kitchen table, not in the front yard.

It's important that you let your child develop and change her own symbols at her own speed. She will come up with the symbols that are important to her so please don't try to teach her new ones. And again, please don't correct or change your child's art.

The kind of drawing that usually comes after basic symbols is another type of symbol, based more on copying than on thinking. It often starts with kindergarten-aged children, although sometimes younger children begin drawing this way. (This is especially true if they draw with older children.) The sun migrates to the upper left (or right) corner of the pages, flying birds become flocks of little *m*'s floating across the sky, and rainbows appear at the tiniest provocation. These new copied symbols don't change much from drawing to drawing.

Many parents view these drawings as the end of their child's originality. It's not that serious! I don't think they're as much fun to look at as the earlier drawings are, but children seem to get just as much pleasure from making them. And the point is not how much we as parents enjoy the finished drawing but what the child got from making it.

Let even these drawings evolve naturally. *If they want to copy, let them copy from each other.*

Two examples of tadpole-man: Untitled, age 4 (top); "Daddy Whale and Baby Whale," age 3½ (bottom)

Art Supplies

Specific advice about art materials will be given with each project, but here are a few basic suggestions about materials for *unstructured drawing:*

Eleven examples of stick figures and symbols

"Mickey Mouse,"
age 3½

"Uncle Todd with Moustache"
age 3½

Untitled, age 4

"Family" (pregnant woman), age 4

"Daddy in a Heart," age 4

"Mary and Angel," age 4

"Mommy Dancing," age 4 ½

"Little People, Big Ears," age 5

"Me and My Friends," age 5 ½

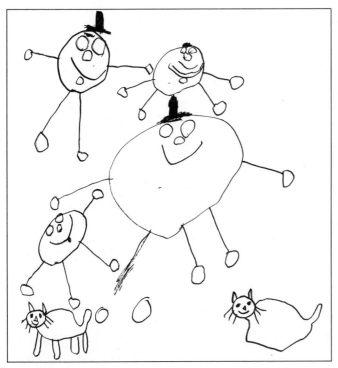

"People and Cats," age 4 ½

"Robot," age 5

Paper

Younger children (two- and three-year-olds) usually make big marks, so they need big paper. Try to make it 18″ by 24″ or thereabouts. You can go down to 9″ by 12″ for three- and four-year-olds. You can even try unlined 3″ by 5″ cards for four- and five-year-olds.

The paper shouldn't have printing on the drawing surface, but there can be printing on the back (as with computer paper).

For two-year-olds, try taping down the corners of the drawing paper. This keeps the paper from wrinkling and tearing during strenuous workouts.

It is good if the tabletop is a different color from the drawing paper. If you put white paper on a white formica tabletop, very young children may be unable to see the edges of the paper. They color over the edges onto the tabletop.

Don't spend a lot of money on paper at this point. Quantity, however, *is* important; try to have lots of paper (scrounged or bought) always available for drawing.

Drawing Materials

The basics are crayons and markers. For two- and three-year-olds, buy the big ones. (Make sure you buy the large *size,* not the large *set.*) For four- and five-year-olds, you can buy skinnier crayons and markers, but don't buy the huge sets. Sixteen colors are plenty to choose from. There's no point in cultivating greed.

Crayons: Your child can use both regular colors and brighter fluorescent colors. But, especially for two- and three-year-olds, you want the crayon marks to be highly visible. For this reason, avoid offering the very light crayon colors for use on light paper.

Markers: Offer only watercolor markers, never permanent markers. (Even with watercolor markers, discourage your child from drawing on his body.) Again, avoid using the lightest colors on light paper.

Here are a few other suggestions about markers:

- Remember that they are transparent and won't show up well on medium-to-dark drawing paper.

- Select pointed markers, not the wedge-shaped lettering ones. Check that the caps stay on well.

- Try to resist scented markers, or any other gimmicks marker makers might manufacture. I was visiting a school once when a child ran up to me exclaiming, "Smell my drawing!" It was a disorienting experience. Children seemed to be selecting colors primarily on how they smelled rather than how they looked. (Another problem with scented markers is that the children using them often walk around all day with highly colored nostrils, victims of overenthusiasm.)

Other Drawing Materials

There are several other drawing materials good for unstructured drawing.

- Chalk and pastels are fun for four- and five-year-olds to use on dark construction paper.

- Charcoal is best used on light paper. Try it with four- and five-year-olds.

Chalk, pastels, and charcoal all smear, and might frustrate some tidy children. *Offer them anyway* from time to time. This is one instance when you could make a few suggestions about subject matter—encourage smeary subjects such as dandelion puffs, clouds, or hairy spiders. Don't fight the drawing materials; have them work for you.

If you decide to use fixitive to protect your child's chalk, pastel, or charcoal work, use it outside, away from your child. Read the precautions on the label, and then be twice as cautious. *Don't let your child use fixitive.*

- Don't use india ink with children. It stains and it's not safe for them.

- I discourage the use of school-type materials such as ballpoint pens and hard pencils. For one thing, they don't make very beautiful drawn lines and, for another, the lines don't show up as well as with the suggested drawing materials. Let's face it—your children will have to use pens and pencils often enough. Let them have a little variety now!

Free drawing can be done with brushes, crayons, pencils, or markers.

Unstructured drawing should be by far the largest part of your at-home art program. It's the easiest part; there's very little you have to do. And it's truly failure-proof; there's no way a young child can draw "wrong."

Drawing Activities

Books

The following two projects are best done by children age four and older. The first involves a (very) little effort on your part.

LITTLE BOOKS (4+)

One evening, gather some *scrap paper* together. It should be white or some other light color. Cut it into skinny strips (about 3″ by 8″, for example, but the strips can be any size). You need only three or four strips to make a six- or eight-page book. You can also cut a *construction paper* cover. Vary the sizes, colors, and bindings if you want to. You can bind the books with *staples, brads, yarn,* or *pipe cleaners.* You'll probably be able to fill a shoe box with them during the "Movie of the Evening."

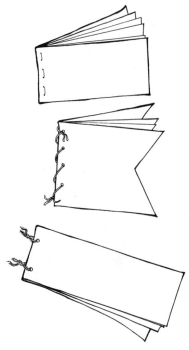

Markers work well with these little books. Your child's drawings in a book might be unrelated, or they might tell a story (don't be too picky about plot development at this point, though). Either way, ask your child if he would like you to write down his words about the drawings.

When my oldest son was four, he saw *Superman: The Movie.* It made such an impression on him that he did a very long book (on unlined 3″ by 5″ cards) about the movie. I was amazed at the details he remembered! He also made a cassette "sound track" to go along with his book. This kind of regurgitation is a good idea for two reasons: (1) it helps the child sort out the chaotic images he's just seen and (2) it helps the parent become aware of any fears or misunderstandings the child may have from the experience.

Print his words, using upper- and lowercase letters correctly. (Your printing should be small—don't take over the book.) Then read it back to him, often.

Be sure to put the date on the back of the book. It may be a little book, but it will be a big treasure in years to come.

Little books can be stapled (top), stitched with yarn (center), or bound with twisted pipe cleaners (bottom).

SCRAPBOOKS (3+)

Remember those old-fashioned scrapbooks with paper pages? They still make them! Hunt one down, and give it to your three-, four-, or five-year-old. (The blank books sold in stationery stores can be used also.) Those paper pages are good to draw on with *markers,* and good to *paste* favorite *magazine pictures* and *greeting cards* on, too.

If you feel up to it, you could even help your child decorate the cover of the scrapbook—I suggest magazine pictures. Cut out some favorites and be sure to include a couple of big pictures. Your child uses *white vinyl glue,* thinned with a little water, as the adhesive. She should glue

down the big pictures first. If the thinned glue resists when your child brushes it on, add a few drops of liquid detergent to the mixture. (Have your child brush the glue on the scrapbook, not the picture.) She may give her cover a final coat of the thinned white vinyl glue, which will make the pictures shiny. She can add more pictures later. (Parents: You may need to help with the shiny glaze.)

The scrapbook doesn't need to have a theme, but some children like themes. Here are a few ideas:

- different people

- things I like

- scary things

- vehicles

- animals

- whatever your child dreams up!

Since these scrapbooks are big, don't expect them to "read" like a book. They will be worked on over a long period of time.

Both of these drawing projects are good to bring with you on car trips, but I suggest switching from markers to *crayons,* which are less likely to end up on shorts, knees, or car upholstery.

Drawing with Crayons

I've already mentioned big crayons (especially good for two- and three-year-olds) and skinny crayons (good for four- and five-year-olds). Fluorescent crayons come in the big size only. You can buy crayons in most supermarkets.

Traditionally, many of us associate crayons with coloring books. Please don't do this anymore. There are many crayon activities that your child can do without coloring books.

"But coloring books are good for developing eye-hand coordination," you might argue. "Eye-hand coordination" is one of those phrases people invoke when defending an activity they just simply feel like doing. What are we really talking about when we apply this handy phrase to coloring books? Neatness. Staying inside the lines. Control. These

are things that describe the rest of our lives. Why should we ask them of art, especially during childhood?

This low opinion of coloring books seems to be shared by many others educated in the 1960s, as I was. I do feel, however, that coloring books are okay to use under a few circumstances:

- *If your child is in a weakened condition.* If he is in bed with a cold, or held captive in the backseat of the car during a long trip, he might be diverted by a coloring book.

- *If you are in a weakened condition.* If you are sick in bed, or are held captive in the front seat of the car during a long trip, you might need a coloring book . . . for your child.

- *If your child really likes coloring books.* Some children (four- and five-year-olds, usually) find them absorbing and relaxing.

Even under these few circumstances, use coloring books sparingly. And don't consider them art—consider them tranquilizers.

Actually, one of my biggest gripes with coloring books is that the drawings are so bad. Why should your daughter spend half an hour coloring in someone else's badly drawn kitten? What does that do for her own aesthetic development?

If you decide to buy a coloring book, please don't buy it for a child under four years of age. Just buy your younger child a tablet of blank newsprint, and let him draw on his own! (This is a good idea for older children, too.) There are a few coloring books on the market that you might consider:

- Susan Striker's *Anti-Coloring Book* series. These are really drawing books and are usually better for children over five years of age.

- Coloring books of simple patterns. Some of the hard op-art or quilt patterns are better for older children.

- Coloring books of American icons such as Donald Duck or Mickey Mouse. I like these better than the coloring books that represent various toys on the market.

Crayon resist (crayon with thin
tempera wash)

FREE DRAWING ON BIG PAPER (2+)

Tape down the corners of a big (over 12″) sheet of *white* or *light paper.* (Put either a couple of sheets of newspaper or newsprint under it for a more sympathetic drawing surface.) Computer paper or newsprint is fine for crayon work.

Get out the *big crayons;* offer colors that will show up well. Repeat as needed. That's all.

FREE DRAWING ON SMALL PAPER (3½+)

The paper for this can be 9″ by 12″ or smaller. *Blank newsprint* is fine. You probably don't need to tape down the edges of the paper. The child can use *skinnier crayons* if he wishes.

Your three-year-old may still be "scribbling," but probably has something to say about his drawing. Ask if he wants you to write down his words about it. Print them small, using upper- and lowercase letters correctly. Read them back to him.

CRAYON RUBBINGS (4+)

Your child needs *thin paper* for this project; newsprint or computer paper works well.

Rubbings are done by placing the paper over a shallowly textured surface such as leaves or pennies. Your child then rubs a *crayon* over the surface.

You and your child can choose an assortment of things she would like to try rubbing. Select natural objects as well as man-made ones. (If your child selects something you feel wouldn't work, let her try anyway—unless it's a snail, or something like that! Children learn by doing things themselves, not by being told about them.)

If your child does a series of rubbings on same-sized paper, you can help her bind them together into a Rubbings Book (see the Little Books section on page 15 for book ideas).

CRAYON RESIST (4+)

Oil and water don't mix—and that's the basis for resist projects.

Your child can use *white* or *light construction paper* for this, but try to offer *lightweight white poster board.* (Packets are sold in many supermarkets and discount stores.)

Any crayons work, but bright colors work best with dark paint. You can use ordinary crayons, but *fluorescent crayons* are especially good.

Your child crayons any design or picture he wishes. His next step is to paint a thin wash of paint over the crayoned poster board. He can use *watercolor* or *thin tempera* for this paint.

If he uses watercolor, help him mix it up in a *little dish* so he can "wash" it over the picture quickly. He uses as *big and soft a brush* as possible, and doesn't scrub the paint onto the crayon marks. He strokes from side to side, and tries to cover each area with just one stroke.

If he decides to use tempera, you should thin it with water until it looks more like a watercolor wash. *Don't add any liquid detergent to the wash; if you do, the "resist" won't work.* Again, he uses a big, soft brush, strokes once, and doesn't scrub.

The crayon colors spring to life against the dark wash. (Magicians can draw "invisible pictures" on white poster board with a *white crayon* or piece of *paraffin.* The picture appears only when the covering wash is applied!)

CRAYON ETCHING (4½ +)

This project is similar to crayon resist in that the same materials are used. But it is a little harder.

Your child works small. Cut a piece of *lightweight poster board* for your child. It should be under 6″ in length or width. Put a piece of *newspaper* or *newsprint* under the poster board.

Now comes the hard work. Your child needs to *crayon very hard* over the whole board. (That's why she has such a small piece.) She can use as many colors as she wants, but should crayon off the edges, and crayon as long as she can. Ask her not to draw a specific scene, just to cover the board with beautiful colors.

Dust off the crayon bits, and mix the wash. Again, this can be *dark watercolor* or *thin tempera. Do not use india ink for this part even if you used it when* you *were a child. It is not considered safe for your children to use.*

Crayon etching (crayon and tempera paint etched with large unfolded paper clip)

This time you must add a few drops of *liquid detergent* to the wash. This lets the wash cover the crayon without resisting.

Your child brushes on the wash, then waits for it to dry. (It dries quickly.) Unfold a *paper clip* for her to scratch whatever design or picture she wishes. The paper clip goes through the dry wash, exposing the crayon colors underneath. That's etching.

I'd like to say some good words about crayons. Children today are offered markers so often that they sometimes miss out on crayons. Crayons smell good, feel good, sound good, and look great. Unlike markers, they allow children to vary the pressure used. They're clean and don't dry out, either. Good old-fashioned crayons—provide them more often.

Drawing with Oil Pastels (4½+)

Oil pastels are small so are best used by four- and five-year-olds. They come in vivid colors, blend almost like paint, and look wonderful on dark backgrounds. They aren't powdery like ordinary pastels.

Buy the smallest set of oil pastels you can. They get used up quickly and you will have to peel down the paper around them as your child uses them up.

Your child can use oil pastels on any color of paper, but I suggest *black construction paper* or another dark color.

Oil pastels are a drawing material and can be used like markers or crayons, but the best way to use them is to take advantage of how they blend; otherwise, your child could just as well use markers or crayons.

On a piece of scrap paper, show him how the colors blend. Put down a heavy patch of blue, then a heavy patch of yellow right on top. Green! Then leave your child in peace.

He may do just an outline drawing, or he may attempt to blend colors. He may blend colors you don't like, but don't hover, calling out tasteful color combinations. Answer any specific color questions you can, though; refer to the Color Wheel (see page 247) if necessary.

Drawing with Chalk Outside (3+)

This project is done only with permission; otherwise, it's not art, it's vandalism! Select a likely patch of *driveway* or *sidewalk* to draw on.

Your child can use *white chalk* or *pastels* for this project. (Do not use oil pastels, though. Just use common pastel-colored chalk. First test the colors on a hidden patch of driveway—some colors don't hose off well.)

If your child does this on wet or damp pavement, the chalk won't wear off so easily. Unless you want these drawings around for a long time, your child should draw on a warm, dry day.

Your child may want to end her drawing session by getting out the hose and "erasing" her work. Fine! Or she can just watch the drawings slowly disappear, day by day.

It's fun for her to draw on a bumpy surface for a change, and it's always fun to make art outdoors. Something else I like about this kind of project is that the child isn't making a *product*; she's enjoying the *process* of making a drawing.

Drawing in Dirt (or Wet Sand) Outside (2+)

It's fun, but is it art? Well, one morning I went next door to visit my neighbor. She was working in the garden, and her two-year-old son, Evan, was working nearby. As we talked, Evan came up to me several times, asking me to break a little branch "right there," or to choose between this stone and that one.

He led me over to his project. It was a big drawing-sculpture he had made in a patch of damp earth. He had walked all around it as he worked, placing a stone here, poking in a branch there. He had spent at least half an hour on it, and it was art.

Your child draws with oatmeal in his high chair tray. He draws at the beach. If you have a backyard, one of the nicest things you could do for your child is to have a big pile of sand in some shady corner near a hose. He can draw there,

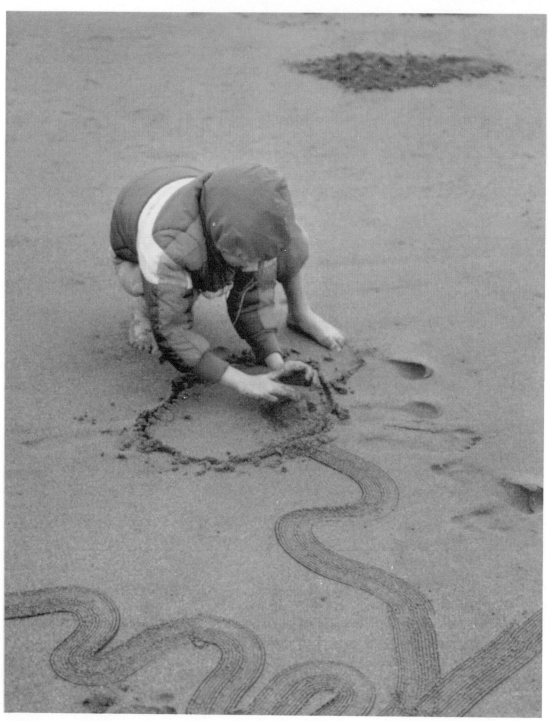

Drawing in wet sand

too. Encourage your child to take part in this ancient art activity. He's not just messing around!

The most expensive climbing structure in the world can't compete with a sand pile or dirt patch. It's a little inconvenient, and it doesn't scream "Look what I spent on my child!" but it's a gift that means something.

Drawing Words to Use with Your Child

Drawing line

long line, short line
straight line, curved line, circle, dot

Paper

Markers

Crayons

Color

light, dark
bright, dull

Artists to Look at with Your Child

Pictures of cave paintings

Mary Cassatt (beautiful pastel work, often of children)

Paul Klee (small, fanciful drawings)

Henri Matisse (wonderful drawn line and pattern)

Illustrators and Their Books to Read with Your Child

Don Freeman *(Corduroy)*

Jane Hissey *(Little Bear's Trousers)*

Robert McCloskey *(Make Way for Ducklings, Blueberries for Sal)*

Maurice Sendak *(Where the Wild Things Are)*
William Steig *(Doctor DeSoto)*
Garth Williams

2
Painting for Children Age 2–5

The children had spent the morning mixing food colors in glass jars, with the teacher's careful guidance. Red and yellow had made orange, just as blue and red had made purple. Jars of many different colors now littered the table. ". . . And what would happen if we mixed *all* these colors together?" asked the teacher. "We'd get a rainbow!" shouted one ecstatic child.

If only it was that easy! Color mixing is one of those things we learn through hard experience, trial and error. The right projects can help this learning process. Most of the following painting projects stress color mixing.

When your two- or three-year-old paints, she often layers the paint. It looks as if she is painting one picture right on top of another. That's okay. Let her alone—let *her* decide when she's done. *The act of painting is more valuable to her than the painting itself is to either of you.*

And even if your four- or five-year-old is *drawing* recognizable symbols, her *painting* is often still nonobjective. That's fine. It's harder to do detailed work with a brush than it is with a crayon. And why should paintings look like drawings anyway?

Tempera Paint

Tempera is the paint you will use most often. You can buy it in two forms:

1. Dry, or powder: Pour some into a container, add a *few drops* of water or liquid starch, and stir to make a paste. Then thin with more water, usually to a milk-shake consistency.

2. Mixed, or liquid: This is already mixed with water. Thin it with more water, if necessary. Buy mixed colors if you can—they are much brighter.

If a child is allergic to eggs, sometimes he will have a mild reaction to skin contact with tempera.

You can buy tempera in art supply stores, through some catalogs, and sometimes in paint supply houses or discount stores. Your child can do many of the book's projects with one or two colors of tempera.

If you can buy two colors, get two that will mix well together. Here are some color-mixing ideas:

red + yellow = orange

yellow + blue = green

blue + red = violet

yellow + green = yellow-green

yellow + orange = yellow-orange

red + orange = red-orange

red + violet = red-violet

blue + green = blue-green

blue + violet = blue-violet.

There are a few things you can add to tempera to make it behave differently:

● Ivory Flakes makes tempera wash out of clothing a little more easily. *(Do not substitute a harsher detergent for this purpose!)*

- Liquid detergent (a few drops only) makes the tempera cover shiny surfaces without "beading."

- Liquid starch makes the paint feel slippery.

- White vinyl glue makes a shiny, water-resistant paint. (It makes it harder to wash out of clothing and brushes, though.)

The other paint you will buy is a set of watercolors for four- to five-year-olds. Buy a small set of eight colors only.

Brushes

Your child will only need two or three brushes for painting with tempera. You may already have them at home. They should be different sizes—one can be a flat brush. These can be bought at an art supply store, through a catalog, or at a paint supply house. Buy the cheapest ones you can, but check the bristle attachment to make sure the bristles don't shed or fall out at the slightest pressure.

A watercolor brush is included in each watercolor set. Check the brush for shedding, and buy a replacement if necessary. Watercolor brushes are small and have soft bristles.

Paper

Paper should be 12″ by 18″ or bigger for two- to three-year-olds, and can go down to 9″ by 12″ for four- to five-year-olds. It has to be sturdy enough to withstand heavy paint and aggressive brushwork. *Do not use newsprint* for painting except in two activities:

- It can be used to lift a monoprint.

- It can also be used for stamp-printing.

For thick tempera you can offer construction paper, computer paper, white shelf paper, butcher paper, or brown wrapping paper. Use any medium-weight paper you have access to. It's fine if there is printing on the reverse side—that doesn't bother most children at all.

Flat brush (left); round brush (right)

Finger-painting (tempera paint and liquid starch)

Watercolor paints are transparent. For that reason, you must use white paper or very light-colored construction paper. Anything else just won't work.

Painting Activities

FINGER-PAINTING (2½+)

Put a piece of *oilcloth* or some *newspaper* on the kitchen table. Your child can work on a *cookie sheet,* which is easy to clean, but you might eventually want to reserve one cookie sheet for art. (Art is better for you than cookies, anyway.) Your child can wear an apron for this project.

Mix up one or two colors of *thick tempera,* or choose two dry colors. See the color-mixing suggestions mentioned earlier.

Your child chooses a piece of *construction paper* and places it on the cookie sheet.

Pour a puddle of *liquid starch* on the paper. Add a spoonful of mixed tempera or sprinkle the dry tempera on the starch. Your child can now finger-paint.

Try changing the color of paper your child paints on. You can also add the second tempera color (mixed or dry) and your child can mix them on the paper. Don't turn this into a big color-mixing lesson, though.

MONOPRINTING (3½+)

This project begins just like the finger-painting project, but it can be done directly on the *cookie sheet* (or the *oilcloth* for that matter). Pour some *tempera* on the cookie sheet. Remember to add a few drops of *liquid detergent* if the tempera is "resisting."

Let your child finger-paint, then add the second color of tempera. Have your child wash his hands in the soapy water, and dry them.

Your child then selects any piece of *12" by 18" paper* and presses it on the finger painting. He then lifts the paper slowly and carefully. The reverse image of the finger-painting is transferred to the paper—that is the monoprint.

Add more paint and have your child repeat the process. Try using a different color of paper.

Your child can also vary the final effect by using different pressing techniques. For example, if he "draws" with his fingertips on the back of the monoprint paper, a squiggly painted line is picked up.

The slightly older child (4+) can place *leaves* or *paper cutouts* on top of the finger painting. He then washes up, and makes a monoprint. He can try this with different colors of paint or paper. Thinner papers such as newsprint usually work best with these negative-space monoprints. (Negative space is the space created by the leaves in the monoprint.)

Monoprinting (from finger-painting done with tempera paint)

Stamp-Printing Activities

Here are the supplies you need:

old washcloth or other absorbent fabric scrap

cookie sheet

tempera

liquid detergent

almost any paper

stamping tools (see individual projects)

For all of these stamp-printing projects, the best result is achieved if the parent makes a simple stamp pad for use with tempera paint. Here's how to do it.

1. Get an old washcloth or other absorbent fabric scrap. (You may also use paper towels.)

Monoprinting (with tempera paint and leaf)

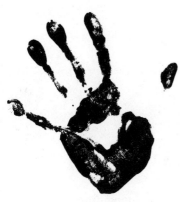

Handprint (with tempera paint)

2. Rinse the washcloth with water and wring it out thoroughly.

3. Spread it on the cookie sheet, and brush on the thick paint. You may swirl two colors together on the wash cloth.

HANDPRINTS (2+)

Making handprints is an ancient printmaking activity and is the earliest children do. You need:

bucket of soapy water and old towel

tempera

stamp pad (see instructions above)

paper

First your child washes and dries his hands. He then presses his hand on the stamp pad and stamps it on the paper. (Parents: Check the pad at this point to see if there is enough paint.)

Remind your child to press his hand on the pad again for each new print. For a change, offer white paint on black paper. These prints make great cards for grandparents and are fun to marvel over in later years. Parents: Be sure to name and date them.

FOOTPRINTS (3½)

Most of the supplies for this project are the same as for Handprints.

basin of water and old towel

tempera

stamp pad

paper (try a roll of shelf paper)

This is fun to do outdoors on a hot day. The same procedure is followed as for handprinting. Or, if you don't want to use paint, the child can take two or three successive steps, from the water basin and watch the footprints fade.

Cookie Cutter Prints (3½)

Use the same basic stamp-printing materials as in the previous two projects. You also need cookie cutters. Use simple shapes such as hearts and crescents; avoid complicated ones like rocking horses.

Your child follows the basic stamp-printing procedure previously outlined. Remember to offer different paper sizes, colors, and shapes. *You may need to remind your child to keep stamping the cookie cutter on the pad.*

When your child is finished, have her soak the cookie cutters in the soapy water and help wash them. (For some children this is the best part!)

Many other kitchen gadgets can be used for stamp-printing. Just look around.

Fruit and Vegetable Prints (4+)

Here are the supplies you will need:

tempera

stamp pad

almost any paper

assorted cut fruits (such as ½ apple, ½ dried-out orange)

assorted sliced vegetables (such as celery stalk or green pepper)

Your child follows the same basic procedure previously outlined. Encourage her to try stamping different fruits and vegetables in different colors.

Fruits and vegetables can be sliced in various ways for different effects. Parents: You do the slicing, naturally.

Color-Mixing Activities

Simple Color Mixing (3½+)

This is a parent-child activity that doesn't result in a finished product. Always work on newspaper, and protect clothing.

Cookie cutter printing

Three examples of stamp
printing using fruit and
vegetables

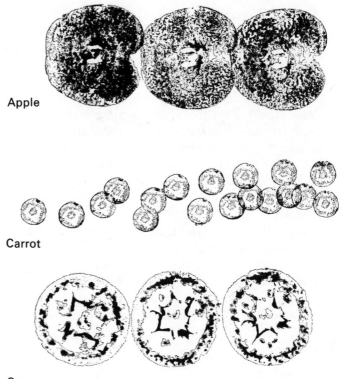

Apple

Carrot

Orange

Assemble a few *glass jars* or *cups,* and put an inch of
water in each. Have your child drip some *food color* (one
color) into each jar.

Select another color (see suggestions at the beginning
of this chapter), and let your child add the second color and
mix them.

After this has been repeated in different jars with vari-
ous combinations, let your child mix any color to see what
happens. (Any rainbows?)

Carefully pour the color mixtures down the drain, and
help your child wash the jars.

Food colors are transparent. To make a tint of any
color, all you have to do is add water. For example:

red + water = pink

blue + water = baby blue

yellow + water = pale yellow

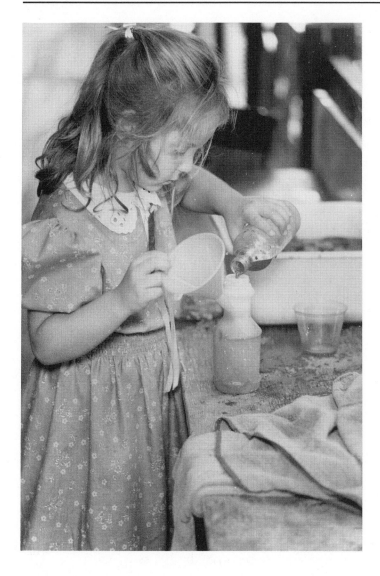

Simple color mixing

Drip-Dye (4+)

For this project you need:

newspaper

food color in squeeze bottles or used with eyedroppers
(some groceries sell large, relatively inexpensive bottles
of food color)

Eyedropper for drip-dye project

water

solid-white paper towels or flat round coffee filter papers

cookie sheet, waxed paper, or aluminum foil

spray bottle filled with water

Work on newspaper. Protect your child's clothing. Assemble the food color in squeeze bottles, or use eyedroppers.

Help your child fold the paper towels or filter papers in half, then in fourths. Put the folded papers on the cookie sheet, waxed paper, or foil.

Your child drips food color (or tints) on the folded paper. Help her blot the paper and then unfold it.

For a softer design, lightly spray the folded papers with water. Then have your child apply the food color or tints drop by drop, and watch the colors mix and spread! This project makes a symmetrical design when the paper is unfolded.

WATERCOLOR (4+)

Your child needs:

set of watercolors

good watercolor brush

glass jar for rinsing (large mayonnaise jar works well)

clean paint rag or paper towels

lots of white paper, 8″ by 10″ or larger

Watercolors are fun for children to try even though they present a painting challenge. Watercolors are transparent, so no color can be covered completely. In addition, your child uses only one brush and must learn to rinse and wipe it when changing colors. Parents: You can demonstrate this to the child.

Beginning watercolorists may well be most fascinated with watching the rinse water change color. Don't think the project is wasted if this happens.

The watercolor painting itself often looks more like a drawing than a painting. If the child does try to layer the paint, it often gets "muddy" as the colors mix. Provide lots of paper so your child can experiment; children often turn out watercolors in large quantity.

WATER PAINT OUTDOORS (2½)

Paint roller

This is a good project for a warm day. It should always be done with permission, and is a good way for parents to keep a child occupied while they are working outdoors. All "painting" is done with water only. You need:

water

bucket or paint pan

big old brushes or rollers

Assemble a bucket of water and assorted brushes. A roller and roller pan can be used, too. Give the child a "job"—an area to "paint" (driveways, walls, and fences are good places to work). Enjoy your child's company as you both enjoy being outdoors.

You probably have noticed that easel painting is not mentioned in this chapter. There's nothing wrong with easel painting except that it involves buying (and storing) an easel.

I always had an easel for my children, but they seldom used it. It was a minor ordeal to drag it out and clean it off. But, more important, my children didn't even *like* the easel. It made art too much of a "big deal"; it made them a little self-conscious.

Anything that makes art seem harder to do, or less a possible part of everyday life, should be avoided. Art isn't something you have to do in the corner, at a certain time, wearing special clothes! It's a natural activity.

In addition, I don't think it's necessary (or even beneficial) for children to have the same things to play with everywhere they go. Your child doesn't need an easel at the day-care center *and* at Sunday school *and* at her best friend's house *and* at home.

Art is art even without an easel!

Painting Words to Use with Your Child

Paint

> tempera paint, watercolor paint
>
> thick paint, thin paint
>
> drips, drops

Brushes, Stroke

> wide brush, narrow brush
>
> hard bristles, soft bristles
>
> long stroke, short stroke, curved stroke
>
> dot, dab

Color

> light, dark
>
> bright, dull
>
> mix colors, blend colors

Shape

> big shape, small shape

Artists to Look at with Your Child

> Piet Mondrian (bright color, nonobjective work)
>
> Georgia O'Keeffe (beautiful color)

Illustrators Whose Books Contain Interesting Paintings

> Leo Lionni (*Fish Is Fish:* stamp-print image)
>
> Beatrix Potter
>
> Maurice Sendak
>
> Brian Wildsmith

3
Collage for Children Age 2–5

A collage is artwork that is held together by glue. Since most children are pack rats, collage work offers a good opportunity to use cherished stored-up Stuff!

There are only two things you must remember in collage work:

1. Make sure that your child is using a strong-enough base for the collage he is doing.

2. Make sure that he is using a strong-enough adhesive for the collage he is doing.

The Base

If your child does artwork away from home, I'm sure he has brought home a flapping collage. Big bulky objects are glued down on a flimsy piece of paper, often newsprint. It looks terrible because the weak base takes away from the strong collage materials the child has chosen.

Common sense will help solve this problem. But here are a few general guidelines:

- *Newsprint:* This is good only for lightest-weight collage, such as with magazine pictures.

Corrugated board

- *Construction paper:* This is good for many collage projects. The collage materials should be flat or almost flat. Lightweight materials such as Cheerios or small Styrofoam pieces are okay. (With tissue collage, use only white or light construction paper.)

- *Lightweight poster board* (sometimes called railroad board): This is excellent for tissue collage if the board is white. You may use any color for other collage work—use it with fabric scraps, construction paper, or medium-bulky found objects such as spools or acorns (if lightweight).

- *Corrugated board* (brown cardboard box material, also available and inexpensive in sheets from many art supply stores): This is good for use with very bulky collage materials such as egg cartons, pine cones, etc. It can be cut by a parent using a utility knife or paper cutter. It may be painted any color before your child starts his collage—use "glue paint" (tempera mixed with white vinyl glue).

- *Other:* Shoe boxes, Styrofoam meat trays, oatmeal cartons, etc., may be used as bases. Just make sure the base is stronger than the things your child will be gluing on it.

The Adhesive

I'm sure your child has brought home a shedding collage before, too! Beans, felt pieces, and sticks fall to the floor as she holds her collage up for your inspection.

There are several adhesives your child can use in collage work. The trick is to find the right one for each project. Here are a few guidelines for adhesives:

- *Liquid starch:* Use this only for tissue collage. Your child will apply it with a small brush.

- *Paste:* This may be used for light- to medium-weight flat collage materials. It is good for two- and three-year-olds because they may use their fingers with it, or a glue stick, or a small stiff brush.

- *White vinyl glue:* This is the most versatile adhesive your child will use. Try to buy it in a large size at a

discount store or the hardware store—you can then refill a smaller squeeze bottle for your child to use. You may also pour it onto a small paper plate for her to use with a glue stick or a small stiff brush. Discourage your child from using her fingers to spread white vinyl glue.

White vinyl glue may be used *thick* for the heaviest or bulkiest collage work. It thins with water. It is used *medium-thick* for medium-weight collage materials. Dilute it more for lightest-weight materials such as tissue or magazine pictures. *Thin* white vinyl glue dries clear and gives a glossy finish when brushed over a collage.

Tempera (powder or liquid) may be added to white vinyl glue (of any thickness). It colors the glue. This is what I refer to as "glue paint." It dries shiny and is a little more water resistant than plain tempera.

If your child is using white vinyl glue on a slick collage base such as foil or the waxed side of a milk carton, add a few drops of liquid detergent to the glue. This lets the paint spread without resisting.

When your child uses white vinyl glue, you must wash the glue stick or brush right after you finish. If you don't, the glue dries hard, and the stick is no longer usable.

- *Other:* If you buy any other adhesive, check the ingredients carefully. Check the warning labels, then be twice as cautious. (**Most labels are intended to warn adults, but some things that are safe for adults aren't so safe for small children. Do not let your child use rubber cement, Super Glue, a hot-glue gun, or spray adhesive.**)

If you have a two- or three-year-old child, you will notice a couple of interesting things about her collage work. The first thing is what I call the "collage sandwich" phenomenon.

Even if you limit the amount of materials available to her in any given collage projects she often layers the materials on the base. She covers small objects with bigger ones, and you may feel she's just wasting the things you've gathered. She isn't. *Remember: It is the act of making this collage that is of value to her, not the collage itself.*

I do suggest limiting the amount of collage materials on the table for these young children; there should always be a choice, but it should be a limited choice. I then urge you to allow your child to use any or all of those materials in her collage. She may bury a pretty object under a larger one. Let her. Is something less real or less valuable because it is hidden? Let her make a collage sandwich if she wants. You may end up with a 2-pound collage, but so what? Use it as a paperweight!

The second thing you'll probably notice about your two- or three-year-old's collage work is the glue. Her logic may go something like this: "I want this to stick. I want it to *really* stick, so I'll put on *lots* of glue!" You can best control this problem by putting out only a small quantity of glue or paste. (Sometimes if you color the glue, it is easier for your child to notice the amount she's using.)

You could explain to your child that "things stick together better with less glue" but that doesn't *sound* logical, even to me.

Your four- or five-year-old is often in "better control" of collage materials and of the glue. Actually, I think her intention may well be different as she works. A younger brother might be thinking, "I like this!" (glue). Or he might be telling a story to himself while layering the materials. But your four- or five-year-old often thinks, "I want to put this *here.* That would look good *there.*" She pays more attention to composition, to what the finished object will look like, and usually spends longer on it, too.

If your four- or five-year-old becomes an experienced collage artist, she will be less apt to pool the glue or to make glue lakes so that things *really* stick! But your child will have learned this through experience, not because she has come around to your way of thinking.

There are countless failure-proof collage activities your two- to five-year-old could do at home. It's just a question of selecting the right base and the right adhesive. On the following pages you'll find a few collage ideas to get you started.

Collage Activities

Magazines are a good collage resource. Children enjoy selecting magazine pictures for their art, and it's a good way

of recycling a magazine, too! You may already subscribe to a children's magazine; if not, I suggest *My Big Backyard* or *Ranger Rick.* (You can sometimes pick these up at yard sales if you're lucky.) These are excellent sources of nature pictures.

Children also love pictures of people, especially of other children, and most especially of babies. Be on the lookout for likely pictures to save; you know your own child best.

But remember to collect pictures *he* would like. You might snip out goldfish when he would prefer jellyfish. You might snip out bananas when he would prefer Twinkies. Let him dream. . . .

You do have to point out, however, that these are magazines that people are through with. Therefore, your child must always *ask* before ever cutting up a magazine. Always. (Please don't even mention books.)

You could go through a discarded magazine with your child, and he could point out pictures he wants to save. An older child, say four on up, could cut out some pictures himself. But tear the whole page out first—that makes it much easier for him to cut out part of a page. (Most children can cut with some precision by about age four and a half, with practice.)

Store the pictures in a shoe box. After a while, you will have lots to choose from. (Also, toss old greeting card pictures into the box. You always wondered what to do with those. . . .)

MAGAZINE COLLAGE (2½)

Here is what your child needs:

base (newsprint, computer paper, or construction paper)

white vinyl glue or paste

brush or glue stick

magazine pictures in shoe-box lid

Your child selects the pictures she wants, then glues them down. Period. It may end up as a "collage sandwich," but that's okay.

Blunt-nosed scissors

She can also draw (scribble, probably) on or around the pictures with *big crayons* or *markers.*

If she has a story to tell, print her words carefully (and small and plainly) and then read them back to her.

Magazine Collage (4+)

Your child needs the same supplies listed for the above collage project. Also put out a pair of good, *blunt-nosed 5″ scissors.* (Test them before buying. They shouldn't be dangerous but they should cut. That eliminates about 80 percent of the children's scissors on the market.)

Your child can select from a wider assortment of magazine pictures and may want to cut them up. That's okay—these aren't dollar bills, after all.

He will probably "dot" the pictures around the page. That's fine. There isn't a right (or wrong) way to do this project (or any project in this book).

Offer him crayons or markers—he may very well just draw *around* the magazine pictures. But he probably has something to say, in which case you can print his words and then read them back.

Bean, Pea, and Macaroni Collage (4+)

This collage uses materials most of us already have at home. The only secret to the project is to use *uncooked beans, peas, and macaroni!*

Assemble a variety of these items. (You could put them in an empty egg carton, leaving a space or two between different varieties.)

You will notice many collage possibilities the next time you go to the supermarket: black, green, red, yellow, and white beans.

If you are using macaroni, you could dye it first if you wish. It is a worthwhile thing to do if you have enough assembled. Any uncooked pasta product works, as do *unvarnished wood scraps.* Dye both at the same time. Slick surfaces such as white beans, rice, or varnished wood do not take the color well.

Materials for bean, pea, and macaroni collage

How to dye pasta and wood:

● Do this alone. It can be messy.

● Do it outside, especially if you use rubbing alcohol in the dye bath.

● Pour a dye bath base of *rubbing alcohol or white vinegar* into a shallow basin or bowl.

● Add some *food color.* The idea is not to have to change the dye bath base with each color change so start with the lightest color (yellow). (You can buy large bottles of food color at many food discount stores. Buy blue color at a cake decorating supply house.) If you add a little food color to the rubbing alcohol, the color will be a tint. If you add more, the color will be more vivid.

● Place some macaroni in the dye bath. When it is dyed (this takes only a few seconds), lift it out with a *slotted spoon* and drain it on *folded newspaper.*

Use a slotted spoon to drain
dyed pasta.

- Add red dye a little at a time. This gives you a range of warm colors: yellow/yellow-orange/orange/red-orange/red.

- Or add blue dye a little at a time. This gives you a range of cool colors: yellow/yellow-green/green/blue-green/blue.

- When everything is dyed and dry, store items in *clear plastic bags* and pour the dye bath down the drain.

If that sounds like too much work, stick with natural colors. But in that case I'd suggest using the macaroni either on a colored base or with *glue paint* (white vinyl glue mixed with tempera) so that the macaroni will show up better.

The base:

Washed *Styrofoam meat trays* are a good base for this project. Your child could also use a piece of *corrugated board* or *lightweight poster board* as a base. *Construction paper* is adequate, but not ideal. It's a little flimsy for this project.

The adhesive:

Use *white vinyl glue* as the adhesive for this project. Color it with liquid or powdered *tempera* or *food color* to make "glue paint" if you want. Your child uses a *glue stick* or *small stiff brush* to spread the glue. She could also use a squeeze bottle filled with the glue.

Do not use paste for this project. The collage materials will crack off the base much too easily with paste.

Your child dabs or squeezes the glue onto the base, not on the small collage materials. She then picks up the small beans, peas, and macaroni from the egg carton and puts them on the glue.

This can be pretty finicky work. Don't expect a "mosaic" look—she more likely will dot the beans around, or perhaps make trails of them (especially if she is using a squeeze bottle for the glue).

If she wants the collage to look shinier, wait a day or so until the glue dries completely. Then mix a little white vinyl glue with water, and she can brush it on with a soft brush. (Do not color the glue. It looks white, but will dry clear.)

Display:

Have your child decide where the top of the collage is. Poke two holes in the Styrofoam rim at the top, and make a little ring from half a *pipe cleaner.* Thread it through the holes. You can then hang the collage from the ring.

You could also buy some *magnetic tape* at a craft supply store. It's a little expensive, but you will use it in a lot of ways.

For this project, cut off two pieces of magnetic tape about 2″ long. Glue the pieces to the back of the collage—the collage will stick to the refrigerator. (Use white vinyl glue to glue down the magnetic tape. I do this even if the magnetic tape is claimed to be "self-adhesive.")

Doodad Collage (3+)

"Doodad" is not a technical term! But all those little things—thread spools, cardboard, paper towel cylinders, scraps of foil, small cardboard boxes—can be collage treasures.

My children used to keep an eagle eye on the trash. "You're throwing this perfectly good toilet paper roll away?" they would ask in outrage. They knew potential art when they saw it.

What should you save? Well, I'll put it this way: before you throw *anything* away, ask yourself, "Could my child use this in his collage work?" Then save the things that aren't too much trouble (1) to clean off first and (2) to store for a short while. Some things can be used as collage materials, and some can be used as a collage base.

Two ways to display macaroni collage: with twisted pipe cleaners (top); with strips of magnetic tape (bottom)

The base:

If your child is making a small collage, he can use a washed *Styrofoam meat tray* or *stiff white paper plate* as a base. If he is making a larger collage, he should use *corrugated board.*

He can also use a three-dimensional object as a base. *Cardboard boxes, shoe boxes,* and *oatmeal cartons* all make good bases.

The adhesive:

The best adhesive to use with these bulky doodads is *white vinyl glue.* Use it thick; don't dilute it with water. You can color it with powder or liquid *tempera.*

Sample materials (spool and box) for a doodad collage

Your child works flat. If he is trying to glue things onto a three-dimensional object, he must let the glue on the top area dry first. Then he turns the object and starts gluing the next area.

A faster way to glue collage materials onto a three-dimensional base is for the parent to use a *hot-glue gun.* (These are available at hardware stores; buy plenty of glue cylinders, too.) **The hot-glue gun should be used only by the parent.** Your child can point to where he wants something glued. It is safer if you squeeze the hot glue onto the base rather than the small object you are holding.

Finishing touches:

Your child may like his collage as is or he may want to do some painting on it after the glue dries. There are a couple of ways he could paint it, using tempera paint.

First, he could simply paint part or all of the collage with *medium-thick tempera.* (Remember to add a few drops of *liquid detergent* to the tempera if you want it to spread over a slick surface.) You could mix *glue paint* if he wants the paint to look bright and shiny when it dries.

Another painting approach is the action-painting, splatter-paint approach. I like glue paint for this, but regular mixed tempera works well, too.

Splatter painting should be done outside. Ideally, you should have a large cardboard box to put the collage in. This keeps the paint from splattering your driveway or your child.

Your child dips his brush into the paint, then puts his arm well into the big box. He shakes the brush, and the paint flies onto the collage!

Repeat with different colors. He doesn't have to wait for one color to dry before splattering another.

After the paint dries, however, he might want to do one final, special splattering. He can splatter on a final round of glue paint or plain white vinyl glue. Then he can sprinkle glitter onto the wet glue. (He can also use other tiny collage materials, such as sand, crushed eggshells, or crushed macaroni.) Help him tap off the excess.

If your child uses glitter, he must be very careful that he doesn't get it near his eyes. Glitter is expensive, but you can reuse the excess—pour it onto a piece of foil. Fold the foil into a funnel, and refill the glitter jar.

Display:

There are several ways you could display your child's Doodad Collage. If he has constructed a small one, it could be a centerpiece on the kitchen table. (Cover a *shoe box* with *aluminum foil* for a jazzy pedestal if you want to go all out.) You could also put a small collage on a bookshelf or on the mantel.

You could also hang the construction on the refrigerator or the wall as a relief sculpture. Have your child determine which is the top. Poke two holes at the top, and thread half a *pipe cleaner* through the holes. Twist it into a ring, and hang the construction. (You can buy a *magnetic hook* at the supermarket. Use it for hanging art on the refrigerator. And you thought it was for pot holders!)

A third way to display his collage works well for a big construction on a three-dimensional base. Suspend the construction from the ceiling in your child's room. This is a better idea than it sounds; here are a few reasons why.

Hot-glue gun (adults only!)

- It looks great.

- Your child will look at it in a new way.

- It sways (art doesn't have to hold still).

- It gets the construction off the floor.

- It is an excellent way of discovering how well things have been glued down!

In closing this chapter, I want to repeat that these projects are just to get your child started with collage. There are many simple projects your child can do alone, with permission.

It will be difficult for your child to cut very thin collage material (such as tissue) or very thick collage material (such as fabric). Construction paper is the easiest for him or her to cut. If you use more difficult materials, precut some pieces. It will then be easier for your child to do a spur-of-the-moment collage project.

If you want to cut collage shapes, make them simple ones for two- to five-year-olds. Very often, adults labor over complicated shapes such as silhouettes of heads, or turkeys, or Easter bunnies. What does the child do? He or she either

Sample shapes for young children

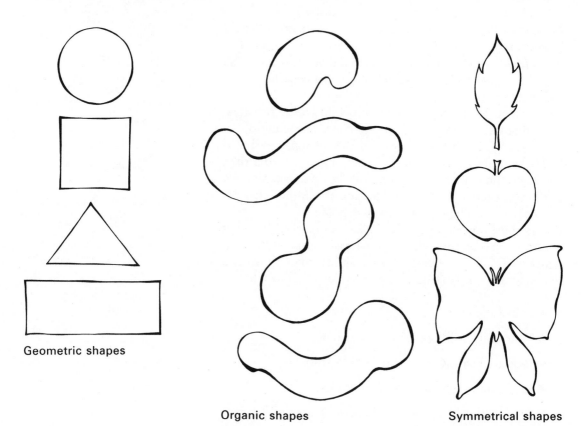

Geometric shapes

Organic shapes Symmetrical shapes

scribbles obligingly over the whole surface, or draws a big smiling face on it! The point is, children don't "see" these shapes as we do, so the whole exercise is often a waste of time. Stick with simple geometric, organic, or symmetrical shapes.

Your child could easily do collage work several times a week. It doesn't have to be a big deal—he or she could start and finish a project in ten minutes and it would still be worthwhile.

Collage encourages flexibility and lets us look at the things in our environment in a new way. It helps us break out of the two dimensions that so often limit our art. It recycles things. It celebrates the ordinary. And in so doing it often brings a welcome element of humor to our art.

Collage Words to Use with Your Child

Collage

> glue, paste, attach
>
> construct, assemble
>
> hang, suspend

Paint

> tempera paint, glue paint
>
> thick, thin

Color

> light, dark
>
> bright, dull

Shape

> big shape, small shape
>
> circle, square, triangle, rectangle
>
> blob

Collage Artists to Look at with Your Child

> Eric Carle (*The Very Hungry Caterpillar:* collage of painted papers)
>
> Ezra Jack Keats (beautiful painting, combines painting and collage, including montage-style collage)
>
> Leo Lionni (*Frederick:* collage of painted papers)

How to cut symmetrical shapes

4

Yarn Art for Children Age 2–5

Children like the way yarn feels. It's like sweaters and blankets, and like kittens and caterpillars. It feels good!

Children aged two to five won't be making complicated embroideries or weavings, but they can enjoy using yarn in a number of art projects. The first project is for children two and a half and older.

Yarn Art Activities

YARN COLLAGE: (2½+)

You need only one color of yarn for this, but make sure that the color stands out against the base you use. Red yarn on a white background would be good, for example, as would yellow yarn on a black background. Pale yellow yarn on a white background would not be good for a two-year-old, unless he uses a vivid or dark glue paint as his adhesive.

This project requires a small amount of effort on your part. Wind some *yarn* about 15 times around your fingers. Cut through the end of the loop, and snip small lengths (about ½″) of the yarn into a *plastic bag*. You could snip different lengths or different colors into different bags if you feel energetic.

51

Do not expect your child to be able to do the cutting himself.

The base:

Since this is a lightweight collage, lots of things could be used as bases. *Construction paper, stiff paper plates, lightweight poster board,* or *Styrofoam meat trays* all could be used.

Your child could also choose to do this on top of a drawing, painting, or construction he has already completed. Encourage this flexibility. Don't put up boundaries between different art forms.

The adhesive:

Your child uses *white vinyl glue* as the adhesive for this project. Color it with *tempera* or *food color* if he wishes. (This makes it easier for your two-year-old to see the glue, especially if he is using a white base.) Your child uses a *brush* to spread the glue.

The only trick to this project is for your child to spread the glue onto the base and not try to dab it on the yarn. Demonstrate this on a scrap of paper by spreading a small area of the base with glue and then patting down some yarn onto the glue. Don't make anything cute—don't set him up to fail! If your child wants to cover a large area with the yarn pieces, show him how to do it in sections. He won't want the glue to dry before he can pat down the yarn.

Please do not draw things for him to fill in with yarn. Let him work directly (and alone) with the glue and the yarn. Just stick around for technical help such as yarn-snipping or hand-wiping.

Extra yarn can be brushed back into the plastic bag to be used again. This is a good time to start a new plastic bag for mixed-up colors.

Snip yarn fuzz into a plastic bag.

Paper Plate Stitchery: (3+)

This project requires a little advance effort on your part. You need a *single-hole punch* and *stiff paper plates.* Buy solid colors, not printed patterns. There are various sizes and shapes to choose from. In advance, punch holes around the edge of the plate. These holes should be about ⅓″ in from the rim, and about 1″ apart.

- If you punch holes too close to the rim, your child may rip through them when she pulls hard on the yarn.

- If you punch holes too close together, it looks too hard and too complicated ever to "do right."

- If you use lightweight plates, they will bend when your child tries to do this project. Use stiff ones!

Punch holes in several plates—you can always use them on picnics if they're not used for stitchery. *Don't expect your child to be able to use the hole punch.*

The project is most easily done with a *yarn needle.* Yarn needles are either steel or plastic and are available at most fabric or yarn stores. They are big and have large eyes—you should be able to "thread" the yarn through one. *Do not expect your child to be able to thread the yarn needle.*

If you don't have a yarn needle, wrap some *masking tape* around the end of the yarn so that it resembles the tip of a shoelace. You need to make it stiff so your child can poke it through the holes. Or buy long *shoelaces* for your child to stitch with.

When she starts, tie the end of the yarn around one of the holes. Leave a long "tail" for finishing. She can then start stitching.

It is very common for a young child to zigzag back and forth across the plate, rather than stitch neatly around the border. That's fine—it's the spiderweb approach. After all, she's not going to wear the plate, so how neat does it have to be? It is also common for a child to skip some holes. That's okay, too.

When she is done (and *she* decides that), help her "tie up any loose ends." (You could always tape them to the back if you're stymied.)

If your child has left the center of the plate accessible, she could finish (then or another day) by drawing a picture or gluing a treasured greeting card or magazine picture onto the center.

Display:

You could glue a strip of *magnet tape* onto the back of the plate if your child would like it to hang on the refrigerator. Use *white vinyl glue.*

You could also hang the project on a wall. Have your

Punch holes ⅓″ in from rim of plate and 1″ apart.

Close-up of punched holes

Leave a long tail for finishing.

Simple shapes for sewing cards

child decide where the top of the plate is. Poke a *pipe cleaner* through two of the punched holes, and twist it into a ring. Hang the plate from the ring. It could be hung on the refrigerator or a wall; to hang in a window, hook the ring over the window latch.

SEWING CARDS (3½)

You probably remember laboring over sewing cards when you were a child. Toy manufacturers sell sets of precut, prepunched, predesigned cards for children to lace up.

Lots of children enjoy this type of project, but you can easily make it more creative. All you need to get is *lightweight poster board* (any color). Construction paper will bend, and corrugated board is too hard to cut.

Cut some simple shapes from the poster board. They should be between about 6" and 9". Don't panic. These shapes can be as simple as circles, triangles, rectangles, or squares. If you are a little more ambitious, try organic shapes, rounded hearts, or eggs. Avoid complicated silhouettes and sharp angles.

Next, punch holes around the border of each shape. Use a *single-hole punch*. Again, these holes should be about ⅓" in from the edge and about 1" apart. *Don't expect your child to be able to use the hole punch.*

Your child can use a *yarn needle* to stitch with. Thread it for him. If you don't have one, you might be able to fashion one from part of a *pipe cleaner*. If not, wrap the stitching end of the yarn with *masking tape*. You could also buy extralong *shoelaces* for your child to stitch with.

Cut off a length of *yarn* for your child, and tie one end through one of the holes. (Ask him where he'd like to start. Tie the end next to it.) Remember to leave a long "tail" of yarn for finishing.

He may stitch in and out, or over the edge, or across the whole card. It doesn't matter—please don't correct him. (Our children already have the right idea when it comes to "failure-proof" art; it's our own attitudes that need some readjusting!)

When he decides he's finished, help him with the loose ends. It's not necessary to point out the unstitched holes.

If he has left the center of the sewing card accessible,

Thread a large yarn needle for the child.

he may want to draw on it or glue something down there. He can do this later if he wishes.

Display:

These sewing cards can be hung on the refrigerator or wall. They also make good "cards" to be hand-delivered to appreciative relatives.

Sewing cards are for boys and girls alike. It's more a question of dexterity and temperament than of sex. The shapes you cut out aren't "boy" shapes or "girl" shapes; they are for all to enjoy.

Sewing cards are old-fashioned, but can be an enjoyable project for art at home.

Tie one end to the card, leaving a long tail for finishing.

BERRY BASKET WEAVING (4+)

Who feels guilty when they throw away those green *plastic berry baskets?* I do! Don't throw them out; they can be used in several ways in your home art program.

There are a couple of approaches to the Berry Basket Weaving project. The first is to think of the basket as more of a sculpture base than as a loom.

By this I mean that your child may go back and forth with the weaving materials *across* the basket rather than neatly *around* the sides of the basket. This does not mean he is doing the project "wrong." He is showing an imaginative use of space!

Thread a *yarn needle* with *yarn* for your child. Tie the end of the yarn to the basket. Rethread the needle with more yarn (in different lengths and colors, as he chooses) as needed.

He might also poke *sticks* or *pipe cleaners* through the holes; there's no reason why the materials can't poke past the boundaries of the weaving base.

The second approach to this project is the more traditional one. Your child weaves the sides of the basket. This approach probably would be best with children four and a half plus who have had some simple stitchery or weaving experience.

You might want to start your child off with *pipe cleaners* for this project. They are stiff and pliable, and he can easily poke them in and out of the holes.

Berry baskets are ideal for weaving projects.

Free-form berry basket weaving

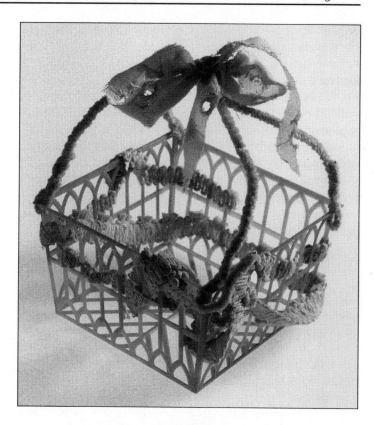

(A note on buying pipe cleaners: There is a tremendous price range for some reason. If possible, buy a large quantity—100 at a time—through a craft catalog. You will probably pay less for 100 than you would for 20 at a craft store.)

Your child can also use yarn for a Berry Basket Weaving. Thread a *plastic yarn needle* for him and tie the loose end of the yarn to the basket. Change lengths and colors for him as he chooses.

He may stitch around the sides of the basket or up and down on a side. The yarn stitches won't be even, and he will probably take shortcuts through the corners. That's fine.

It's not important that he stitch up a perfect basket. I'm sure you already have enough baskets anyway. He will become concerned about doing it more neatly soon enough anyway. Let him set the pace for this.

Encourage your child to vary weaving materials though. Besides pipe cleaners and yarn, he could weave with *long soft grasses, green twigs,* or *fabric strips.* Encourage him to use different weaving materials on the same basket.

Display:

This woven sculpture might be able to sit on a table or shelf. If there is no steady bottom left to it, you could suspend it from the ceiling. It also could be used as a small part of a larger construction your child builds some day. You would use thick *white vinyl glue* (or *glue paint*) or the *hot-glue gun* to attach it to the construction. (**Only adults should use the hot-glue gun. Squeeze the hot glue onto the base rather than the smaller object you are holding.**)

The coziness and versatility of yarn makes it a natural for art projects with children five and under.

Textile Words to Use with Your Child

Yarn

stitch, sew, weave

collage

sculpture, construction

yarn needle, scissors

Texture

rough, smooth

soft, fluffy, fuzzy, scratchy

Color

light, dark

bright, dull

Shape

big shape, small shape

circle, square, triangle, rectangle

Size

big, small

long piece, short piece

Textile Artists to Look at with Your Child

I suggest that you visit the textiles section when you go to the art museum. There are many beautiful things to look at from Africa, Central America, and Polynesia.

There are also contemporary artists doing exciting work in this area. Especially look for three-dimensional weavings and the use of unusual weaving materials. Visit local craft shops and fairs.

5

Sculpture for Children Age 2–5

Many parents shrink at the thought of doing sculpture projects at home. Sculpture sounds so . . . big!

It can be big, but that's not the most important thing about it. *What's important about sculpture is that it's not flat.*

It seems to me that we, as adults, tend to equate being "good at art" with being good at drawing. (And we equate being good at drawing with visual realism.) But there are lots of ways to be "good at art." I would guess that the most underidentified artistic giftedness is spatial giftedness.

Think about sculptors. Think about ceramists and weavers. Now think about architects, landscape architects, and interior designers. Think about choreographers and dancers. Where did these people come from?

All of them were children once, and I'll bet they were children who thrived on using *space*—being in it, playing in it, building in it, creating in it. But we often don't see these activities as art-related, so we don't encourage or respect them enough.

Sculpture can be messy. It takes up space. (That's the point of it.) And what do you do with it when you're done?

I hope this chapter convinces you to encourage your child to make sculpture at home, even if it's on a small scale. The projects are quick and easy as well as being failure-proof.

It's good for *every* child to work with three-dimensional materials, but it might be especially good for *your* child. Who knows?

Playdough (2+)

Homemade playdough is best, but any playdough will do. Why is homemade playdough best?

Have you ever noticed how children eat just about anything they've helped prepare or take part in any activity they help plan? It's the same with playdough. Children naturally want to use something they helped make. They're involved with it, they're proud of it. That's why it's worth going to some extra trouble to make your own playdough.

It also saves a little money, which is nice. And children often prefer the way homemade playdough feels.

You may already have a favorite recipe for playdough; there are lots of them. Here are two that work.

How to Make Uncooked Playdough

This is a good recipe to make with your child. He can help measure and stir. Print a recipe card and cover it with plastic so it can be wiped and used over and over.

3 cups flour

1 cup salt

1½ cups plus 2 tablespoons water

1 tablespoon cooking oil

How to Make Cooked Playdough

This playdough feels the most like commercial playdough. In fact, it feels better. Your child can help measure the ingredients into a saucepan at the kitchen table. The parent cooks the dough at the stove, then plops it onto the counter for the waiting child to knead as it cools.

1 cup flour

½ cup salt

2 teaspoons cream of tartar

1 cup water

1 tablespoon cooking oil

Combine flour, salt, and cream of tartar in a large saucepan. Gradually stir in the water mixed with cooking oil. Cook, stirring, over medium heat until a ball forms. Scoop onto countertop for your child to knead until smooth. Adjust either recipe by adding more flour if the recipe is too sticky, or more water if it's too crumbly.

Color can be added to any dough recipe. The only trick is to learn when to add it. If you are using *powdered tempera* for color, add a couple of spoonfuls to the dry ingredients (the flour). If you are using liquid color *(mixed tempera or food color),* add it to the wet ingredient (the water). *The rule to follow is dry to dry, wet to wet.* Then finish mixing.
You can store the dough in a plastic bag. Put it in the refrigerator, but take it out to soften a little before your child plays with it. If the dough starts to smell funny or look moldy, toss it out and start again.

You can make more than one color of playdough. The different doughs will get mixed together eventually though. If you want to make colors of dough that will mix together well, look at the Color Wheel (see page 247). The colors that *won't* mix well are the ones opposite each other on the Color Wheel, such as blue and orange or red and green. (These are called complementary colors. They look good together in a collage, but turn very dull when mixed together. Haul out the little set of watercolors and see for yourself!)

Here are some color-mixing ideas for dough.

red + yellow = orange

yellow + blue = green

blue + red = violet

yellow + green = yellow-green

yellow + orange = yellow-orange

red + orange = red-orange

red + violet = red-violet

The best tools for playdough sculpture

Cookie cutters (even homemade ones) make excellent tools for playdough sculpture.

blue + green = blue-green

blue + violet = blue-violet.

Tools for Sculpture

The best tools are your child's own hands. I wouldn't even put any other tools out for a two-year-old. And for an older child, let her handle the dough for 5–10 minutes before you offer any tools. Then put tools out one at a time, so she can focus on each one.

Here are a few tools your child might enjoy using:

- Plastic picnic knife (3+)
- Rolling pin (3½+)
- Cookie cutter (3½+)

(Remember to offer simple cookie cutter shapes. They're easier to use, anyway. And *do not* offer the

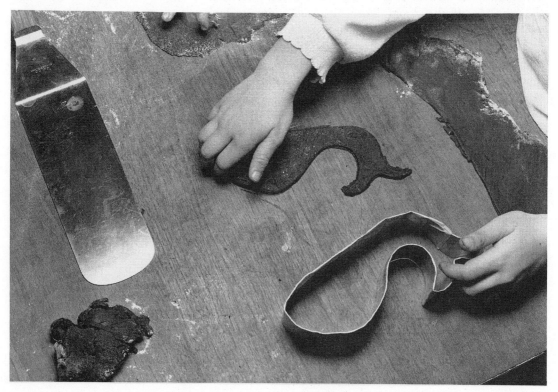

Let the child experiment with different tools.

plastic ones with the design embossed on the top— those are way too bossy. Let your child design her *own* surface.)

Two other tools are possibilities:

- Scissors (4+)
 Some teachers encourage children to cut playdough with scissors. They say the children like it and it's good exercise to cut the dough. My own feeling is that it's not so good for the scissors. In addition, I feel that young children should use tools only for their primary purposes. It's less confusing that way!

● Garlic press $(4\frac{1}{2}+)$

This makes long, squiggly "hair" or "worms." It's fun to use but can make cleanup a pain. It's easiest if you soak the press in water right after using it. Don't let the dough dry in the holes, or you'll have to clean it with a toothpick.

I would like to discourage you from buying lavish playdough kits with lots of little tools. They are much too specific; when children play, they don't need directions! It's not just that you can do it cheaper on your own, which you can, but the whole experience will be much more valuable and enjoyable (and failure-proof) without those gimmicky toys. Let your child make her own fun.

If you feel like playing, too, this is one project where it won't hurt. (Playdough is a sociable art material—we often feel like talking and laughing as we pound away.)

If you join your child, please remember a couple of things:

● Don't try to teach by making a model for your child to copy. Lots of parents do this, then set it up like a little shrine. It says "this is the way to work." It shouldn't.

● Don't spend a long, long time on something detailed and dazzling. Detailed + Dazzling = Discouraging to your child, who wonders how can she match your work. She shouldn't try. She should be pleasing herself, not you.

There are a couple of skills you can demonstrate to your four- or five-year-old though (skills, not projects). You can show her how to roll a "snake" or ball. I think it's nice to get behind her and demonstrate these skills with your hands over her (willing) hands. Then let her try it on her own.

You could also demonstrate a simple "pinch-pot" to four and a half-year-olds, but this is a distant third to "snakes" and balls. Pinch-pots are practical objects—it's hard to imagine them as anything else. I think children get more out of making playful shapes, shapes that lend themselves to imaginative play.

For that reason, don't insist on coiling "snakes" into bowls. Let them be snakes, worms, or caterpillars, or trains, or lines, or

Your child can poke things into the finished dough sculpture if she plans to keep it. Otherwise, put the dough back into the bag. (Sometimes it's more tactful to wait a little while before doing this. Even if your child doesn't want to keep something, she may feel funny about mashing it up right away.)

If you are keeping a project, put it on a stiff base such as a Styrofoam meat tray or piece of corrugated board. This keeps the piece from breaking when it's moved.

Sculpture Activities

Slime (4+)

Children like to play with slime. They can't actually model anything from it, since it doesn't hold a shape, but it feels . . . weird! Here is how to make it:

cornstarch

water

color (add powdered tempera to cornstarch before mixing, or add mixed tempera or food color to the water before mixing)

That's all there is to it. Mix the slime by feel, starting with the water. That way, you control the amount of slime you are making. Trickle in the cornstarch, mixing with your hand as you do. Or let your child mix while you trickle! You want it to feel wet (when squeezed or poured), but dry to the touch.

There's not a lot to this project; your child may spend just 5 minutes with it. But it may turn into a source of real fascination.

- Try it when he has a friend over. They can gross each other out.

• Try it outside on a hot day. Just hose down the work area (and the children) when they're done.

• Try it at Halloween. It's good, clean, disgusting fun!

TAMBOURINE (2½ +)

This project encourages children to make more noise at home. But it's a good idea anyway.

It can be a very simple project for two and a half-year-olds. Here is what you need:

two stiff white paper plates (not patterned)

crayons and markers

magazine pictures and paste

dry beans or peas

stapler or white vinyl glue

Sit your child down with the paper plates. Each plate has two sides—one convex and one concave. (The caved-in side is *concave*—an easy way to remember the difference.)

Your child colors or decorates the *other* side, the convex side. (This is the underside of the plate.) It is a little bumpy, but don't be put off by that. So is watercolor paper that costs $5 a sheet!

She can work with markers or crayons, or markers *and* crayons. She may wish to paste on magazine pictures before or after coloring, or to skip the coloring altogether.

When she decides she's done with that, have her put a couple of handfuls of beans in the plate. Put the other plate on top, and staple them together. *Do not expect your child to be able to use the stapler;* it's not safe anyway.

If you don't have a stapler, you can glue the plates together with thick white vinyl glue. You have to do this, rather than your child. Squeeze a bead of thick glue along the upper rim of the plate holding the beans. Press the other plate on top, and let the glue dry for a day. (It's better to use the stapler if you have one because your child will want to shake the tambourine right away.)

Staple plates together to create a tambourine.

This project can also be fun for an older child. Here is a way of making it a little more challenging for a four-year-old.

Tambourine with Tissue Collage (4+)

You start with *two stiff white paper plates.* Fold a piece of *colored tissue paper* and cut some simple shapes. Remember that tissue is hard to cut. It's a little easier when you cut several layers at once. Folding the paper also keeps it from slipping as you cut. *This is probably too hard for your child to do alone.*

You can cut more than one color of tissue paper at a time—just fold the papers together—but don't make it too thick. If you do this, consider using related colors of tissue. Related colors are next to each other on the Color Wheel (see page 247). The colors blend together when glued down, and related colors work best for this. Here are a few related color ideas:

Sample shapes for cutting tissue paper

orange + red-orange + red

blue + blue-violet + violet

green + yellow-green + yellow

yellow + yellow-orange + orange

Monochromatic color schemes work well, too. (A monochromatic color scheme has tints and shades of one color.) Here are some monochromatic color schemes:

pink + rose + red

light blue + blue + dark blue

tan + brown + dark brown

You don't need lots of shapes; save the extras for later collage work. And remember to keep the shapes simple.

Your child can use *liquid starch* or *thin white vinyl glue* (no color added) as the adhesive. He puts the starch on the convex side (underside) of one plate, and places some tissue pieces on top. He works with the collage surface face up, of

Stitch pre-stapled plates
together to create a tambourine.

Finished tambourine with crepe
paper streamers stapled on

course. Encourage him to overlap the pieces. Remind your child that the starch goes on the plate, not on the tissue. And wrinkles in the tissue make the project look even better.

He then does the same on the convex side of the second plate. Put them aside to dry, face up.

Later, he puts a couple of handfuls of *dry beans* in one plate. When you staple the two plates together, you may want to staple in some streamers at the bottom. Cut a piece of *crepe paper* or some long strips of tissue for the streamers.

If you don't have a *stapler,* you can glue the two plates together with *thick white vinyl glue.* Squeeze a bead of glue along the upper rim of a plate, and press the second plate down on the glue. Allow plenty of time for the glue to dry. (You could use a *hot-glue gun* if you are in a hurry. **Do not let your child use a hot-glue gun.**)

There is a third way of attaching the plates. It requires more effort on your part, and in fact is really a stitchery project. It requires a *single-hole punch.*

Take one plate, and punch holes around the rim. The holes should be about ⅓" in from the edge and about 1" apart.

After you have completed one plate, put the second plate against it. Punch holes around the rim of the second plate. This way, the holes line up. (Don't try to punch through both stiff paper plates at once.) Have your child put dry beans between the plates.

Next, either staple, tape, or clip the plates together so they won't slip (and scatter the beans) while the child is stitching.

Thread a *yarn needle* with *yarn* for your child, and tie the loose end through a hole. Leave a long tail for finishing. Your child can now stitch the tambourine. Tie up the loose ends.

Staple on some streamers, if he wants. (Sneak in a few staples around the rim of the tambourine if his stitching looks wobbly.)

Your four-year-old can easily do the quicker version of this—the one with markers, magazine pictures, and the stapler. (You do the stapling.) This quick version is a good idea if he has a friend over, or if he wants to do this as part of a (small) birthday celebration. Then *all* the children can make a racket!

Puppet Activities

Lots of children like puppets. Puppets are a natural link between play and theater, and are always a good excuse for talking to yourself. (Not that children need an excuse for this.)

There are wonderful hand puppets parents can buy for children. I used to buy each of my children one for Christmas, and pretty soon we had quite a collection. (Please don't buy string puppets for children under five; they get tangled up immediately, and just make everyone frustrated. It's a lousy way to spend Christmas afternoon.)

Even if you buy hand puppets, your child should have the chance to make her own as well. She can begin with this simple project.

Plain paper bag for puppet

Paper Bag Puppet (2½)

For this project you need a lunch-size *brown paper bag*, or any unpatterned bag, and *dark markers* or *crayons*. The bag lies flat as your child works.

Turn the paper bag over so that the bottom flap isn't in her way. She can then decorate the bag with crayons and/or markers. (The dark colors show up better against the brown bag.)

She can turn the bag over and color on the other side, too (over the flap), if she wants. Remember, she is probably still a scribbler. Don't nag!

Here are a couple of cautions:

- Don't try to get her to draw a face on the bag, or even to see the bag as a head. Why should she? It doesn't look at all like one. That's just a convention we pick up with more experience. She may see her puppet as a person, but she may see it as a tree, a bird, or . . . a talking paper bag!

- Don't try to get her to use the flap as a mouth. This is another convention we learn later on. Anyway, it's too tricky for a two-and-a-half-year-old to manage.

What is the value of this, then, if she just ends up talking to a scribbled paper bag stuck over her hand? The value lies in the talking! And she's playing with something she made herself, in a way that may be unlike how she plays with her other toys.

Paper Bag Puppet (3½)

This is really the same as the previous project, but your child now has more puppet experience and may plan what he wants to make a little more.

He starts out with a *brown paper bag, crayons,* and *markers* as before. He may want to do some *collage* work as well. Put out a few *buttons, fabric scraps,* or *aluminum foil* and see what happens. *Thick white vinyl glue* is the best adhesive for this project.

Again, he probably won't see or use the flap as a mouth.

Paper Bag Puppet (4½)

An experienced four and a half-year-old puppeteer may have a more specific idea of what he wants to make than a younger child. He may be eager to proceed on his own, using a combination of drawing and collage.

He may begin to be frustrated in his attempts to make it "look right," though. *If so,* it is okay to offer a little technical assistance. This is what I consider technical assistance:

- Cutting materials that are hard for him to cut, such as felt or yarn

- Cutting shapes (or outlining them with his direction) that he can't cut or draw yet

- Helping him remember materials he might use on a project: "We have some foil. We have some yarn pieces left," etc.

- If he gets stuck, helping him remember things about his subject: "Let's see. Dogs have ears, whiskers, and a collar. And sometimes fleas!" etc.

But this is what you should avoid:

- Assembling a "kit" for him to execute (and execute is probably an accurate description)

- Correcting him about color accuracy in his choices: "People don't have green hair," etc. (People don't, but paper bags might.)

- Informing him about body parts his puppet "should" have: "It should have two ears, and one red tongue," etc. Let him be playful and imaginative.

STICK PUPPETS (4+)

These can be fun for four-year-olds to make. This is really a glorified drawing project—the puppets are made from cut-out drawings done on a light color of *lightweight poster board.*

Cut the poster board into small pieces (about 4"–6" or so). Vary sizes and shapes, but keep the shapes neutral. For example, don't cut out a cat's head, cut out a circle. Don't cut out a snake, cut out a long, skinny rectangle. Let your child decide what to make.

Your child uses *crayons* or *markers* on the poster board, drawing whatever she pleases. She can glue things on the puppets, too. I suggest using *white vinyl glue* if she chooses to do this.

She may want to leave them as is after coloring and decorating, but they also look nice cut out a little more around the edges.

Lightweight poster board is fairly easy to cut with a good pair of scissors. If she has trouble with it, though, offer to do it for her. Try to leave a narrow border of poster board around the outside lines.

Next come the sticks. (This is what makes them "stick puppets!") I suggest using flat *popsicle sticks.* They aren't as long as dowels but are a lot easier to glue down. They don't poke like dowels, either.

Your child can attach the sticks with *thick white vinyl glue.* She squeezes the glue along the top one-third to one-

Sample "neutral" shapes for stick puppets

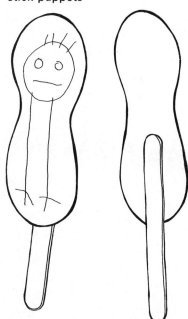

Glue the popsicle stick halfway up the back of the puppet shape.

A plain white sock turns into a puppet.

half of the stick and places the stick at the bottom of the puppet. Now comes the hard part—waiting for the glue to dry!

If you're not crazy about hard parts, you could use the *hot-glue gun* to attach the sticks. **Do not let your child use the hot-glue gun,** or hold the stick while you squeeze hot glue on, or press the stick onto hot glue. *You* get to take the risks.

Squeeze hot glue onto the top one-third to one-half of the stick, and press it onto the bottom of the puppet. Your child can play with the puppet within minutes.

She may make several puppets at a time. Keep them in a shoe box; they can provide good company on long car trips.

Here are two other puppets that are easy to make, although they require more parent involvement.

Sock Puppets (3+)

Sometimes I wonder what small children must think when they see an adult stick a hand in a sock and strike up a conversation. But they catch on quickly to this, and soon do it, too.

Often, parents make these as a way of recycling old socks, but you could splurge on a pair of new socks, and turn them immediately into puppets. (When you think how much you pay for one store-bought puppet, this doesn't seem so extravagant.) Buy *solid-color socks,* not argyles; your child will notice the details that are sewn or glued on better. But this is the time to buy violet or fuchsia socks! Don't limit yourself to white.

Let your child decorate the sock, or you could do it on your own as a gift for him. Use *markers* (a permanent, small laundry marker is good if you are making a puppet on your own, but **don't let your child use permanent markers**) and *collage.* You could stitch or glue on any details.

Your child uses *thick white vinyl glue* to attach the paper or fabric trimmings. If *you* are making the puppet, use thick white vinyl glue or the *hot-glue gun.* **Do not let your child use the hot-glue gun.**

If your child makes the puppet, you should do the

Sample hand puppets using yarn, pompons, felt, and buttons

sewing (buttons, etc.) Don't worry about making these puppets last forever—you won't be tossing them in the washer. You'll be surprised at how long they'll be batting around anyway.

Remember that your three-year-old, and even many a four-year-old, will simply thrust a hand into a sock to play with it. It's hard for them to pinch the sock to make a talking "mouth," so don't design a gift puppet this way.

FINGER PUPPETS (3+)

Here is an easy way to make four finger puppets:

Turn an *old pair of pants* inside out. (These should be pants that can't be given to someone smaller. Usually the knees go long before the cuffs, though, so this is a good way to use up the cuffs.)

Sew two inverted U shapes on each cuff. The hem of the cuff will be the bottom of each finger puppet.

Cut out the puppets, allowing a ⅓″ border around the stitching.

If you do this as pants (yours or your child's) wear out, you can accumulate lots of puppet bases as time goes by. Pull them out some rainy day when your child has a friend over or is recuperating from the measles.

The puppet bases are now available for decorating. Since they would rarely be light colors, collage works best on these. (Markers are transparent and don't show up well on dark colors.)

Here are a few things you or your child could use to decorate the puppets:

- fringe, "fun fur," yarn
- buttons, plastic eyes
- felt, fabric scraps
- construction paper, doilies

Accumulate puppet accessories over time, and keep them with the puppet bases.

Finger puppets are good toys to bring on car trips. They also help while away the hours spent in restaurants, waiting for the grilled cheese sandwich to materialize.

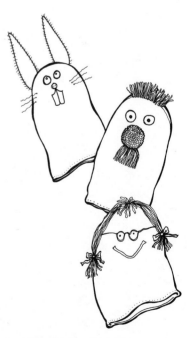

Sample finger puppets decorated with felt, plastic eyes, pompons, fringe, and yarn

The simplest puppet stage:
spring tension rod with towel
thrown over it

THE SIMPLEST PUPPET STAGE EVER (3+)

You can spend a lot of money on a puppet stage for your children. Or you can spend a lot of time hacking one out of a large cardboard box, assuming you have one handy. With either approach, you next get to use up a lot of space storing the stage.

Nothing is wrong with this if you have a lot of storage space. (Do you happen to know anyone who has? I haven't met that person yet!)

A puppet stage can be like an easel: It's a constant reproach that you're not using it enough. It makes you feel guilty. Who needs that? Save your guilt for the good stuff.

Here's how to make a simple, quickly assembled, easily stored puppet stage:

- Buy one *spring-tension curtain rod* that will fit into an interior doorway.

- Throw a *sheet* or *blanket* over it.

If that seems too painless, you and your child could make a special curtain to fit the rod. I would suggest painting designs on it with *glue paint.* (Glue paint is made by mixing white vinyl glue with tempera paint. This makes a shiny, vivid paint and is a little hardier than plain tempera. Even so, don't plan on washing the curtain. You won't need to—unless someone throws tomatoes.)

If you think your child might like a little glamour, say for a Las Vegas–style production, sprinkle *glitter* on the wet glue paint. **Be careful that your child doesn't get glitter near his eyes.**

To store the puppet stage, just roll the curtain up around the rod, and put it in the corner.

How to be an audience:

I think there should be a special place in heaven for kindly adults who make up the audience for a puppet show (or play, or dance, or recital of a cartoon plot) performed by small children. These productions are sometimes fun, but they can be a little tedious (bordering on excruciating) at times. Why bother?

Puppet stage curtain decorated
with glue paint and glitter

We bother because:

- They are exciting and fun for a child.

- They help her organize her thoughts and plan ahead.

- They let her show off a little in a loving environment.

Here are a few "don'ts" for the captive audience:

- Don't nudge one another and laugh at the perform- ance, unless you're sure it's a comedy.

- Don't fidget and peer at your watch.

- Don't go overboard with applause and praise, unless that is your natural style.

- Don't ask her to do it again in front of people she doesn't know.

If your child seems to be having trouble concluding her performance, you can say in a kindly way, "I need to go (fill in the blank with a chore) in three minutes. Can you finish by then?" Don't actually count down to zero (out loud, anyway) but *often, children need help finishing up.*

You may love being an audience, or you may merely tolerate it. But one thing's for sure: Productions get more lavish and complicated as your child gets older.

My children's favorite production in later years was known as The Haunted House. I was the perfect audience/ victim for this extravaganza. I was usually plenty nervous by the time they had spent an hour secretly preparing their room for the show.

I would be led into a completely darkened room and abandoned. The show would begin. Mercifully, I forget the details, but there would always be a dramatic finish. A hand would shoot out from under the bed and grasp my ankle! A towel would drop over my head from the top bunk! A shriek would split the night.

That should make listening to two paper bags or socks conversing seem a little easier.

Other Sculpture Activities

Foil Sculpture (4+)

This project was always the absolute favorite (apart from drawing) of my youngest son. In fact, one year we had the following conversation:
"What do you want for your birthday?"
"My own roll of foil."
"But I always give you foil whenever you ask."
"Well, I don't want to have to ask."
(Those were the days. Birthdays have gotten a little more complicated now. . . .)

All that you need for this project is *aluminum foil.* This project can be done by four-year-olds, as long as you're not expecting them to model recognizable objects. Older children often can form quite detailed sculptures, but four-year-olds won't be able to.

Still, they will enjoy manipulating the foil. Tear off a piece of foil about 12″ long. (You can vary the lengths as time goes on, but don't make them too long—it can be hard to handle.) Give it to your child to play with. Pretty easy!

He might use it to wrap an object, but as it gets crumpled he will probably wad it up more. He can crush it, twist it, tear it, stomp it. Be as lavish as you can possibly be with the foil. Try not to think "he is wasting all of that perfectly good foil" but think "I never knew a sculpture material could be this inexpensive and convenient!" Well, give it a try.

Your child might not need any guidance when working with the foil. But if he gets discouraged trying to make detailed foil sculptures, switch to something like modeling clay. Foil sculptures at this age are more likely to be simple "rocks," or "snakes," or just twisted, glistening shapes.

If he tries to work in pieces, say to attach a foil arm to a torso, it won't work. More frustration: The arm will fall off before long. These have to be one-piece sculptures.

But your child can have some fun with the sculptures after he finishes modeling. Here are three ideas that he can combine in various ways:

1. **Flatten them!** He can stomp on the foil. It's surprisingly fun, if a little rowdy. The flattened foil pieces look

good glued on *black construction paper.* Use *thick white vinyl glue.* He might want to draw on the construction paper (before or after gluing) with *oil pastels.*

2. **Mount them!** *Corrugated board* is a good base for the unflattened sculptures. Your child could paint the base first with *glue paint* if he wants to change its color. (Glue paint is white vinyl glue mixed with tempera paint.) When the glue paint has dried, glue the sculpture down. *You will probably have to do this.* Have him show you where he wants it. Use *thick white vinyl glue,* and allow plenty of time for it to dry.

　　An easier way to attach the sculpture to the base is to use a *hot-glue gun.* (**Do not let your child use the hot-glue gun.**) This works well because the glue dries almost at once; awkward foil shapes don't topple over before the glue has dried.

　　Have your child show you where he wants the sculpture glued. Squeeze the hot glue onto the base, not on the sculpture.

3. **Paint them!** If you think you can't paint foil, you haven't tried *glue paint.* This works especially well on foil, since the silver shines through the glue. (White vinyl glue is clear, not white, when it dries.)

　　Mix tempera with the white vinyl glue. Thin the glue paint with water if necessary. If it "resists" (beads up) when your child paints, then add a few drops of *liquid detergent* to the mix.

　　Glue paint can be transparent or opaque depending on how much tempera is added. Add just a little tempera (or substitute food color) if you want it to be transparent. (You'll be able to see the silver foil through the paint.) Add more tempera if you want it to be opaque. (It will hide the silver foil.)

　　Either way, the paint looks beautiful on the foil.

Wood Scrap Sculpture (3½ +)

　　This project is similar to the Doodad Collage described in Chapter 3. It is basically an assemblage of wood pieces, but encourage your child to use any materials (even "junk") that catches her eye.

　　The adhesive to use is *thick white vinyl glue.* For a more

colorful glue, add tempera or food color to it—now it's *glue paint.*

Toward the end of the project your child may want to attach small sculpture materials to the sides of the construction. You might find it easier to use a *hot-glue gun* for these awkward finishing touches. **Do not let your child use the hot-glue gun.** She can point to where she wants the small objects glued. Squeeze the hot glue onto the construction, not onto the small objects.

The base for this project will probably be a short length of *board* or a piece of *Masonite.* If it's going to be a very small assemblage, you could use a *Styrofoam meat tray* as the base. Use what's handy, but make sure that the base can support the construction.

What wood should your child use to construct the sculpture? Maybe you're lucky enough to have a wood-worker in the family. If so, save scraps over a period of time. Otherwise go to the lumberyard. They will usually sell you (and occasionally give you) bundles of small scraps they've accumulated.

You could also purchase a box of wood scraps from a mail-order craft supply house if you really get desperate. It's fun to order special wood supplies (like spools and popsicle sticks) from them anyway.

Before gluing:

There are a couple of things your child might enjoy doing before gluing the wood pieces together. Neither is necessary to the project, but either might end up being the part your child enjoys most!

Your child could sand the wood scraps with *sandpaper.* Use a *sanding block* for sanding flat lengths of wood. Sanding wood sounds good and smells good.

After she dusts off the sanded wood, she could draw on the pieces with *watercolor markers*; unvarnished wood can make a good drawing surface. She can have fun learning that if she presses down hard with the marker, the color spreads into the wood. Dots and lines are fine—don't expect detailed pictures. She could also glue or paste *magazine pictures* onto the wood.

You could dye some of the wood scraps before she starts sanding, coloring, or gluing. This procedure is described on the following page.

Sanding block

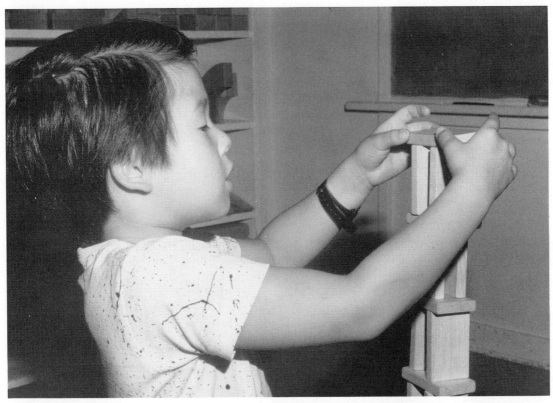

Here is how to dye unvarnished wood scraps:

- Wipe any dust off the scraps.

- Do the dyeing alone; it can be messy.

- Do it outside, especially if you use rubbing alcohol in the dye bath.

- Pour a dye bath base of *rubbing alcohol* or *white vinegar* into a shallow basin or bowl.

- Add some *food color.*

- Lift the wood scraps in and out of the dye bath with a slotted spoon. Drain them on newspaper.

As I explained in Chapter 3, the idea is to get as many color changes as possible without changing the dye bath. For this reason you will probably dye one batch of warm colors and one batch of cool colors. (Please refer to Chapter 3 for specific dyeing suggestions.)

Wood scrap sculpture can be glued or left "freestanding," to be built again another day.

When scraps are stained in this way, you are still able to see the beautiful grain of the wood. It's not covered up as it would be by paint.

Gluing:

Your child works on newspaper when gluing—it's almost a certainty that your three-year-old uses too much glue on this project. (She may notice the amount of glue she's using better if you color the glue. It somehow looks "stronger," too!)

Let her decide what to glue where; if it doesn't work, it doesn't work. Let her discover this for herself. (Please don't say "I told you so.") And don't give your child a building assignment. She's not making a functional object; that's not the point. (For some reason, adults often encourage children to make birdhouses. Please don't do this. You'll be doing a favor to your children . . . and the birds!)

When she decides she's finished, put the sculpture someplace safe to dry. Give it plenty of time—at least a day.

After gluing:

When the glue has dried, offer your child the opportunity to work some more on the project. *This opportunity is especially valuable to four and five-year-olds.* She could do lots of things at this point. Here are a few ideas from the four art areas we've covered already:

Drawing: She could draw on the sculpture with markers, crayons, or oil pastels.

Painting: She could paint on light-colored wood with watercolors. She could paint with tempera. You could mix glue paint and she could paint with that.

She could splatter-paint the sculpture with tempera or glue paint. Put the sculpture in a big cardboard box outside. She reaches into the box with a loaded paint brush, and splashes paint on the sculpture.

Collage: She could glue or paste on such things as magazine pictures, greeting cards, fabric scraps, pompons, sticks, leaves, cones, and seed pods.

Yarn: She could glue small yarn pieces onto the construction. She could weave a long piece of yarn around and around the sculpture.

The idea I'd like to get across here is that these different activities should not be isolated from one another. There are no "art laws" that forbid us from combining materials and methods in any way that works. Don't be intimidated by art. Your children aren't!

Outdoors Nature Sculpture (2+)

In Chapter 1 I described a timeless art activity: Drawing in Dirt (or Wet Sand) Outside. This drawing project can easily become a sculpture project. It's true that neither one gives you something to hang on the refrigerator, but fridge art isn't the only art there is. There doesn't have to be a tangible result for an art experience to have been worthwhile.

There is no one way to do Outdoors Nature Sculpture. It's a nonproject project. It could be as simple as winding yarn around a tree trunk, or it could be a complex structure created in the sandbox. The three components to such an activity are found in the title of the activity.

Outdoors: Why do art outdoors? Why *not* do it outdoors? That's where children like to be, so art should be there, too. If it is possible to do it outdoors, do it. Children will make art more often, and it will seem less confining and restrictive to them.

Nature: The idea of this project is to use natural elements when working. These include water, wind, earth (let's skip fire!), rocks, leaves, sticks, etc. There's no reason these can't be combined with manufactured things to make art, but I'd like to encourage you to use natural things. Why?

When we make art, our attention is intensely

Outdoor nature sculptures can
be found as well as made.

focused for a period of time. (It's really for a pe-
riod of timeless time.) This attention often brings
a feeling of heightened awareness. There's no rea-
son to believe that children feel this any less than
we do as adults.

I think that focusing this attention on our
natural surroundings can't help but do us some
good. We become more aware of the physical
world and how beautiful it is.

Sculpture: Sculpture uses up space. Stretch out! Art isn't always 9″ by 12″; it doesn't always fit into a portfolio. And sometimes you can't even label it. So any version of this project could be done outdoors with natural elements and would use up space. The project could be small (he carefully piles up stones; she gathers pine needles and ties them together with a blade of grass). It could be large (she wraps yarn from bush to bush, weaving her own web; he spends an hour mounding sand, digging trenches, crowning it with seaweed. Then he launches himself at it, and it's gone in a second).

This project is the ultimate in failure-proof art. All that it needs is your respect. Give your child the time to "do nothing" outside whenever possible. Let him make (and demolish) what he likes, and let him choose *not* to make or "do" anything. Being outside is enough, sometimes.

Start of an outdoor nature sculpture

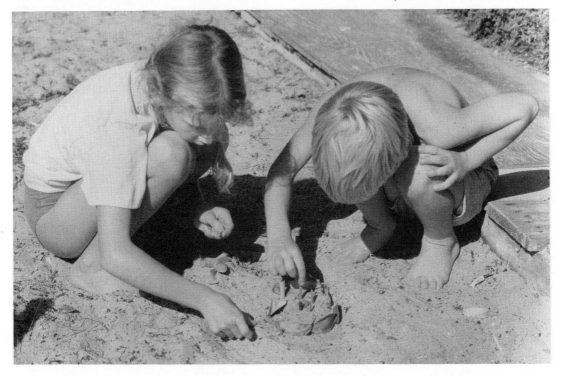

"Among a thousand clouds/7"
charcoal-on-paper drawing by
Sally Warner

Here is the only thing at all I can remember of my own preschool experience: I am outside sitting in a big cardboard box. The teacher is calling my name over and over. She wants me to join the other children inside. This makes being in the box even more precious; I am about to lose the moment. And it is a vivid moment—I am happily alone. It is finally quiet. Colors: brown box, blue sky, white clouds. The clouded sky is framed in a perfect square by the box as I look up. The box smells wonderful. The only sounds are

the wind and the birds . . . and the teacher's voice calling me in. I was probably being called in to color a mimeographed picture. And that was probably called "art."

When my younger son was very small, he was telling me about a special tree. I listened and then told him that in ancient times, people thought that a special tree like that had its own spirit. There was a shocked pause. "Well, I still believe that, don't you, Mommy?"

Maybe children don't need us to remind them how extraordinary our world is. But maybe we can help them learn not to forget it.

Sculpture Words to Use with Your Child

Sculpture

> construction

> model, form, build, construct

> glue, paste, staple, attach, stack

Wood

> board, scrap, spool

> sand, stain

> tools

Color

> light, dark

> bright, dull

> mix colors, blend colors

Shape

> big shape, small shape

Weight

> heavy, light

Puppet

 hand puppet, stick puppet

 sock puppet, finger puppet

 stage, audience

 performance

Sculptors to Look at with Your Child

Red Grooms (cartoonlike, walk-through sculpture environments)

Louise Nevelson (wonderful big constructions)

Niki de Saint-Phalle (colorful, humorous pieces)

Afterword to
Part One

The five chapters in Part One contain projects that can be done over and over again with slight variations. In our quest for new-and-improved experiences for our children, we should never underestimate the value of repeating experience, even (or especially) simple experience.

The variations on these projects are up to you and your child, of course. This book is intended as a way to begin; it provides a foundation. I feel that it provides the young child with enough of an art foundation to give him or her a running start, made up of enthusiasm and confidence, on the elementary school years ahead.

As you vary the projects and invent new ones, go over the following ten reminders:

1. Are all of the art materials safe for young children to use?

2. Is your child still pleasing him- or herself with art, or is your child trying to please you?

3. Are you starting to place more emphasis on the finished art "product" than your child does? Please don't.

4. Are you allowing your child to make art in nonisolated, natural family surroundings?

5. Are you starting to make patterns for your child to copy? Please don't.

6. Is your child being offered enough three-dimensional art activities?

7. Are you forgetting that there's no reason not to draw on a collage or paint on a sculpture? Mix art media.

8. Are you insisting that your child work the "right way" in an art activity? Please don't.

9. Are simple drawing supplies always available to your child?

10. Are you allowing enough time for your child to work in a relaxed manner? And allowing your child to decide for him- or herself when to end a project? And to help clean up?

In Chapter 5, I spoke a little of the timeless feeling of heightened awareness that sometimes comes to us when we are making art. I feel that this is the gift that art gives us, and it can be far more valuable than any finished product. This is especially true with children five and under.

Part Two
Age 6–10

Introduction for Parents of Children Age 6–10

The art of a six- to ten-year-old child is completely different from that of a younger child in his or her intention in making it, in the way it looks, and often in the way the child feels about the art when he or she is done. This difference can create a mine field of misunderstandings for well-intentioned parents eager to encourage their once-avid young artist. And this period is when failure-proof projects are really important.

How and Why the Older Child Makes Art

Once, your child waded right into making art. Your child didn't think too much about what he or she was going to make or worry about how it would look. Your child just went ahead and did it. And often the very young artist suffered from "art amnesia"—he or she not only wouldn't recognize the finished drawing or painting, but also didn't recall making it. That won't happen with older children; they'll remember.

Now, your child plans things a little more. "I'm going to make *this*, and I'll need *these* colors." Your child spends more time on an art project. He or she is usually more demanding about what materials to use. Your child is often

more critical of how it looks when he or she is done. Why doesn't it look "right"? What did he or she do "wrong"?

This seems to happen even when we are struggling to raise our children to be creative and experimental. Maybe it's because we can't isolate our children from a critical world; once they're in school full-time, all bets are off! Or maybe this new self-criticism is something we all go through in growing up, and our art is just a handy target. Either way, it happens. The important thing is to learn how to wriggle around it.

But I think that the biggest difference in intention is that your six- to ten-year-old is beginning to view his or her art as a possible means of self-expression. Your child therefore expects a lot more from the art.

"Self-expression" is a term that we use a lot without thinking about what it really means: the expression of one's inner self, which is made up of thoughts, feelings, dreams, and vision. If you know a child is in this age group, you know that he or she has a lot of self to express! Wouldn't you find it difficult to reveal your innermost self through crayons and paste? A child does, too; his or her art can look like "baby stuff."

What the Art May Look Like

Children age six to ten are still interested in making art, but they soon form an opinion about their artistic abilities: they are "good at art" or they are "bad at art." Most of them seem to decide that they are bad at art.

Or, rather, this is decided among them. Occasionally a misguided teacher will perform the art anointments, but I think nowadays it is primarily the children themselves who decide. I guess this is just one of the many "pecking orders" that children establish.

Who is deemed "good at art"? Usually it's children with a facility for drawing. (There go painting, design, and sculpture.) What do they draw? They often draw cartoons, copy comics or advertisements, or work on elaborate lettering and doodles. (There goes any attempt at visual realism or experimentation.) Now I'm not saying that these children *aren't* good at art. I was one of them! It's nice to be judged good at something. But it's a shame for the other children to give up on art.

Some of them keep on plugging away at art anyway. Home is the best place for them to do this. Home is where children can try new things away from the tyranny of classmates. And that holds equally true for the children who are "good at art."

I feel that almost all children in this age group need the safety net of "failure-proof" projects. The projects in Part One were primarily presented in a way designed to keep us as parents from failure: in the understanding of our child's creative process; in the expectation of what his or her artwork will look like; or in the understanding of art materials and ways of working with them. In Part Two the projects are designed to give as many children as possible a feeling of success.

How the Child May Feel About Art

Children age six to ten feel that a project is successful if they like the way it looks when they're done. They don't really care how they "got there." A seven-year-old doesn't say "this painting is a mess, but I sure learned something!" A nine-year-old doesn't say "I hate this sculpture, but I really used the glue well." It's either a hit or a miss.

Listen to your child when he or she brings a by-the-numbers, craft-type project home from school, camp, or even an art class. If your child thinks it looks good, he or she likes it. He or she doesn't say "the teacher made me do it this way" but says "mine is almost as good as the teacher's"! He or she doesn't say "Cathy did something different with the yarn" but he says "Cathy did it wrong."

Ideally this shouldn't happen, but it does. I feel that the most realistic approach we parents can take is to try to find an art balance that the child is happy with. Here are four elements I look for in a home art project for six- to ten-year-olds:

1. Will the finished project be good looking (flashy) enough to appeal to the child?

2. Is there enough structure in the procedure to reassure the child that he or she is doing the project "right"?

3. Is there still room in the process for the child's individual choices to be made? Choices about color, shape, size? Choices about how long to work? Choices about what it will look like when it's finished?

4. Is there still some art in the project? Is there room for aesthetic choice, for intuition, for "self-expression"?

I think that an *ideal* art program for these children would be centered primarily around numbers three and four (choices and self-expression). But I also recognize that many children (and parents) don't have the artistic expertise or self-confidence for these aspects to carry the home art program. Numbers one and two (flash and structure), combined with choices and self-expression, make any program more likely to be used day in and day out.

This approach to art at home for ages six to ten is a sort of "treading water" approach. We aren't really getting anywhere, but we aren't sinking either! I hope that this isn't a defeatist attitude to take about the home art of this age group. I consider it a realistic attitude. So many of us stop making any art at all during these years. Think back. Isn't this when you stopped feeling at home with art?

For now, any art at all is better than nothing. If your child can get through this period with some art enthusiasm still flickering, you've done a good job!

I happen to believe in a rigorous approach to art education as we get older. I also believe that struggle and even failure are necessary parts of our individual artistic development. But that comes later, and it probably won't happen at home.

You might not like the art your six- to ten-year-old chooses to make, but what's important is that he or she is making it: The process is still going on. And there are still ways to bring creativity to each experience.

- Your six-year-old might draw endless rainbows, flowers, and butterflies. Encourage him or her to vary paper

color, size, and drawing materials. Have him or her make some greeting cards on good paper. And save some—you'll be glad you did.

- Your seven-year-old is crazy about some heavily advertised toy. Have him or her start a scrapbook! (See Chapter 1: Scrapbooks.) Your child could make a collage of cut-out advertisements. He or she could draw the toy over and over and write stories about it. He or she could make some greeting cards featuring the toy on good paper.

 There's nothing wrong with a little obsession. The trick is to squeeze some art out of it.

- Your eight-year-old likes coloring books. Buy one with quilt patterns for him or her to color. Try him or her out on Susan Striker's *Anti-Coloring Books* (see Bibliography). (These are really guided drawing books and are lots of fun.) Or have your child *make* a coloring book of his or her own drawings, to keep or give to a younger child, by drawing with a black marker on 8½" by 11" typing paper and then photocopying the drawings.

- Your nine-year-old likes to draw the same cartoon figures over and over. Encourage your child! Provide lots of typing paper for him or her to use. Check "how-to" cartoon books out of the library so he or she can create new characters. Photocopy some blank cartoon-strip squares for your child to fill in. Buy some white self-adhesive labels so he or she can make talk balloons. Maybe he or she could paint a big pop art–style cartoon on illustration board for his room. See Chapter 6: Cartooning Activities for more details.

- Your ten-year-old likes lettering. Again, provide lots of typing paper for him or her to practice on. Enlist your child's aid in making yard-sale signs. Have him or her create the lettering for the family photo album. Buy special squeeze-on paint and let your child design his or her own sweatshirt! (**Be sure to read paint labels carefully for safety warnings.**) See Chapter 6: Lettering Activities for more detail.

 Don't worry about originality or "good taste" at this point. Just try to keep art alive at home in any way that you can.

In the Foreword I list some art materials that are fairly inexpensive and easy to find. Many of the materials recommended are ordinary household items such as aluminum foil and Styrofoam meat trays. All of these materials will still be used by your six- to ten-year-olds.

If you can, though, I recommend that you **begin to purchase higher-quality art materials from time to time.** There's only just so much art we can expect our children to create with macaroni and aluminum foil.

For example, your child might prefer to use modeling clay for greater modeling detail. He or she might enjoy making a collage on illustration board rather than on poster board. He or she might benefit from lettering on good drawing paper or even graph paper rather than newsprint or computer paper. These older children are often more likely to know just what they want and are prepared to wait for it. They sometimes "need" a certain marker or a certain size of paper. Try to honor these cravings when possible. They are a sign of your child's growing aesthetic development and of his or her growing independence as well. That means these are good signs.

The point is, your child's art work is important to him or her. Bringing better art materials into the home art program as your child gets older shows him or her:

- that you think it's important, too, and worth going to some trouble and expense for

- that you know that how the art looks is important to him or her

- that you want the art to last

Purchase better art materials gradually, and have the purchase reflect your *child's* special art interest. And once you buy something, give it up. Don't hover over it, cautioning your child to "be careful" or to "save it for something special." **Nervous art is no fun.**

There are some higher-quality art materials listed in Appendix 1: A List of Art Materials.

· · ·

I have given age suggestions for each art project in Part Two. The label "7+" means that most seven-year-olds could do the project and so could eight-, nine-, or ten-year-olds. Some five- or six-year-olds might be able to, also, but don't push it. *The age suggestions are intended as guidelines that help keep each project failure-proof.*

There are no "boy projects" or "girl projects" in this book. I arbitrarily gave each project to a "he" or "she" just to make the instructions easier to read and the project easier to visualize. But a child's interest in any project will be more a matter of temperament than of sex. *Parents: When reading or explaining a project to your child, you may want to change the "he" in an example if she's a "she"!*

Before Your Older Child Begins a Long Project: Advice to Parents

Some of the projects near the end of Part Two are long and even a little complicated. I think that projects requiring your older child to plan ahead, to visualize what comes next, to be flexible when things don't turn out as expected, and to wait for the finished result are well worth doing. But if you don't have time for these longer projects, or if your child just prefers the shorter ones, that's fine, too.

If you decide to try a long project, here are some suggestions:

- Read through the entire project before your child begins. Tell your child a little about the project, and show him or her the illustrations in that section.

- The long projects are broken down into briefer work segments. Don't try to do it all in one day. Review the part of the project your child will do that day, and interpret it to him or her. (Older children might want to read through the project themselves, one segment at a time.)

- Stay available for technical assistance. Some children might need a little help with ideas—there are lots of suggestions and variations for each project in the book.

- Don't let your child begin a long project with too rigid an idea of how it "should" look when he or she is done. Stress flexibility, fun, and experimentation.

● No matter what, give your child the opportunity to repeat the art experience. That's when your child really can use what he or she has learned.

Keeping Creativity Alive

The years from six to ten are the years many of us remember most vividly when we look back upon our child-hoods. It seems that we really begin to feel like "ourselves" during these years—our mature selves. But during these years we also start to narrow our definition of the word *creativity*: it begins to become synonymous only with visual art. That's like saying we have leg muscles just so we can play volleyball! **Creativity is an inner resource that can enrich every aspect of our mature lives—it's not just the visual arts.**

The potential for creativity (the act of making something new) lives in each of us. Most of us act less and less upon this potential with every passing year. Our own creativity becomes a memory—something we outgrew our lost along the way.

I feel that we can make it easier for our six- to ten-year-old to hang onto an individual vision of self-as-creator, and the best place to do this is at home. I also think that if our child grows up believing in his or her own creative self, he or she will have a better chance of finding constructive outlets for creative energy in later years.

The child's creativity will not be just a memory; it will be a cherished personal resource, a thing to nourish and to use every day.

6

Drawing for Children Age 6–10

Encouraging Continued Creativity

Drawing is still at the heart of your six- to ten-year-old's art at home. By "drawing" I mean free drawing, which is good news for parents! All that you have to do is provide the materials—you don't have to teach anything. (The "nonartist" adults I've taught have been so anxious about their drawing skills that they've practically blacked out at the very word *drawing!*)

These children will draw at school (usually during non-art classes), at home, in the car, in the waiting room, or in restaurants. Always carry *black fine-point nonpermanent markers* with you for impromptu drawing opportunities. *Unlined 3" by 5" cards* or *small blank pads of paper* are a good idea, too. **Encourage your children to draw often. Encourage quantity.**

But please don't insist that your child draw on both sides of the paper. I was a fairly docile child, but when the teacher ordered us to turn the paper over for "drawing number two" I rebelled. I would rattle my paper, pretending to comply, then continue with what I was doing. My reason? I felt that "drawing number one" wouldn't be able to breathe if I turned it over!

What will the art look like? Here are nine examples.

"People and House," age 5 ½

"Teddy Bear, Pegasus," age 6

"Horse," age 6

"Clouds, Birds, Sun," age 6

"Girl," age 6

"Flowers and House," age 5 ½

"Christmas," age 7

"Persimmon Body," age 7 ½

"Girl in Plaid Dress," age 8

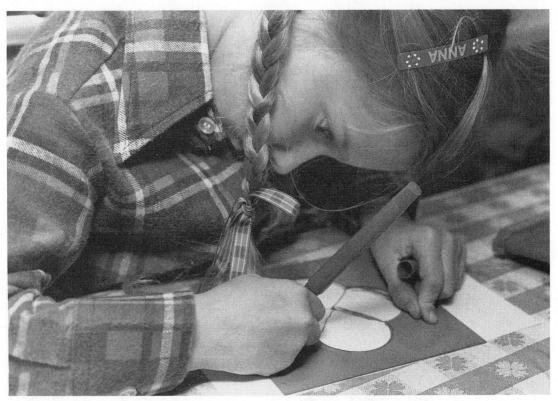

Free drawing is for children of
all ages.

What the Art Will Look Like

What will your six- to ten-year-old's drawings look like?
They rarely are based upon specific observation. For exam-
ple, let's say a seven-year-old wants to draw a cloud. She
doesn't go outside and look at the sky. She doesn't even sit
inside and wonder "cumulus, cirrus, or nimbus?" She proba-
bly draws a cartoonlike scalloped shape and calls it "cloud."
She may draw a cloud anchoring each end of a hovering
rainbow, then wedge a sun up in the corner, sprinkle in some
M-shaped bird-lines and quickly plant some flowers along
the bottom. She is likely to do variations of her favorite
drawings over and over. Boys do, too.

Just provide plenty of white paper. It can be small (3″
by 5″) or large (12″ by 18″ or larger, although children don't
seem terribly interested in big drawings at this age). Buy
skinny water-based markers in different colors. I also suggest
black Flair or Pilot markers for fine detail. (Hint: Your child
may get frustrated if the marker colors seep into one an-

other, staining the lighter colors. This is called "bleeding," and the way to avoid "bleeding" is to start with the lighter colors and work darker. Finish with black. This requires advance planning. It's no longer a matter of making a drawing and then "coloring it in." The markers still "bleed," of course, but it's not visible!)

Offer other drawing materials to your six- to ten-year-old from time to time. Please refer to Chapter 1 for a few ideas. But don't be surprised if your older child prefers skinny markers. The detailed drawings she loves are easier to do with skinny markers.

Are these repetitive, stereotyped images a waste of time for your child to make? I don't think so.

- Your child is having fun in a constructive way.

- Her drawing is often a social activity as well.

- She appears to be getting *something* out of the experience. It doesn't seem to be aesthetic, but perhaps it's a physical/intellectual/neurological/emotional benefit. Wow!

- **I don't think that any drawing we make is a wasted effort. We learn something from every one.**

It's a big step to break away from these copied images when we try to draw objects we "know." Most people never do break away. Of the hundreds of "non-artist" adults I've taught, I've probably had only a dozen who didn't naturally make stick people and lollipop trees—their copied people and tree symbols—when they drew.

I don't think that's so strange. "Visual realism" is just another idea; it's all marks on the paper. One kind of drawing isn't intrinsically more "real" than any other.

I vividly remember when I first made the big step from the symbolic to the "realistic." I was nine years old, and I didn't really make the step myself—I was pushed!

There was an "art expert" who came to our class once or twice a semester. He taught us an art trick each visit, and

Provide plenty of white paperl Here are two examples of stories created by young artists.

"The Square Planet and Its Moon," age 5 ½

"The Planet and Its Moon"

"Man on the Planet"

"Problems on the Planet"

"Close-up of Man on the Planet"

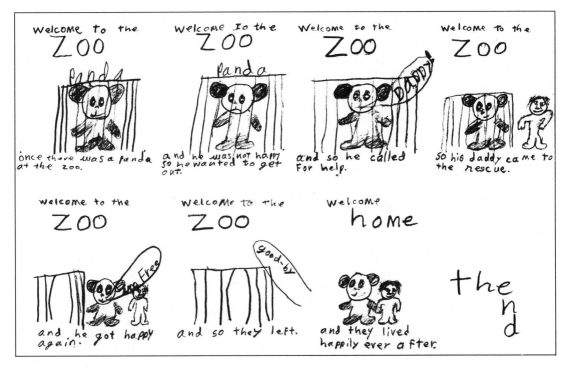

"Welcome to the Zoo," age 9 ½

then we would copy what he did. I remember being taught to paint a "blossoming fruit tree." We could do it in five minutes flat.

But I never learned anything worthwhile from the expert; it was our regular fourth-grade teacher who ended up teaching me the most. We were all coloring away one Friday afternoon. (I guess that was the designated "art period," when everything else had been done and we were too worn out for "real work"!) We were laboring on versions of the cloud-and-rainbow drawing I described earlier. But *we* always added a blue stripe along the very top edge of the paper to designate "sky." We didn't even think about it. "Now I'll put in the sky!" And up the stripe would go.

For some reason this finally drove our teacher wild. He shouted at us to line up, and he marched us out to the playground. We were terrified, as you can imagine. Then he pointed up to the (barely blue) sky and swept his arm down toward the treetops. "All blue! No stripe!" he yelled. I could see that he had a point, although it took me a while to see what it had to do with drawing! That was the first glimmer I had that art could be based on something other than thinking or copying.

Drawing stereotyped images is rarely a waste of time.

"This is a Unicorn," age 6

"Unicorns," age 6

"Carousel Horse," age 6 ½

"Unicorn in a Heart," age 8

"Christmas Tree," age 6 ½

"Christmas Tree" (With Wiring), age 6 ½

Children learn something from every drawing they create.

"Balloons," age 6½

"Flowers," age 6½

"Sun, Kite, Rainbow, Clouds," age 8½

"Trees, Clouds, Birds, Fancy Lady with Rainbow Body," age 6½

"People, Rainbows, Balloons," age 8

We often try out an idea of visual realism before we try direct observation itself. For example, do you remember drawing a cube at this age? We learn to draw a cube "in perspective" (which is an idea) and then "shade it in" (another idea). (Things do look shadowed and "in perspective," sometimes, but I am talking about arbitrary choices here.) All of this happens without looking at an actual cube. This cube-drawing activity is a natural bridge between thinking and looking.

It seems to be easier this way for us to edge into any attempt at visual realism we might make, and some children don't even give it a try. Here is the rough progression I've found that many children go through:

1. **Drawing ideas:** We draw and shade a cube. Perhaps we expand this by drawing and shading houses or skyscrapers, putting objects in front of other objects, and shadowing and highlighting things. We do all of these drawings without pictures or models.

Art can be based on thinking or imagination
as well as on visual realism.

"Inside a Train," age 6

"Rocket Ship," age 6 ½

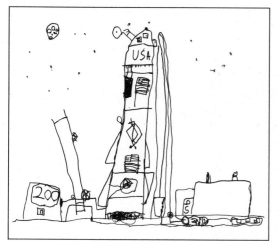

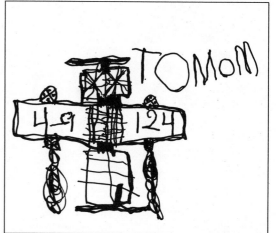

"Airplane," age 6 ½

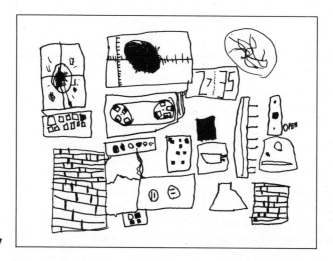

"Computer," age 7

2. **Drawing from pictures:** We copy (or even trace) photographs or other artwork. We pay special attention to the use of shadowing and highlighting to achieve a more "realistic" look.

3. **Drawing from real life:** This is the big jump. To do this, we have to be able to put things that we know are three-dimensional (that have length, width, and depth) onto a two-dimensional surface (paper, which has length and width but no depth).

Some people can do this easily; it seems to come naturally to them. It can be tremendously frustrating, though. I once saw a seven-year-old howl in rage at a "failed" drawing, rip it to shreds, and stuff the shreds into his mouth for the coup de grace! Passion.

I think that everyone who wants to can learn to do it, though. Here are two of the best drawing books to help adults who want to learn: *The Natural Way to Draw:* A Working Plan for Art Study by Kimon Nicolaides and *Drawing on the Right Side of the Brain* by Betty Edwards (see Bibliography).

We know from experience that the house across the street is more than 2″ high, although if we go only by how it appears as we look at it, it would seem miniature. We know that we can grasp a handful of weeds but not a handful of clouds. Yet when we see a sky full of clouds above a field of weeds, we see them both equally—we don't physically touch them with our eyes. If we drew the weeds and clouds, both would be just marks on the paper. Once we learn to "turn off" our knowledge of the individual parts of what we are seeing, we can easily draw the whole. Just think of what you are seeing as a "picture" that you can copy if you wish to.

Most children give up on this pretty early. They do begin to make more and more ambitious drawings—doodling and lettering can become elaborate, as can the drawings mentioned earlier in this chapter.

I would like every child to learn to draw as well as she is able to and wishes to. This includes being able to draw

Here are some early attempts at visual realism.

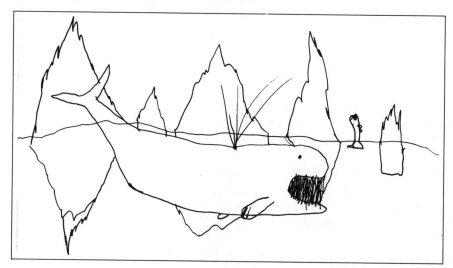

"Whale and Icebergs," age 7

"Toothbrush and Mug," age 8

"Bicycle," age 9

"Birdcage and Baby," age 8

"Windowbox," age 9

Upside-down doll and watch
traced on typing paper from
magazine pictures

Enclosed shapes traced on
typing paper from magazine
pictures

"realistically" if that's what she'd like to do. I happen to think that **drawing in this manner is a unique way of knowing what is being drawn.** Perhaps your interested child is lucky enough to have a teacher able to teach this. If not, the drawing books mentioned earlier will help your child find her way as she gets older.

But I think that it's impractical to expect big jumps in drawing to happen at home when most parents feel that they themselves can't draw and have such an initial resistance to it. For this reason the drawing projects in Chapter 6 take a different approach.

These projects are intended to give the six- to ten-year-old a "stretch" without setting her up to fail. They are intended only as additions to free drawing.

Drawing Activities

Tracing and Overlapping (8+)

"That's good! Did you trace it?" Tracing has become synonymous with "cheating" in art, but I think there are ways of using tracing constructively and creatively. This project also involves overlapping nonobjective shapes.

Overlapping anything in art is hard for most people to do. I discovered this during years of teaching. The same problems cropped up in drawing, painting, and collage, so I began to design projects that would specifically address this weakness.

Working with nonobjective shapes presents problems, too. It's a lot easier for people to see "things" (a tree, a cloud) than to see the spaces and shapes between and around things. But I think it is these nonobjective shapes that are the interesting ones in any composition. This project sensitizes children to nonobjective shape.

Your child works on a sheet of *newspaper. Typing paper* is good to use for this project. Your child draws on the paper with skinny *markers* or *colored pencils.* (If she gets frustrated by smearing the marker with her hand as she works, encourage her to draw with another piece of paper under her drawing hand to shield the drawing surface.)

Find a *magazine* with lots of pictures. (Advertisements are good to use.) Before she begins, have her turn the maga-

zine upside down. It's easier to see things as shapes if you turn them upside down. We can't often do this with "real life," but we can do it with magazine pictures!

There are two kinds of shapes to look for. You decide which will be easiest for your own child to see nonobjectively.

1. **Upside-down objects:** With this approach we look at a pictured object (a bottle, a building) as a shape. We try not to think "bottle" or "building." This presents a challenge: If you find your child thumbing through the magazine searching for things she likes (a kitten, an ice cream cone) go on to the second approach and try drawing upside-down object shapes later.

2. **Created shapes:** These shapes are the ones between objects and around them, extending out to the edge of the page. (Start to look at each page as a composition made up of objects and created shapes.)

Looking at shapes between objects

- **Enclosed shapes:** The easiest shapes to see are enclosed shapes. For example, if you are looking at a picture of a boy with his hands on his hips, you see two triangular shapes (the spaces between his arms and his body). These are pretty obvious.

- **Shapes between objects:** If you are looking at a picture of two people facing one another, the space between them defines the two people. It says how close they are and whether they are leaning away from or inclining toward one another. Even if you are looking at a picture of two boxes, your eye is drawn to the space between them. It tells you about the boxes somehow.

These shapes are especially interesting because they contain the "ghosts" of the objects themselves. They are often very beautiful shapes.

- **Shapes around objects:** If you are looking at a picture of skyscrapers silhouetted against a cloudless sky, it is easy to see a created shape. It is the sky, the saw-toothed shape (the tops of the buildings) going all the way up to the sides and top of the page. Practice seeing these shapes—they're the hardest ones for most people to see.

Looking at shapes around objects

Various shapes traced on typing paper from upside-down magazine pictures

Overlapping shapes decorated with small-scale patterns

(These shapes are also called "negative space," but whenever I use this term with children they look at me as if I just stepped out of the "Twilight Zone." It does sound a little peculiar.)

Thumb through a few upside-down pages and point out a couple of these shapes to your child, then have her show *you* a couple. *Tell her that the idea is that no one will even be able to guess what made the shape.*

With the magazine upside down, she traces around a shape with a *marker* or *colored pencil.* It's best if she selects big shapes—she'll be forced to overlap them sooner! (Don't let her do it in pencil and "go over" it later. Have her "throw caution to the wind" and just *do* it.)

Then have her turn the pages and find another picture. She selects another big shape and traces around it on the same piece of paper. She slowly builds up her design out of many shapes. She can use any colors, and even do some shapes in marker and some in colored pencil. She should vary the shapes—some might be long and thin while others might be rounded. She should also vary sizes, once she's put in a few big ones to get started.

There are a couple of rules for her to follow. These aren't "art law" rules, though, they're more like game rules for this particular project.

- Each shape must be connected with another shape. The lines must overlap somewhere—there will be no floating shapes.

- Shapes must actually go off all four sides of the drawing paper. (That's why she's drawing on newspaper.)

She'll probably overlap at least 8 to 12 shapes, maybe more. When she decides she's done, she should stop and look at the composition. She notices the drawn shapes and . . . *new* shapes she's created by overlapping.

She might like to leave it just this way, or she could go on to decorate it. She could blend colored pencil colors in selected shapes, or fill selected shapes in with solid marker colors. She could also draw small-scale patterns in selected shapes.

The decorated shapes could be selected randomly or could follow a planned approach. Here are three ideas:

1. She could decorate many of the shapes around the four outside edges and leave the center white.

2. She could decorate the center shape and leave the edges white.

3. She could start at one edge and snake her way across the page, decorating connecting shapes until she reaches another edge.

Variations:

This is a little harder. She traces one shape over and over again, turning her drawing page as she works. She goes off all four edges of her drawing paper. She has to pay more attention to the shapes she's *creating* by her overlapping, though. She creates her own long skinny shapes and small shapes for variety.

Display:

If she really likes the finished drawing, it's fairly easy to mount it and even frame it. You need to buy a pretty color of *mat board* at an art supply store. She will probably choose a bright color that is already in her drawing.

Kangaroo shape repeatedly traced on typing paper

Cut a piece (or have it cut at the art store) that is bigger than the drawing, but a standard frame size. For these drawings 11″ by 14″ or 12″ by 16″ is a good size. (Save the rest of the mat board for other projects: she can draw with oil pastel on all colors)

You can use either *rubber cement* or *spray adhesive* on the back of the drawing. **Work outside, and do not let your child use either rubber cement or spray adhesive.** Put the adhesive on the back of the drawing, not on the mat board.

Place the sticky drawing on the mat board. Then later on you can buy a ready-made frame (Lucite box frames work well) and hang the drawing. Having something framed makes it look even better, and can be a real thrill for anyone.

Cartooning Activities

Simple cartooning can be fun for children as young as six years old. For the idea of cartooning to make sense to them, though, the child has to be familiar with the form.

There are three things to mention about the cartoon form that can seem bizarre to a young child.

1. **Window format:** We come to understand the idea of telling a story through successive "windows" in a panel by experience. Read the comic strip "Calvin and Hobbes" to your child to familiarize him or her with this storytelling format.

2. **Talk balloons:** Twenty-five years ago I got to design and teach my own art program for the first time. I was working with a group of children under five years old, and I learned a lot.

 One day I read a cartoon-style story to them. The illustrator had drawn "talk balloons" above the characters in the story. When I finished reading, the children began an animated discussion of the plot. To my surprise, several children agreed that it was a story of people who were about to be "sworded"! (This especially startled me because I thought they said "sordid.")

 I looked at the story again and saw what they meant: There were large hooked shapes hovering over the poor

Three conventions of cartooning: window format (top); talk balloons (center); cropped image (bottom)

little cartoon people. I understood then that the "talk balloon" is a convention that we only gradually come to understand. So when you read a comic to a very young child, point to the balloon and say, ". . . and Calvin says" or ". . . and Dennis says" to give your child the idea.

3. **Cropping (and hiding):** When we see a photograph or illustration showing only part of something, or where part is hidden, we assume that the rest of it is there somewhere. Very young children don't always make that assumption; they're more apt to "believe their eyes" without questioning it further.

Cartoons don't need words! Alex (age 7) placed this wordless cartoon under his pillow so the tooth fairy would know he had lost a tooth.

"Rosy Cheeks," age 6

"Toothbrush vs Teeth," age 7

Once, I read an olden-days picture book to some very young children. The woman in the book wore a floor-length dress, and when I'd finished reading, that's all they could talk about. "This is about a lady with no feet!" one said, and several others agreed. They listened to my hurried explanation with skepticism. I don't think I convinced them.

But this experience and others like it convinced *me* that very young children are apt to "read" a picture as a whole and often can't visualize objects that are hidden or extended past the edges of the page. (It's like that with words, too, in a way. Small children usually believe their ears, too. If they hear that someone has been "fired," or has "caught a bug," they can become alarmed or excited. These children "take it literally" until they learn otherwise.)

So before your child is ready to try cartooning, he should be familiar with and accept cartooning and pictorial conventions. He should truly "get it" himself.

Once that has happened, he can start cartooning. He can do this before he learns to read and write on his own—cartoons don't need words! My children used to "write" me notes to remind me what they wanted from the supermarket. These notes were in cartoon form and were terrific.

There are some excellent cartooning books on the market. Here are two recommendations: Ed E. Emberley's cartoon books, and *Teaching Children to Draw* by Marjorie and Brent Wilson (see Bibliography). If your child is interested, these books tell about creating a character (Emberley) and telling a story (the Wilsons).

This book has a different approach. I will focus on line quality in cartooning. There are three kinds of line we'll be exploring: the calligraphic line; the broken line; and the connected line.

I hope that over the years your young cartoonist will choose from these different approaches to create a cartooning style that satisfies him. *Encourage your six- and seven-year-old to experiment freely and frequently with simple cartooning before going on to these more difficult projects.*

Encourage cartooning with and without words.

"In Front of the Wave," age 7

"In the Wave"

"No Baths Tomorrow," age 6

"Can I Have Some Ice Cream?" age 7

Calligraphy has a thick-thin line.

Calligraphic-Line Activities

Calligraphy is the ancient Asian art of brush-drawing the characters used in communication. Most westerners can't read these characters, but have long admired the way they look. We don't need to know what the character means to admire the expressive quality of the brush stroke.

One of the interesting things about the calligraphic brush stroke is its thick-thin quality. This is what makes it look more like drawing than writing to us, and it is this quality that we will use in this section.

The calligraphic brush stroke isn't easily mastered by *anyone*, and I'm not going to suggest it for six- to ten-year-olds working at home! What I am suggesting is that interested eight- to ten-year-olds can start working on a thick-thin expressive line in their marker and pencil drawings. They can do this with *marker* (one color) or *soft pencil* (4B). But since *calligraphic* is such a pretty word, let's use it.

A calligraphic line can look as if it's alive. Here are three projects that will help your child get used to the idea.

INITIALS (8+)

Your child does this drawing on a piece of *white drawing paper* (9″ by 12″ is a good size) with one *marker*.

He draws his initials very large on the paper. This is a good time for him to use cursive (a style of lettering imitating handwriting) if he has learned it. If not, printing is fine. *The initials should fill up the paper.*

Using the same color marker, he goes over each initial, drawing it thick-thin-thick-thin. Parts of each initial will be as skinny as the original drawn line, and parts will be bulging. He smoothes out any parts of the thick-thin line that don't flow easily.

He can decorate the border if he wants or he could try drawing a thick-thin wavy border all the way around his initials.

FACES (8+)

Calligraphic lines can be very descriptive when used to draw facial expressions. This can be fun to do as a doodling game. With the Faces project, the look of the finished drawing will please your child, too.

Calligraphic initials

The faces can be done on any size paper, but I suggest working on a square. We don't do this very often, and the square is a beautiful shape.

To make a perfect square without measuring, bend the corner of the paper down to form a folded triangle. Cut out the folded triangle, unfold it, and there is your square. If your child's *white drawing paper* is 9″ by 12″, he can end up with a square 9″ by 9″ or smaller.

Now he folds the big square in half, then in half again. Then unfolds it. He has four small squares. Have your child take a *ruler* and draw in the intersecting lines with a *marker*.

He then looks for something round that he can use to trace the head shape. It should be between 2″ and 4″ in diameter. He traces around the circle in each of the four squares. (If he prefers a different head shape he can make up his own, but the idea of the project is to keep the same shape in all four squares and change just the expressions.)

Now comes the fun part—drawing the expressions! It will be easy for him to come up with four.

- He draws the faces as if they were all the same person but with different facial expressions such as "happiness," "fear," "nausea," "anger," "sleepiness," etc. Encourage him to exaggerate.

Calligraphic faces

● Next he goes over the expressions with his thick-thin calligraphic line. This line is best used to emphasize the funniest thing about expression—eyes (anger), mouth (nausea), etc.

● He can add any other details he wants, of course. Encourage him to break out of the head shape itself with hair, ears, etc.

● He might want to label the expressions, or he could just leave them as is so people can guess.

Encourage him to work with an extra piece of paper under his drawing hand so he doesn't smear the marker lines as he works.

I am encouraging him to use just one color of marker, at least in drawing the expressions. He pays much more attention to the line itself if he's not distracted by color.

TRACING (9+)

Tracing again! Your child uses a *magazine* once more, as she did in the Tracing and Overlapping project. She can use *typing paper* for this project and can draw with *marker* (one color) or a *soft pencil* (4B).

Have her select a picture she likes from the magazine. It can be of anything, but there should be no printing over the picture. It's good if there's some appearance of depth (objects in front of other objects). Cut the whole page out of the magazine if you can—it's a little easier for her to work this way.

She traces over the picture with marker or soft pencil (she uses the same drawing tool throughout). She can leave out anything she wants to—that's artistic license! She then puts the magazine picture away. She's done with it.

Encourage her to take some time at this point to just look at her drawing so far and to think about it. This is the part most of us need to work on more. What does she like about the subject itself? Why did she choose it? What does she think is the most important thing about (or in) the picture?

She then goes over parts of the drawing with her marker or soft pencil, building up a thick-thin line. The line

could strengthen shapes in the foreground, or go over the important things in the drawing. But the point is for it to be an expressive line. *All of the lines in the drawing should belong there together.* She won't just have thick, clunky lines in the foreground and thin, wimpy lines in the background.

She goes over the lines and smoothes out any parts that don't flow easily. (If she wants it to look choppier, she exaggerates the breaks in the thick-thin line. Either way, it is a conscious act.) Encourage her to exaggerate.

If she has used a soft pencil for her drawing, you could spray the line with *fixative* to keep it from smearing. **Parents: Do not let your child use the fixative.** Use it outside, read the label, and then be twice as cautious.

Calligraphic tracing from magazine pictures

Display:

A drawing done on paper this thin can get wrinkled or torn pretty easily. If your child would like to keep the drawing, she should put it in her portfolio (see Appendix 3: How to Save Your Child's Art for how to make one) or frame it.

Typing paper is 8½″ by 11″ and the closest standard frame size is 9″ by 12″. If you are using a Lucite box frame, you could simply place the drawing against the white backing and then box it in. There will be a tiny white border around the edges of the drawing.

If you want a colored border, cut a piece of Fadeless art paper to fit the backing (9″ by 12″, 12″ by 16″, or whatever size you are using). Then place the drawing on the backing and box it in. If too much backing color shows through the drawing, place a blank piece of typing paper between the drawing and the backing.

You could also mount the drawing on a piece of colored mat board. Cut the mat board to fit the frame exactly. Use rubber cement or spray adhesive to mount the drawing onto the mat board. **Parents: Do not let your children use rubber cement or spray adhesive.** Always use spray adhesive outside and spray the back of the drawing, not the mat board.

I have been recommending the Lucite box frames because they are easy to find, they go on sale every so often, and they don't overpower the art. But the best thing about them is that they can be used over and over again; it's just a question of changing the display! The art can go back into the portfolio for a while.

The tracing project is not really cartooning, but it extends the use of the calligraphic line your child has been working with. *I hope that she will begin to see that line can have "muscle," that line can be exciting and strong even without color.*

Broken-Line Activities

Once we start trying to draw images that are not stick figures, we usually make outline drawings and then fill them in. For example if we are drawing a house, we draw the silhouette and then put in the windows, door, and doorknob. That's one way we show "space" in a drawing.

I was watching a four-year-old draw once when she discovered this. She dashed off her regular "person," which consisted of a circle (most children consider this the head and torso, not just the head) and two leg lines. She then cocked her head and drew a horizontal line from one stick leg to the other, about halfway down. "There," she said with satisfaction. "That's to keep the food from falling out."

After children have drawn outlines for a while, they might like to experiment with another way of showing shape: the broken line. This can be a very hairy or furry line, so it is especially good in cartooning!

LITTLE CREATURE (7+)

For this drawing your child uses *typing paper* and a *thin black marker* (Flair or Pilot).

She draws a small (about 2″) shape on a piece of typing paper. This is just an outline, and it should be dark. She can do it with a thick marker. It can be a simple circle, square, or triangle, or a blob.

She then puts another piece of typing paper over it. She draws "fur" lines radiating out from the solid line on the bottom piece of paper. She "outlines" the whole shape with these radiating lines.

Now come the eyes, which she invents. Who knows how many? And they can be happy, sad, mad, etc. She can draw these with a solid line.

Finally, she can add any details she wants: ears, feet, a bow tie. These details, too, can be drawn with a solid line

Little creature with traced feet

for contrast. Sometimes it's fun to trace these details from various magazine pictures. For example, she could add a pair of bony, bare human feet to her little creature. (My favorite monster in Maurice Sendak's *Where the Wild Things Are* has human feet!)

After she has played with the Little Creature project, she could try the following related activities.

Magazines (8+)

She could find an animal picture she loves in a *magazine.* She cuts it out (if possible) and puts her *typing paper* on top. She then draws her radiating fur lines around the photographed animal underneath.

She includes more interior details in this drawing. This presents a greater challenge: to have the broken fur lines make sense! For example, if she is drawing a cat with his tail curled against his body, the fur lines should describe the tail—the way the fur grows, how relaxed the tail is, etc.

Broken lines create a mouse.

Drawing on Her Own (9+)

She can plan her own drawing using the broken line. She won't be tracing anything, so she can use good *drawing paper* for this. She draws with *marker* and needs a *2B pencil* and a good *eraser* for her preliminary sketch.

First, she should think about what she would like to draw. It could be something real or imaginary but should lend itself to the broken line she is now familiar with. There should be a reason for drawing it this way.

She then makes a pencil sketch of the basic shape on the drawing paper. She draws it lightly so that it will be easy to erase later on. Now she switches over to marker—the marker lines radiate out from the lightly drawn pencil outline.

She finishes with interior details and anything else she might want to add. Finally she carefully erases her preliminary pencil lines. (Make sure the marker lines are dry first. If she is drawing on a slick surface such as poster board, the marker takes longer to dry.) I suggest that she use an *Artgum* or *kneaded eraser* rather than a harsh pencil eraser. The drawing paper won't suffer as much.

Connected lines create these faces and calligraphic lines outline them.

Connected-Line Activities

This is a good line to use in drawing facial features. Drawing with the connected line is like a game: we draw the whole object without lifting up the marker. This is similar in a way to "contour drawing" (Nicolaides and Edwards). In this case, though, the line is not being used to depict an actual outline but rather a descriptive expression.

A good way to try this out is for your child to begin with the Faces project approach on page 122. He folds a square piece of *drawing paper* into four squares and draws a head shape in each square.

Now he chooses a marker and draws a connected-line face in each head shape. He evolves his own way of doing this, but here is a good way to start: He can begin with an eye. He draws the eye and eyebrow, then works his way down the side of the nose. He then creeps right into the mouth and then crawls up the other side of the nose into the second eye.

It's like a game—encourage him to think of the line as a piece of string that he can't cut, no matter what!

Once your child has experimented with the calligraphic line, the broken line, and the connected line, he can easily combine them in different ways. It's just a question of having the line serve its best purpose in any drawing. Here are a few ideas for line combinations that he could try:

- He could draw a person with calligraphic hair and a connected-line face.

- He could draw a broken-line creature with calligraphic body details.

- He could draw a connected-line head with calligraphic features.

TALK BALLOONS (6+)

Children enjoy making their own funny cartoon "talk balloons." They can do this even before they can read or write well. One of my favorites was done by my younger son when he was five, and is still on my mirror. I was having a rough day when all of a sudden it appeared:

HAVEUHUGGEDMOM2DA?

Self-adhesive labels are good to use for this project. Buy a package of big ones—2″ by 4″ are a good size to use.

You will probably buy white ones, but bright colors are finally available. The colored labels are good to use on white drawing paper.

With permission, she could make funny captions for various pictures in an old magazine. I suggest using a *black skinny marker* (Flair or Pilot) for the printing. She could leave the label shapes as is or cut little speaking "hooks" before peeling off the paper backing. Captioning is fun for her to do with a friend; they can inspire one another to greater and greater witticisms.

White labels also work well on colored construction paper. She could make a talk balloon for an oil pastel drawing on black construction paper, for example (if it has anything to say!).

Talk balloons cut from self-adhesive labels

POP ART POSTER (9+)

Cartoons are a popular art form. The Pop Art Poster is a more advanced project than those previously described and is really a painting project. But it can be fun for a child who is an avid cartoonist. Here is what he needs:

heavy white poster board or illustration board

2B pencil

two or three colors of tempera or glue paint (one will be black)

narrow brush

He sketches out his cartoon on the heavy white poster board with the 2B pencil.

He then paints in the background with the tempera colors. (He leaves the talk balloon area white.) He can mix white vinyl glue with the tempera to make glue paint, which won't "bleed" when he paints over it and will look a little shiny when it dries.

After the colors have completely dried, he finishes by painting in the black cartoon lines and lettering with a narrow brush. He may use a simple outline, or a calligraphic, broken, or connected line.

Flip Book (8+)

Animation is another popular art form. Children enjoy making their own cartoons, and the easiest way to begin is by making a flip book.

Buy the smallest and cheapest *pads of unlined paper* you can find. Your child uses an entire pad for each project, so buy several. She uses a *thin black marker* to draw with—I suggest Flair or Pilot.

Children often teach each other how to make animation flipbooks, but here are a few hints to make the project easier:

- Your child starts at the back of the pad and draws her way to the front. That way she can see the cartoon mark on each previous page.

- She should work in only one color to begin with.

- She moves the mark very slightly from one page to the next.

- When she flips through the finished book, the cartoon mark is animated!

Your child doesn't have to be able to draw Mickey Mouse or Popeye to make a cartoon flip book. In fact, she should start out with very simple marks.

- She could begin with just a dot and move it around.

- She could draw a bouncing ball.

- Stick figures are good for this project. She could draw a stick figure doing aerobics or growing hair!

- She could draw a face and change its expression.

Flip books are small and easy to carry around. They are an inexpensive project, too. And they require concentration; your child has to think ahead while she is making each drawing. She has to plan how to get the mark from here to there.

In spite of being easy to make and good for her, flip books are fun!

Lettering Activities

Fancy lettering

Lettering is like cartooning in that children have to understand the conventions involved before it is worth doing as an art project. Once your child is reading and writing with ease, he can start playing with the letters.

The easiest lettering is just with plain drawn letters. Your child could use different colors of *marker* although ideally not within the same word. (Young children seem to lose track of the word when they change colors.) He could also begin to exaggerate the letters, making them long and skinny or short and fat.

Next, he will probably experiment with fancy letters. These are basically plain drawn letters with curlicues and frills added. Again, encourage him to use different colors. He or she might also enjoy drawing them with *oil pastel* on *black construction paper.*

Enclosed lettering (8+) is harder to do. Enclosed lettering calls for each letter to be drawn as an enclosed shape. There are lots of different styles your child could try. Here are a few.

- Plain block lettering (8+): This is just like ordinary printing. He should practice this awhile before going on. Big lined kindergarten printing tablets (newsprint) are good for practicing enclosed lettering.

- Balloon lettering (9+): This lettering uses all round shapes—there are no straight lines. It looks funny!

- Lightning lettering (9+): This lettering is made up of all straight lines and angles—there are *no* curved lines. Your child could use a ruler for this if he or she wants to.

Your child could color inside the enclosed letters with *marker* or *colored pencil.* If he chooses marker, he might want to draw the letters lightly with *2B pencil,* then use the marker colors from light to dark, ending with black. This way he won't see the marker colors "bleed" into one another. If he uses colored pencil, encourage him to try blending colors within a letter—that's one of the things colored pencils do best.

BLOCK

BALLOON

LIGHTNING!

Three examples of enclosed lettering: block (top); balloon (center); lightning (bottom)

Your child could also draw patterns within the enclosed letters. He could make squiggles, polka dots, stripes, or little blue fish!

Here are a few ways for your child to use these new lettering skills.

MONOGRAM (8+)

A monogram is made up of the two or three first initials of your child's name. Each person has a monogram, and its letters can make a strong design.

Your child could use her lettering to draw or write her monogram in many different ways. She could draw with *markers* on *white paper* or *light-colored construction paper*. She probably now has many styles she could try. Encourage her to work in different sizes. She could also draw with *pastel* or *oil pastel* on *dark construction paper*.

If she likes doing this, she may well accumulate many monograms (perhaps of all family members, including pets) done in different styles, colors, and sizes. If she would like to put them all together in a *collage*, she could cut each monogram out around the two or three letters. (Suggest that she leave a narrow border around the outer drawn line.)

Buy a piece of white *illustration board* or *heavy poster board* (any color) as the base. Have her arrange the trimmed monograms, encouraging her to overlap them or have some going off the edges. She can trim the overflow later.

There are a couple of adhesives she could use. If she has drawn on a fairly heavy base such as lightweight poster board, she will need to use *thick white vinyl glue* as an adhesive. For lighter-weight paper she can use *thinned white vinyl glue* or *paste*.

If she is something of a perfectionist, though, she may get discouraged at the way lightweight papers wrinkle and bubble when glued down. I remember "ruining" many projects this way when I was this age. If she becomes frustrated, you could offer to help with the gluing.

You can use *spray adhesive* or *rubber cement* on the backs of the monograms. **Do not let your child use spray adhesive or rubber cement.** Use them outside, and remember to put the glue on the backs of the monograms and not on the base.

Neon Light Sign (8+)

My Room
Welcome
Danger
Please knock!

Here are four ideas for signs your child might make for the door to his room. He can use any style of lettering, but these signs can look especially vivid when done with *oil pastel* on black or other *dark construction paper.* The letters glow like neon against the dark background.

All your child needs to do is draw the lettering, decorate it, and perhaps design a border. He should check with you for the house policy about taping things to doors (or walls), but I suggest that you mount a small bulletin board to his door for a few years if tape bothers you. *Communication is more important than decoration.*

Lettering and Cartoons (8+)

This approach could be used in any of the lettering projects so far. It just involves your child's working her cartoon characters into (and in front of, and behind) the lettering.

For example, she could draw a funny big calligraphic face peering from behind a Neon Light Sign. She could draw a furry broken-line character sitting atop her Monogram. She could even turn her letters into cartoons by exaggerating them and adding faces, hair, or feet.

Letters can be turned into cartoons.

GRAFFITI (10+)

Calm down. This project is just *called* Graffiti! It's large, it's colorful, it's (sort of) spontaneous, and it's a good safe way for your child to try out this alluring form of lettering.

This project is big and will take a beating. I suggest using *Masonite* as a base. Get a piece 2' by 2' or bigger—your lumberyard may have odd-sized leftover scraps you can buy.

Since Masonite is so dark, you will need to prime it with white or another light color. The primer needs to dry waterproof so it won't "bleed" into the markers or paint used in later lettering. You could prime the Masonite with *white latex paint, gesso,* or even *white glue paint* (mix white tempera with white vinyl glue). Prime it outside a day in advance; your child can help.

The actual lettering can be done with *marker, oil pastel,* and/or *glue paint.* **Do not let your child use spray**

Anni shows that free drawing can take place anywhere.

paint. Spray paint is not safe for children to use. Encourage your child to start with large-sized letters so he doesn't get hung up in a corner. He can also draw in cartoon figures if he wants to.

Apart from perhaps a few forbidden words, throw good taste out the window and just let him loose. After all, that's the whole point of the project!

The letters in our alphabet are elegant and beautiful combinations of straight lines and curves. By playing with the letters and using them in art, your child's attention will be drawn to this beauty. Letters aren't just to struggle with and master; they are to appreciate and use.

Drawing Words to Use with Your Child

Continue to use the art words listed at the end of each chapter in Part One. Here are some additional words to use, depending upon the age of your child.

Drawing

 line, enclosed shape

 trace, overlap

 perspective, volume

 line quality

 calligraphy

 broken line

 connected line

Two dimensions (two-dimensional; 2D)

 length + width (a flat object such as paper or cardboard)

Three dimensions (three-dimensional; 3D)

length + width + depth (an object with volume
or bulk such as clay or wood)

Color

highlight, shadow

staining, "bleeding"

Cartooning, animation, pop art

Lettering, graffiti, doodle

Artists to Look at with Your Child

Continue to look at the artists mentioned in Part One.
Here are some additional artists to look at.

Book of Kells (wonderful lettering, mesmerizing)

Paul Cézanne (especially broken-line quality in draw-
ing)

Keith Haring (cartoonlike, graffiti-style painting)

Rico Lebrun (calligraphic line in drawing)

Roy Lichtenstein (big, cartoonlike, pop art painting)

Rembrandt van Rijn (beautiful drawings, calligraphic
line)

Illustrators

Mitsumasa Anno (*Anno's Alphabet*)

Chris van Allsburg (beautiful value drawings)

Bill Watterston ("Calvin and Hobbes" comic strip)

Taro Yashima (*Crow Boy:* broken line)

7

Painting for Children Age 6–10

The mother was preparing to mix some tempera for her six-year-old daughter's painting project. "What color would you like?" She asked her child. "Mauve," the daughter replied quietly, but with certainty.

Painting can be even more frustrating than drawing for this age group. Children this age are very concerned with detail in their art, and it's hard to show detail with a paint-laden, shaky brush.

Sometimes, therefore, they give up on using paint. For example, watch a nine-year-old paint a portrait. Often she gets tangled up in the eyelashes and hair before painting the basic shape of the head. A ten-year-old painting a tree may get similarly caught up in the branches, twigs, and individual leaves without noticing the real shape of the tree. These children are really trying to draw while they paint, treating the brush as if it were a clumsy marker. And they are often much more particular about wanting specific colors. You will probably need to refer to the Color Wheel more often for color-mixing instructions. (To get mauve, mix white with a little red, a little blue, and a tiny bit of brown.)

Watercolor brush

In the following projects I have tried to bypass this frustrating approach. When these projects use paint, it is because no other art material would work as well.

The projects use the same paints described in Chapter 2: Tempera Paint (page 26) and Watercolor (page 34). Here is a brief review of their special qualities:

Tempera Paint

You can buy powdered or mixed liquid tempera. Buy mixed tempera if you can—the colors are brighter. Buy two or more colors if you can and refer to the Color Wheel (see page 247) or the Appendix 1: List of Art Materials for color suggestions. If you buy powdered tempera, mix it first with a few drops of water to make a paste and then thin it.

Tempera paint is opaque. This means that you can't see through it, so it can be used on any color base.

If you add a few drops of liquid detergent to tempera, it will spread on a slick painting surface without "resisting" (beading up). If you add white vinyl glue to tempera, you make glue paint, which is shiny and more water-resistant when it dries.

Watercolor

You can buy a set of dry watercolors for your child to use. He might want more than eight colors, but don't buy a set with so many colors that they are too tiny to easily use. Splurge on a good brush or two. It's maddening to these children when a cheap brush sheds while they are painting. The painting can look like someone dragged a cat over it.

Watercolor paint is transparent. This means that you can see through it, so the paper must be white or else the color won't show up.

Monoprinting Activities

Monoprint means "one print." Some simple monoprinting activities are given in Chapter 2. These are still fun for older children to do, but your six- to ten-year-old is now ready for more advanced monoprinting, too. He will use *tempera* (not mixed with white vinyl glue) for these projects.

I suggest that he use a cookie sheet to paint on. If he wants to work bigger, he can paint on a big piece of plastic sheeting or oilcloth and lift the print. Your child can also try to do the following:

- vary paper size and shape
- paint with a tempera tint (color mixed with white) on dark construction paper
- try a tempera shade (color mixed with black) on light construction paper
- experiment, with different patterns and fingertip pressures when making the print

Hint: For all monoprinting activities, use less paint than you think you should. Too much paint goops up the image.

Here are four specific monoprinting activities your child could try.

MONOPRINTING WITH LEAVES (6+)

Your child selects several *green leaves* to use. Encourage him to choose different sizes and shapes.

Your child uses *tempera* paint with his fingers on the *cookie sheet* or *plastic*. For this project there shouldn't be much pattern to the paint surface.

Monoprinting using tempera paint and leaves

He then washes his hands and places the green leaves on the paint. The leaves create unpainted leaf spaces in the monoprint.

Your child presses the *paper* he has selected onto the paint. Thinner paper works best for this project. He rubs carefully around the leaves underneath. When he has finished rubbing, he lifts up the paper. That is his monoprint.

You should see little wavelike patterns on the pulled paint surface. These are a beautiful characteristic of this monoprinting process. (Check at this point to see if your child is using too much paint on the cookie sheet—that's the most common mistake.)

Your child could use the leaves for another monoprint or could press their painted surfaces onto another piece of paper. This is a *stamp-print.*

FINGER WRITING (8+)

In all printmaking we create a reversed image of what is being printed. A good way of pointing this out is with finger writing.

Your child finger-paints with *tempera* on the *cookie sheet* or *plastic.* Again, he makes an unpatterned paint surface; he wants his finger writing to show up.

Ask him to print his name with his *finger* in the paint. When he washes up and lifts his monoprint *paper,* his name will be backwards! He can hold it up to a mirror and see it the way he wrote it. Have a *small mirror* already at the work area so your child doesn't stalk through the house with a wet painting.

If he wants to make a monoprint that can be read easily, he has to write backwards in the paint; this is hard to do.

Finger writing monoprint with
tempera paint

He could practice his backwards writing on a piece of paper and hold *that* up to a mirror to see how the monoprint will look.

If he has too much trouble with reverse imagery, though, encourage him to stick with pictures or designs for the time being. He can wrestle with backwards letters or numbers later.

Cut-Out Shapes (7+; 9+)

This project is similar to Monoprinting with Leaves, but your child makes her own shapes for the monoprint. She can cut any shape out of *newspaper* or *newsprint.*

For a seven-year-old I would suggest any shape that isn't a letter or number. She finger-paints on the *cookie sheet* or *plastic* with *tempera,* washes up, and places the cut-out shape(s) on the paint. She presses the *paper* down and rubs it, then lifts it up. The cut-out shapes appear as unpainted spaces in the monoprint.

A nine-year-old might like to cut block letters out of newspaper or newsprint. (She doesn't have to cut out backwards letters for monoprinting, though; all she has to do is turn them over.)

Monoprinting using tempera paint and shapes cut out from newspaper

She paints on the cookie sheet or plastic, washes up, and places the turned-over letters or numbers onto the paint. Then she presses her paper down and lifts.

LAYERING COLORS (8+)

Of course your child will often mix two tempera colors together on her cookie sheet or plastic before printing. Please refer to the Color Wheel (see page 247) for colors that mix well together. But there is another way to use more than one color in this project and that is through multiprinting on one piece of paper.

The *tempera* colors won't mix in this art activity; they'll layer. *This project is valuable because it encourages experimentation, delays immediate gratification, and requires visualization.*

For this project encourage your child to concentrate just on color, pattern, and varied size of the paint surface. Skip the backwards writing and cut-out shapes for now.

She lifts a monoprint in one color, cleans up that color, then lifts another monoprint on the same *paper* but in a different color. (It might also be in a different shape to make it more interesting to look at.)

I know this seems like a lot of trouble, but it's worth the effort. If you want to get more monoprints for the trouble, approach it this way:

- Do three or four different monoprints for each color you use. Just refresh the paint between each monoprint. (This is a good time to experiment with different paper colors and fingertip pressures.)

- Then change paint colors and print each monoprint again. Each one is still a monoprint because each is different from the rest.

Your child can repeat this color-changing process until she runs out of paint or energy.

Oil Pastel Activities

Oil pastels are used for making drawings, but they can also be used for "painting." They aren't paints, but the colors can mix like paints.

Oil pastels come in sets of bright colors. Your child can do lots of projects with a small set of 12 colors. They aren't expensive, but your child will use them up quickly sometimes.

Oil pastels are fun to work with. They aren't like any other art material.

- They are much brighter than chalk.

- They don't smear as chalk does.

- They are cheaper than most paints.

- You can work with them anywhere, even outdoors or (carefully) in the car.

- There is almost no cleanup at all with oil pastels.

You'll need the following materials for the next four projects:

set of oil pastels

construction paper (dark and light colors)

ruler or straightedge

First, your child experiments with the oil pastels on a piece of dark construction paper. He makes some lines. Next he tries filling in a small area very solidly, pressing down hard on the oil pastel. He chooses a color he would like to mix with that solid color and applies it directly on top. (He may want to refer to the Color Wheel on page 247 for color-mixing ideas.)

With oil pastels your child mixes his colors right on the paper. He can do highlighting and shading this way, too. Highlighting and shading make a drawing or painting look as though it has volume—more solid and real. When he highlights and shades, he is working with different values. *In art, value means light and dark.*

When he highlights, he adds a lighter value where light hits the object he is drawing or painting. When he shades, he adds a darker value where the real object is darker.

Highlighting doesn't have to be done with a white oil pastel, although it can be. Your child can use another color, but should make sure it is a lighter value. It's the same with

Outline of an apple for oil pastel

shading. Shading doesn't have to be done with black. He can use another color but should make sure it's a darker value. He can also build up a highlight or shade with more than one color.

An easy way for him to check value in his colors, his painting, or the object he is painting is to squint his eyes. That way he can see the lights and darks without getting confused by the colors.

Here is an exercise your child can try if he wants to practice highlighting and shading.

APPLES (9+)

1. Your child selects an *apple* and washes it.

2. He draws the outline of the apple two times on a piece of construction paper, then fills in the outlines very solidly with whatever color the real apple is.

3. He looks at the real apple, then at the first drawn apple. Using a white oil pastel, he mixes in the highlights where the light hits the apple. Using a black oil pastel, he mixes in the shades.

4. He looks harder at the real apple. Does he see any other colors in the highlights and shades? Maybe he can imagine them. Now your child works on the second drawn apple. Taking a light-value oil pastel, he mixes in the highlights. (Maybe he needs more than one color.) Using a dark-value oil pastel, he mixes in the shades.

After he is sure he's done, he can eat the apple.

Now that your child has had some practice with oil pastels, he can probably think of lots of ways to use them. Here are three oil pastel projects your child could try.

IN THE DARK (6+)

This project will be done on *dark construction paper.* Ask your child to think of something that glows in the dark. She probably has many good ideas of her own, but if she needs a little inspiration, here are some ideas:

- outer space

- underwater

- Halloween

- Independence Day

- her backyard at night

- what she sees when she closes her eyes

Any of these ideas would look good on a dark background. Encourage her to try some color-mixing, highlighting, and shading as she works.

The next two oil pastel projects are nonobjective designs. (He will not draw a recognizable object or scene when he does these two projects.) He can use any color of construction paper.

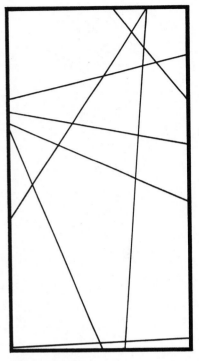

Crisscross lines

CRISSCROSS (9+)

1. He works with a piece of *newspaper* under the *construction paper.*

2. He gets a *ruler* or *long straightedge* and draws lots of *oil pastel* lines on the construction paper. They should intersect and go off all four sides of the paper. He uses as many colors as he wants.

3. He chooses some of the shapes he has made and fills them in with different colors of oil pastels. He can try color-mixing, highlighting, and shading.

THE BLOB (9+)

1. Your child works on *newspaper* for this project, too. He can use any color of *construction paper*—he knows what he likes by now!

2. In the center of his construction paper, he uses *oil pastel* to draw an enclosed "blob" shape. (This kind of shape is also called an "organic shape.") He attaches another blob to the first and keeps on attaching them

Connecting blobs

until they fill in the whole page. He tries to include one or two big blobs and some little ones, too. He uses lots of colors. His design looks a little like soap bubbles stuck together.

3. He now chooses some of the shapes he has made and fills them in with different colors of oil pastels. Again, he can try color-mixing, highlighting, and shading. He might also want to fill in some blobs with small-scale patterns. He might try polka dots, insects, stripes, small scales, or any pattern of his choice.

After he finishes either the Crisscross or The Blob, he might want to cut into the edges. He loses some of the design but ends up with an interesting shape. *Art doesn't always have to be a rectangle.*

Finally, your child cleans up his work area: Artists always take good care of their materials.

Watercolor Activities

Blobs filled in with small-scale patterns

Painting with watercolor is a very hard technique to learn. Why even try it at home, then?

For one thing, watercolors are so easy to buy. In fact they're the easiest paint to buy and store. Dry watercolors take up practically no space and last forever. (Adult artists can use watercolors in tubes rather than dry in pans, but I don't suggest this for children.)

In addition to these practical qualities, though, I think that watercolor has several attributes that make it valuable for art at home:

● *Watercolor is beautiful.* The colors are transparent, and we can "feel" the quality of the water itself when we look at a watercolor painting.

● *Watercolor is spontaneous.* It has a feeling of immediacy (which comes from the way we must work with it) that gives the painting a lot of energy.

● *Watercolor is personal.* We are alone with the colors— we can quickly mix them or use them as is. The watercolor is a direct color response, an individual notation.

Here is what your child needs to continue watercolor work:

a set of watercolors

a couple of good brushes (one should be very skinny for detail work)

saucers for mixing colors

white paper

clear water jar or can for rinsing

paint rags or paper towels

drawing board or piece of Masonite

A word about paper: You want your child to experiment freely with the watercolors, so start with cheap white paper. Blank computer paper or typing paper is fine. Later on, splurge on some artist's watercolor paper if you can. It is sold in pads or large sheets that you may wish to cut down. But when you buy a piece of expensive paper, don't let it intimidate you (or your child) or all will be lost! Just let your child use it and enjoy it.

Here are three watercolor activities your child can try.

WET-ON-WET: WASH (8+)

In this project your child either paints with related colors or with tints and shades of one color. (This is called a monochromatic color scheme. Monochromatic means one color.)

Here are some colors you could use for a related color scheme:

yellow + orange + red

green + blue + yellow

red + violet + blue

Here are some ideas for a monochromatic watercolor scheme:

red: add a little black to make a shade,

add water to red for a tint

blue: add a little black to make a shade,

add water to blue for a tint; etc.

Your child puts her white paper on a drawing board or piece of Masonite. She works at the table or on the floor. She begins by brushing clear water over the entire surface of the paper. Then she strokes the color on; it "feathers" out onto the damp paper.

Encourage her to use big, bold strokes (this is easier if she has a big, bold brush) and to work quickly. The colors mix together as she works.

For a little variety, she could draw on her paper with *clear paraffin* before initially wetting the paper. The watercolor "resists" the paraffin, and she is able to see the drawn design when she paints.

Your child could also wait for the wet-on-wet wash to dry and then glue on a black focal point. The focal point provides contrast. Black stands out vividly against the soft, blended colors, and the small cut shape stands out crisply against the swirling background. The black focal point really pulls this project together.

If she wants to try this, she can cut a design out of *black tissue, Fadeless art paper,* or *construction paper.* It could be anything: her initials, a snowflake, the silhouette of a butterfly. She then glues it onto the dry paint surface. She can use either thin *white vinyl glue* (she brushes it onto the back of the black paper because if she brushes it on the watercolor paper the paint colors will run) or else *you* can use *spray adhesive* on the back of the black paper. **Parents: Use this outside, and do not let your child use spray adhesive.**

Wet-on-Dry: Detail (8+)

This is really an overlap painting project, and it requires some patience and advance planning. It also requires an awareness of the one basic quality of watercolor: its transparency.

Your child will be disappointed with watercolor if he tries to paint a light color on top of a darker one. For example, if he paints a blue wash for the sky and then tries to paint a yellow sun on the blue sky, he gets a not-very-satisfactory green. Too often, as a result, children settle for a "mosaic" or puzzle-piece approach to watercolor and never learn to paint in beautiful layers.

What works with tempera paint (painting layers that can hide one another) doesn't work with watercolor. *What we really want to do is to learn to admire watercolor for what it can do rather than despise it for what it can't do.*

To layer watercolors, your child learns to work with the lightest colors first and work his way to the darkest colors. This wet-on-dry project uses the light-to-dark layering approach with watercolor.

Your child paints a watercolor using light- to medium-value colors. He works on white paper, as always. The colors can just make a swirl as they wash over the paper or he can paint something specific, but remind him to make it a "background" since he will paint the details later.

Encourage him to work on several paintings at once. With watercolor the ideal is spontaneity and vivid expression. Spontaneity can be hard work, as we all know! Take the pressure off any one painting by working on several— your child is old enough to do this now. His watercolor work will get looser. A feeling of spontaneity will thus have a better chance of popping up in a painting.

Value in art means light and dark. One way for your child to check comparative values is for him to squint his eyes as he looks at the colors. He will save the dark values for the next part of the project.

Your child lets the preliminary paintings thoroughly dry. (The painted surface should no longer feel wet or even cool before he proceeds.)

He then paints with watercolor on the dry painted

surface. He chooses any darker value(s) to use: dark does not always mean black. Some hues are naturally darker in value than others. He could also mix a shade of any color by adding black to it.

- *He could use a narrow brush.* It's a good contrast to the big strokes underneath. It's also easier to paint details with a narrow brush.

- *He might go off at least one of the sides of the paper.* This is a good time to stop floating little "island" pictures in the middle of the paper.

Your child could simply paint thick-thin intersecting lines across the paper; encourage him to turn the paper as he works. He could paint a ladder or a spiderweb if he wants it to look more "like" something.

He might want to try a tree, a forest, or a mountain range in darker values. Or he might prefer to paint a city at twilight.

Encourage your child to work in more than one darker value. And let him work in as much detail as he wants; when he paints wet-on-dry, the painted details stay crisp and distinct.

Using Tints in Watercolor Activities

When your child is painting with tempera, she mixes a tint by adding white to the color. But with watercolor she adds more water instead. So to mix up red watercolor she uses a little water, and to mix pink (a *tint* of red) she uses a little *more* water! She just thins the paint more.

One of the ways watercolor was commonly used in the past was as a tint with pen-and-ink drawings. Children often like the way these watercolored drawings look—it's the comforting "coloring in" approach, after all. But it's a difficult process to duplicate at home.

For one thing, your child can't use india ink. **India ink is not safe for children to use. (It also stains like crazy.)**

But when your child tries to paint with watercolor over a marker drawing she has done, the marker lines "bleed" into the paint. Here are two ways to get around this problem:

1. She can paint with the tints first, then finish with the *thin black marker* line drawing.

2. She can draw some pictures to tint later, *photocopy* them, then tint the photocopies. Your child can make her own book of paintings.

Encourage your child to make the tints really work in the painting. There should be a reason for using tints rather than stronger, brighter colors.

Additional Painting Activities

ACTION PAINTING (8+)

"Action painting" is a term used to describe the work of the abstract expressionists of the 1950s. It's a good, failure-proof approach for your child to try at home. It's especially valuable at this time when he might be getting too caught up in (and frustrated by) detail. Action painting is never prissy! Encourage him to give it a try.

Your child could use an active, splatter-paint approach for many two- or three-dimensional projects. Since the paint layers will build up quickly, it's necessary to have a sturdy base on which to paint. The following project uses squares of *corrugated board* as a base.

Your child could work on any size board, but I like the idea of working in multiples at this age. Squares are beautiful, easy to cut, and fit together perfectly. Cut several squares the same size (about 6″ by 6″, for example) and have your child paint them with *black glue paint.* (Glue paint is made by mixing tempera with white vinyl glue.) Parents: Cut the corrugated board with a utility knife; **do not let your child use the knife.**

After the black glue paint has dried, your child can start his action painting. Help him mix some *colors of thick glue paint.* He will be able to use the black glue paint again.

This is a good project for him to do outside. Put some *newspaper* in a *big cardboard box,* and put the painted squares on the newspaper. Your child reaches inside the box (bare armed!) with a paint-laden *brush* or *stick,* and flicks the glue paint onto the squares.

He can splatter on additional colors without waiting for

the previous ones to dry. He could try using black again toward the end of the painting session, which will unite the built-up painting surface with the base. It adds a little mystery, too.

The squares will probably be stuck to the newspaper by the glue paint. You can lift them onto clean newspaper before the glue paint dries or just let them dry, and then cut the boards away from the paper.

The glue paint is glossy and bumpy when it dries. (Your child might want to do some crayon rubbings on the painted surfaces. See Chapter 1, Crayon Rubbings, for details.)

Your child can play with the squares, arranging them into a pleasing pattern if he wishes. He could then mount them on a slightly larger piece of corrugated board pre-painted with a solid color of glue paint. He will either use *thick white vinyl glue* as an adhesive (give it a full day to dry) or ask you to glue the squares down with the *hot-glue gun.* **Do not let your child use the hot-glue gun.**

Your child could also do this project with *plain mixed tempera.* Don't thin it too much—you might want to mix the powder with liquid starch for a little extra gloss.

If you decide to use glue paint, though, be sure to clean your brushes right away. Otherwise the glue will dry on the bristles and the brush will be ruined.

Stamp-Printing

Fruit and Vegetable Prints (see page 31) are still fun for ages six to ten to do, but older children will probably plan a more complex pattern. Encourage them to overlap the stamped images. Your child can use tempera paint on a home-made stamp pad when printing. This yields a clearer, more consistent image than just dunking the potato in the tempera.

How to make a simple stamp pad:

1. Get an old *washcloth* or other absorbent fabric scrap. (You may also use paper towels.)

2. Rinse the washcloth with *water* and wring it out thoroughly.

Stamp-printing with orange and carrot

3. Spread it on a *cookie sheet* and brush on the *thick tempera* (not glue paint). You may "swirl" two colors together on the washcloth; related colors work best. Related colors are next to each other on the color wheel.

POTATO PRINTS (6+)

This is a little harder version of plain fruit or vegetable printing. Rather than simply printing the natural shape as is, your child alters its surface. Slice the *potato* in half for your child. *Make it a very straight slice!* She either cuts into the exposed flat surface to create an etched design or cuts around part of the exposed flat surface to create a raised design. You may need to help her with either approach. The raised design seems to be the easiest to visualize but the hardest to cut.

Here are a few hints:

● She should keep it simple! Your child could just scoop a circle out of the middle of the potato, for example. Or she could cut out intersecting notched lines or a "happy face" with a plastic knife.

● She could cut a square or triangle in the center of the flat potato surface and then cut away the surrounding area, leaving the raised shape. It's easier to cut straight lines than curves. (She needs to cut away only about ⅓″ for the potato to print well.)

● She blots the starch from the exposed potato surface before printing.

● If your child wants to carve a different image, she can usually do it on the same potato half: just slice off the old surface for her.

When she starts printing, remind her to stamp the potato on the *tempera stamp pad* between prints: stamp, print, stamp, print. (That's why it's called a stamp-print!) These natural prints can make pretty designs to hang in the kitchen. She can try printing the same image in various colors or printing with black or white tempera on a vivid

Stamp-printing with potato

Fingerprint animals made with
tempera paint and felt-tip
marker

color of *construction paper*. If your older child gets frustrated with an incomplete stamped image, she can try pressing thinner paper against the potato rather than stamping the potato on the paper.

Fingerprints (7+)

This is fun for your child to do when he has a friend over. It really is a combination stamp-printing and cartooning project!

Make a very *small stamp pad* for your child to use. Or you could make several and offer a variety of colors. Brush *tempera* onto the pads. **Do not use office-style inked stamp pads for this project. Your child shouldn't get that type of ink on his fingers.**

Your child makes some simple fingerprints on small pieces of *paper* (vary sizes and colors of paper). Then he washes his hands and waits for the paint to dry.

Next, your child draws with *skinny markers* on and around each print. He turns the fingerprints into cartoons. Remember that markers are transparent, so if he draws on a fingerprint, the marker color has to be darker than the paint color for it to show up.

He could make greeting cards, postcards, or animated flip books (see page 130) with these fingerprints. And grandparents will love them!

Patterned Tissue (8+)

This is a project you will probably want to do *with* your child, both because it's a little tricky and because it's so much fun. It would be a good project to try a few weeks before Christmas (it has gift-making potential) or before a party (invitation potential).

Here are the materials your child needs:

Newspaper or paper towels for blotting

food colors (you may thin them with water to make tints such as pink or light blue)

shallow bowls or saucers for mixing

marker for labeling bowls

assorted colors of tissue paper (you must use nonwaxy, high-quality tissue papers for this project)

You may also use *bleach* for part of this project but only with great caution. **Parents: do not let your child use bleach without close supervision.** Use it outside, and don't get it on your fingers or clothes.

First, your child puts newspaper on the table, and either changes into old clothes or wears an apron as she works (food colors stain). Then, you pour small amounts of food color into shallow bowls or saucers—not too much, though. You don't want the food color to be too deep. Use a marker to label the newspaper in front of each bowl—sometimes it's hard to tell which color is which.

If your child wants lighter colors (tints), add water to the food color. If she wants a *very* light tint, start with the water and squeeze in just a few drops of food color. Label these too—just print right on the newspaper.

Next, it's time to fold the tissue. You and your child dip the folded tissue into the food colors to make the patterned paper. I suggest starting with small pieces of tissue. Cut the 12″ by 18″ tissue pieces in half. It is much easier to handle a piece 9″ by 12″.

Fold the pieces crisply. Your child can fold squares, rectangles, or triangles, experimenting with the folding patterns. If she would like to make bookmarks or notecards later, she could fold the tissue into a small shape; that way the pattern shows up better on the finished project.

Now comes the dipping. Here are a few hints:

- *Tissue is very absorbent, so your child won't hold it in the food color for long.* Pay attention or the tissue will soak up too much color.

- If she is using tints and full-strength colors, she should use the tints first (they show up best on white tissue). This is another way of working light-to-dark with transparent colors (see Chapter 7, Watercolor).

- If she dips the folded corners, her unfolded pattern will look like a circle or a star. If she dips the straight sides, her unfolded pattern will be a stripe. Keep just a very little color in the bowl or saucer to control how big the circle or stripe can get.

● *Parents: If you decide to use bleach, do that dipping first, and do it outside.* Quickly dip and then blot the folded tissue. Bleach removes color from most tissues and turns the dipped part white. Your child can then add different colors to the bleached parts. This preliminary bleach dip works especially well with *most* darker or vivid colors of tissue. Since food color is transparent, most colors won't show up well on dark or vivid tissue without some bleaching first.

Your child blots her folded tissue in between dips. When she finishes with a folded shape, she should give it a good final blot and let it dry a bit before she unfolds it. (Wet or big pieces of tissue rip more easily when they are being unfolded.) *You probably need to help your child unfold the tissue.*

The unfolding part of this project can be a thrill! The patterned tissue is beautiful. Try to allow enough time for you both to look at what you have made and to remember how you did it. Then try to do it again, even better!

Your child can try patterning some full-size (12″ by 18″) tissue sheets now. Just remember to be extra careful when unfolding the partially dried folded shapes. If part of the tissue rips, save it anyway; she can use the rest.

Here are a few ways of using the patterned tissue:

● She can tape it up in a window. The light looks beautiful shining through it.

● She can use it over a piece of plain tissue to wrap a small gift.

● She can use it in collage work.

● She can add a few drops of *liquid detergent* to thin *white vinyl glue.* She brushes the glue onto *aluminum foil,* then places the tissue on the glued foil surface.

 When the glue dries, she trims away the extra foil. The patterned paper looks metallic and can be used to wrap a small gift or to cover a notebook.

● She can brush *thin white vinyl glue* onto *white lightweight poster board.* She places the tissue on the glued surface. (Your child can glue down a middle layer of *aluminum foil* if she wants the tissue to look metallic.)

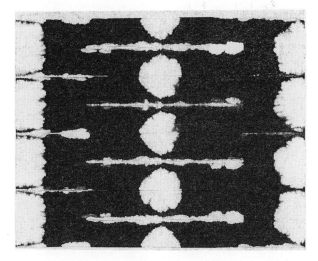

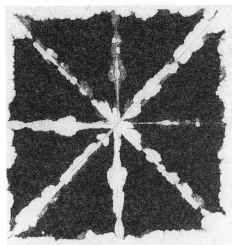

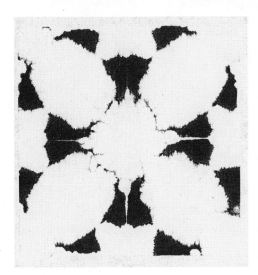

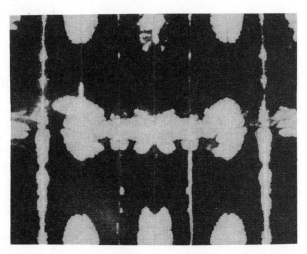

Patterned tissue is beautiful and has a wide variety of uses.

When the glue dries, she can cut the poster board into book markers. She can draw on the back of each one with *marker* or *colored pencil* if she wishes.

- She can fold *white paper* into small greeting cards, or cut postcards out of *white lightweight poster board.* Then she cuts smaller pieces of the patterned tissue.

 Parents: Spray the backs of the patterned tissue pieces with *spray adhesive.* Do this outside. **Do not let your children use spray adhesive.** Place the sprayed tissue pieces onto the greeting cards or postcards.

If you make this special project a full morning's activity, your child will create enough patterned tissue for many projects.

Painting Words to Use with Your Child

Paint

tempera = opaque

watercolor = transparent

tint, shade

highlight, shade

wash, "feather"

Color

related colors

monochromatic

value = light and dark

Shape

organic shape

angular shape

Composition

pattern

scale

overlap

Printmaking

monoprint, stamp-print

reversed image

raised surface, etched surface

Artists to Look at with Your Child

Helen Frankenthaler

John Stuart Ingle (watercolors)

Jackson Pollock (big splattered action paintings)

Henri Rousseau (dreamlike fantasy paintings)

Georges Seurat (painting with dots)

Illustrators

Mitsumasa Anno

John S. Goodall

N. C. Wyeth

8

Collage for Children Age 6–10

Collage (an art project that is held together by glue) is fun for all ages. Your six- to ten-year old will enjoy continuing her collage explorations. She will work longer on each piece and will focus on what she is doing. Seemingly random selection and gluing of collage materials will no longer occur, and the "collage sandwich" approach will just be a memory.

Collage work actually can come out looking close to the way your child hoped it would, unlike some of her drawing and painting projects. The two things that can still trip up a child are choosing the right base and the right adhesive to begin with. Please refer to pages 37–40 for specific base and adhesive suggestions.

When we use the word *painting,* most people understand that it's a big word, that there are different kinds of painting: oil painting, acrylic, watercolor. It's like that with the word *collage* too. Here are some kinds of collage your child will want to try:

- **Montage:** This is collage using magazine or newspaper pictures. Lettering is good to use, too, either as design or message.

Evan completes an assemblage
project.

- **Appliqué:** This collage work uses fabric as a base or
 collage material. It can be glued rather than sewn. Your
 child can try combining fabric with paper in collage,
 using white vinyl glue.

- **Assemblage:** This is three-dimensional collage. Some-
 times it is also called "junk sculpture."

In addition, of course, there are many already familiar
two-dimensional collages your child will enjoy doing and
doing again.

These project words are French, and here's how to pronounce them:

collage: co-*lahj*

montage: mon-*tahj*

appliqué: a-pleek-*ay*

assemblage: ah-sem-*blahj*

(or just use the English

pronunciation a-*sem*-blidge)

The projects in this chapter are all two-dimensional. The first is a tissue collage.

Collage Activities

Tissue Collage (6+)

Sometimes art hangs on the wall. This project hangs in the window and can look almost like a stained-glass window. It is a project that uses repeated overlapping tissue shapes in a related or monochromatic color scheme.

The base for this project is *waxed paper*. Cover the work surface with *newspaper*, and then tear off a long strip of waxed paper (about 24" or longer). Your child can cut it down or change its shape later on.

Fold it in half, then unfold it. Your child does his collage work on one half, then folds the other half over to finish the project. *This is much easier than wrestling with two separate pieces of waxed paper.*

The adhesive for this project is *thin white vinyl glue.* (White vinyl glue dries clear.) You can thin it with water until it is about as thin as milk. Have your child brush a little thin glue onto a scrap of waxed paper. See how it beads up? Now have him add just a few drops of *liquid detergent* and try again. It spreads!

Your child first decides on the simple shape he would like in his collage. He could either cut a pattern out of *lightweight poster board,* or he could just do freehand cutting into the folded tissue. Folding makes the tissue easier to cut and automatically ensures that the shape is repeated.

Cassandra cuts tissue shapes
for her tissue collage.

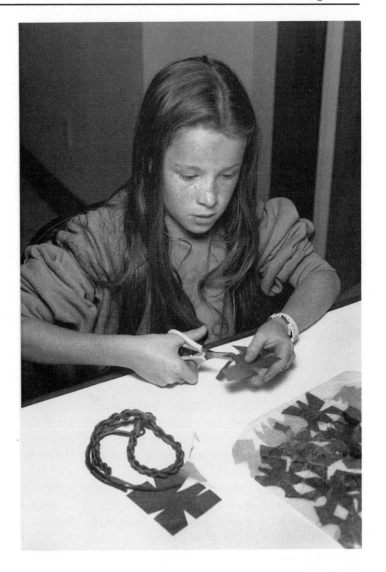

He should then select some related colors of *tissue
paper* for his collage. Here are some possibilities:

red + red-violet + violet

brown + rust + orange

green + yellow-green + yellow

blue + blue-green + green

Please refer to the Color Wheel (see page 247) for more ideas.

White tissue doesn't work well for this project. You can use black tissue, but it can overpower this collage. Encourage your child to select medium-value colors. When your child overlaps even the same color of tissue, though, he'll notice that he has created a shade of that color, without using black.

Tissue usually comes in 12" by 18" sheets. Cut some in half (to 9" by 12") before folding them. Put two or three small pieces of tissue together and fold them for your child. The folded tissue might be about 3" by 4" when you're done, but you could fold it into a square or a skinnier rectangle.

If your child has cut out a poster board pattern, he will trace around it onto the top layer of folded tissue. He will then cut out the shape and *throw away the top shape before gluing.*

Or your child could just start cutting into the folded tissue without a pattern. Any repeated shape, even a roughly cut improvisation, can look strong in collage.

Your six-year-old may need some help with his cutting; sometimes the tissue slips as he cuts or there may be too many tissue layers for him to cut them easily.

Sometimes it's fun for him to take a *single-hole punch* and punch out holes (or "eyes") in the tissue shapes.

When it's time to glue, your child brushes the thin white vinyl glue onto half the length of the waxed paper (either side of the folded crease). Have him work with a *big brush* and generously cover the whole area.

He then carefully places the tissue shapes one at a time on the glued waxed paper. Encourage him to overlap them, to use them reversed and even upside down, and to let some go off the three exposed edges. He can trim them off later.

Don't worry about whether the tissue is "really sticking" or not, and discourage him from brushing the glue onto the tissue pieces, which tear easily when they're wet. Also, the dye in the tissue will get on the brush.

Expect some of the dye to "bleed" a little into the glue on the waxed paper. Wrinkles in the tissue are fine. In fact, they look good on the finished project.

* * *

When he has used all the shapes he wants to (don't make him use them all if he doesn't want to), it's time to "glue the top on." First, he washes out the glue brush if any tissue dye has gotten on it. Your child then quickly brushes some glue onto the rest of the plain waxed paper and folds that glued surface onto his collage. *Again, make sure that he doesn't brush the glue directly onto the tissue surface.*

Expect the glue to look cloudy; it will dry clear. Expect the collage to look a little ragged; your child will trim it when the glue has dried.

Place the collage on a clean piece of newspaper and let it dry. Your child should wash out the glue brush right away. You'll probably need to throw out the watered-down glue, which usually has some dye in it at this point.

Next day, when the glue has dried, your child's tissue collage will be very stiff. Hold it up to the light; the overlapping tissue pieces create new colors and shapes.

Your child will probably want to trim the ragged edges of the collage. He could leave the finished shape a square or rectangle, or he could cut the collage into smaller pieces.

- If he leaves it as a square or rectangle, he can tape it onto his window as is or he can finish the collage with a construction paper "frame."

- He could cut the collage into strips, punch a hole at the top of each strip, and use them in a weaving or sculpture.

- He could make bookmarks from the strips.

- He could cut the collage into ornament shapes and hang them on the Christmas tree.

All of these items are described in more detail in the following pages.

If he cuts the collage into smaller pieces, he may "lose" the original tissue shape, but he will still have beautiful color and newly created, nonobjective shapes. Cutting the original collage down is an especially good thing to do if he is disappointed in the way his collage looks. But he should wait

for it to dry before deciding—he may hate it when it's cloudy, and love it the next day! *This feeling of improvisation may well be the most important thing your child gains from this or any other project.*

Framing for window hanging:

Your child can select any color of *construction paper* for this. Black looks especially good with most colors, and accentuates the stained-glass "feel" of the project.

Traditionally this collage is "framed" only at its top and bottom, like a hanging scroll. This slight added weight lets the collage hang without buckling. So first, your child must decide where the top is! (It may not be where it was when he was working on it.)

Next he decides how wide the construction paper "frame" will be. This is important: a too-skinny band on a big collage looks skimpy, and a wide band can overpower a small collage.

Now he cuts two pieces of construction paper—one for the top and one for the bottom. Each is folded in half. If your child's collage is 12" wide and 18" long, for example, he may choose to hang it vertically. So the only dimension he would have to look at for the framing is the 12" width. He prepares a 12"-plus *construction paper* band for the top and the bottom. If he wants each one to be 2" wide, he cuts two pieces 4" × 12"-plus (allow a little extra) and then folds each to 2" × 12"-plus.

He could even cut designs into the 12" lengths, but he won't cut along the fold. *His cut border can repeat or reinforce something in the original collage.*

- If he has tissue snowflakes in his collage, he might cut black icicles into the top and/or bottom bands.

- If he has fish in the collage, he might cut waves into the bands.

- If he has cut freehand tissue blob shapes, he might cut similar curves into the folded bands.

The folded construction paper bands can be stapled or glued onto the collage. But before your child attaches them, he should think about how he will hang the collage. I suggest

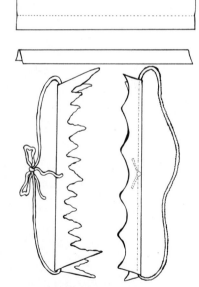

To frame a tissue collage for window hanging, fold construction paper lengthwise (top), then fix yarn for hanging (bottom) before gluing or stapling.

Evan displays his tissue collage
framed in black construction
paper and ready for hanging in
a window.

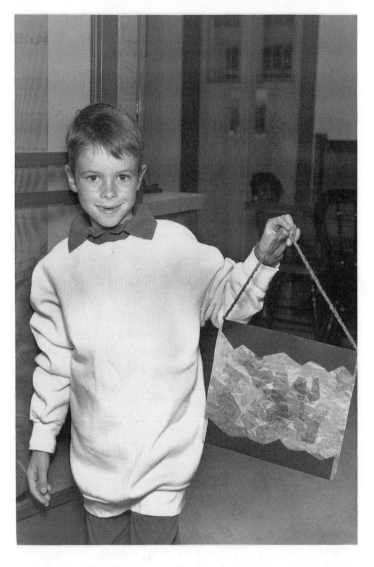

cutting a piece of *yarn or string* more than twice the length
of the top, knotting it, and slipping the loop into the folded
top band before stapling or gluing. He can hide the knot
under the band. *If his tissue collage is very wide, say over 16",
this won't work well because the hanging collage will buckle.
He will prepare a larger collage for hanging by punching two
holes about 10" apart after the frame has been attached.*

Staple the folded bands to the top and bottom of the
collage. (Don't forget the yarn loop!) **Parents: You decide
when your child is ready to use the stapler.**

If he doesn't like the look of staples, he can glue down the bands. He uses *thick white vinyl glue* for this. It looks neat and adds a little extra weight to the top and bottom of the collage. He can just glue the yarn loop (with the knot hidden) right inside the fold.

He should let the glue dry if he is waiting to add the yarn hanger. After it has dried, your child can punch two neat holes about 10" (or less) apart. He can thread yarn through the holes, then knot the ends of the yarn or tie them in a bow.

Another easy way to hang this collage is to poke a *pipe cleaner* (or part of one) through each hole and twist it into a ring. He can hang the collage from the rings.

FLUTTER STRIPS (6+)

Your child can cut the dry collage into long skinny shapes. They don't have to be rectangles—they could be snakes, lightning bolts, or anything. He could work the strips into a weaving or hang them from a weaving or sculpture. The glued paper is very sturdy and can be used in numerous ways.

Your child can punch a hole in each strip with a *single-hole punch.* If the hole is near the end of the strip, make sure it is at least ⅓" from the end to prevent tearing.

Your child can loop a *rubber band, yarn piece,* or *pipe cleaner* through the hole. Let *him* figure out what to do with them after that. Whatever he chooses to use them for, they'll flutter!

BOOKMARKS (6+)

I seem always to be suggesting that children this age make bookmarks. Children are often looking for useful, inexpensive gifts to give to relatives. These might be hard to part with, though.

Your child could cut the collage into skinny rectangles or any other shapes—making "book worms" is always popular. He could glue on a *construction paper* eye, tongue, or hat. He could fringe the bottom of the bookmark. *Don't let him fret over "losing" the original tissue shape.* Point out the striking colors and nonobjective design in the new project.

Flutter strips can be hung with yarn, rubber bands, string, or pipe cleaners.

Tissue collage can be cut to make bookmarks. Add plastic eyes or yarn tassels.

Tissue collage can be turned
into Christmas tree ornaments.

ORNAMENTS (8+)

The glued paper in this project has become translucent, which means that light can shine through it. So one place other than windows that the collage paper is suited for is . . . the Christmas tree!

Your child can decide on two or three simple ornament shapes. Help him draw the ornament shapes on *lightweight poster board* in the sizes he wants. Sketch in a little tab at the top of each ornament shape—that's what the ornament will hang from.

Next, your child cuts out the poster board patterns. *Hint: have him cut the poster board into smaller pieces before cutting out the individual ornament shapes.*

He now puts the patterns on the tissue collage and traces around them with a *skinny marker.* Then he cuts out the ornaments. He may want to make more than one ornament from a pattern.

Next, he takes a *damp paper towel* and wipes the faint marker lines from the waxed paper ornaments, wiping away from the center.

Then your child can decorate the top tab of the ornament. *Construction paper* (especially black) or *aluminum foil* is good for this. The ornament then looks more "finished" and it will also be a little stronger as it hangs. He folds a little piece of paper or foil and glues it to the tab with the fold at the top. He uses *thick white vinyl glue* for this. When the glue dries, he trims the extra paper or foil from the tab. He punches a hole with a *single-hole punch* near the top of the tab. *Don't let him punch the hole too close to the edge; he should leave about* ⅓".

He can hang the ornaments with an unfolded *paper clip.* **Do not hang any paper ornament too close to a light.**

These ornaments also look pretty tied to a wreath or hung from a piece of yarn strung across the top of a doorway.

Here are a few theme variations:

- fall leaves (red and brown tissue)
- Valentine hearts (pink and lavender tissue)
- Easter eggs
- butterflies

To make these ornaments, your child varies the tissue colors used in the original collage and the simple shapes used for the patterns. They all make good year-around window, wreath, or doorway ornaments.

Montage Activities

Magazines are an excellent resource for collage work. It's strange that we don't think of this more often—here we have excellent full-color photographs on good paper all ready to use and we toss out the magazine! Start to look at your magazines as collage material, and don't be distracted by the text. Keep the picture of the baby and throw out the words about disposable diapers.

Or keep the words, if they're funny or if the lettering is especially beautiful. Children (especially over eight) can use print as design; in fact, an entire collage could be done wholly with printed letters. And there might not be a readable word in the entire composition!

Variations for tissue collage ornaments

Children should already be in the habit of asking before they cut anything out of a magazine. But try to say yes. What are you saving it for? Is it really more important than art?

It's easier for your child if you tear out the whole page for her. Then she can easily cut around her selected picture.

Look for old magazines at yard sales and library sales. She can start filling a shoe box with favorite pictures for later use.

SIMPLE MONTAGE (6+)

The base for this collage is a (washed) *Styrofoam meat tray*. These come in different sizes, and the rim provides a ready-made frame. Your child could use it as is or change its color in one of two ways:

1. She could cut a piece of *construction paper* to fit inside the tray. It is a good idea to choose a vivid or dark color so that the magazine picture shows up. She uses *thick white vinyl glue* when she glues down the construction paper.

Styrofoam meat tray provides a ready-made frame for this construction-paper repeat drawing.

2. She could paint the entire inside of the tray with *thick glue paint.* Again, it is a good idea to choose a vivid or dark color. Mix a few drops of *liquid detergent* into the glue paint if the paint "resists" against the Styrofoam.

It would be smart to paint several trays at once. She could use different colors of glue paint, even on the same tray. This really becomes a separate painting project, which is fine, since she has to wait for the glue paint to dry before proceeding anyway.

When the glue paint has dried, it's time for her to glue down the selected picture.

● She could leave the *magazine picture* as a square or rectangle, but it should be a little smaller than the flat center of the meat tray.

● She could cut around the magazine pictures. She'll be able to do more detailed cutting as she gets older.

If she outline-cuts a picture and is left with a straight edge (where the picture was cropped), she can align the straight edge with the bottom of her "frame." There's something distressing about sliced-off images floating in a composition, and the straight edge can be a real distraction.

● She could overlap two (or more) pictures. This is especially effective with outline-cut pictures.

Your child can use drawn or painted *magazine illustrations* as well as photographed pictures. She can combine magazine pictures, *newspaper photographs, or lettering,* and *greeting card illustrations* as she works.

Display:

Your child can poke two holes inside the rim at the top of the Styrofoam tray, using a *yarn needle.* She then pushes a *pipe cleaner* through the holes and twists it into a ring.

If your child wants to hang her montage on the refrigerator, she could cut two 2″ pieces of *magnetic tape* and glue them to the back of her montage with *thick white vinyl glue.*

MONTAGE (8+)

Your child is probably ready to work bigger now. Here are several things she could use as a base for a bigger, more ambitious montage:

- *Lightweight poster board:* This is the easiest and cheapest base to buy. The glue might cause it to warp somewhat, though.

- *Heavyweight poster board:* This works well and comes in various colors. You might have a scrap of this left over from other projects.

- *Corrugated board:* This is so thick that it won't warp, but your child will probably want to paint it first. She uses *glue paint* for this—mix tempera with white vinyl glue. There are slight ridges in the surface of corrugated board but they probably won't bother your child.

- *Foam board:* This is a wonderful base for many collages. It is lightweight, won't warp, and provides a smooth surface to work on. It is available at many art supply stores.

If you think your child wants to frame her finished montage, be sure to start out working in a standard frame size such as 9" by 12", 12" by 16", 18" by 24", etc.

But these projects don't need to be framed to look good. If you don't frame the montage, your child can work on a more unusual base.

- She could work on a long, skinny 10" by 24" rectangle.

- She could cut a large circle out of lightweight poster board and use it as a base. (It's hard to cut curves on a thicker base, though.)

- She could work on a triangular, pennant-shaped base.

The most common approach to this project is for the child to take a few favorite pictures and scatter them around the poster board. That's fine, and that's the way your child might want to start out. But there's not a lot of art in that approach—it's more of a big one-page scrapbook. Encourage her to cluster and overlap some pictures.

Your child might choose a theme. It could be anything: sports, animals, food, cars, people, etc.

But it's unnecessary to have such a specific theme. It could just be "Favorite Things" or "How Gross." But your child will probably have to hunt through magazines for enough pictures for her montage anyway; the hunt is a little more interesting if she is searching for a particular category of picture.

- But if your child has too precise an image in mind during her hunt, she'll never find it. "Birds" is an easy category, but "robins" is an impossible one. Help her keep this project failure-proof.

- Encourage your child to cut out a few very large pictures. This will make the work go faster and make the montage more interesting to look at.

- Allow enough time for her to carefully outline-cut at least a few of the pictures.

- If she works on a smaller base, there is more of a chance for her to overlap some pictures. She also has to deal with the size and shape of the base as part of the composition.

I suggest that your child work from the center of the poster board out to the edges. She puts a picture face down on newspaper and brushes *medium-thin white vinyl glue* or *paste* onto the back of the picture. She should try to brush the glue all the way out to the edges of each picture so that it doesn't curl off the base.

It is a good idea to begin with one or two of the biggest pictures. Smaller pictures can overlap the edges of the bigger ones.

If your child is using lots of square or rectangular pictures, she might want to tilt them as she glues them down. They certainly don't have to look as though they are hanging on a wall! The pictures are design elements in a bigger composition.

When your child has finished gluing, she might want to draw on or around the pictures with *markers,* or she might decide that she would like the entire montage surface to look glossy. A layer of *thin white vinyl glue* dries shiny and clear.

- She uses a big brush and big strokes to apply this "glaze."

- She doesn't do this over markers because the glue makes them "bleed." (Or she could try brushing the glue over marker lines on a piece of scrap paper and see how it looks. She might like it!)

- If she does this final glue wash on lightweight poster board, it warps even more. The wash works best on thicker bases.

FLIP-FLOP DESIGN (9+)

There are some beautiful papers for collage work available in many art stores. Some of them you can purchase by the piece. One colorful paper that is excellent to use in many projects is Fadeless art paper, which comes in packages of assorted brilliant colors. It is the same size as large construction paper (12″ by 18″), but the colors are much brighter. It's only a little more expensive.

Fadeless art paper is thinner than construction paper, so it's not a very good base for collage projects. But it's good to use as a collage material, especially in torn-paper collages: the Fadeless art paper colors are screened onto white paper, so there is an exciting white edge when the paper is torn.

Fadeless art paper is good for this project—your child could use *construction paper* instead, if necessary.

This is a collage project in which the colors don't mix (as they do with tissue collage), so your child could select any two colors.

He could choose related colors again, but he might prefer the excitement of a complementary or split-complementary color scheme. Here are a few ideas; please refer to the Color Wheel (see page 247) for others.

Some complementary colors:

red + green

blue + orange

yellow + violet

red-orange + blue-green

Complementary colors are opposite each other on the Color Wheel. Each color on the wheel has one complementary color.

Some split-complementary colors:

yellow + blue-violet

green + red-orange

orange + blue-green

red + yellow-green

Split-complementary colors are on either side of a color's complement. Each color on the wheel has two split-complementary colors.

Let the Color Wheel be a tool, not a tyrant. Your child can choose any two colors. He might select black + gold, pink + turquoise, or red + white. One color could be Fadeless art paper and the base could be lightweight poster board. (Poster board comes in different colors.)

Next it's time for some experimenting. This is a fold-and-cut project; your child cuts an enclosed shape from a folded piece of paper. When he unfolds the two pieces, he has two symmetrical shapes. (Symmetrical means that a shape is the same on both sides—along a vertical axis—in a composition. The opposite of symmetry is asymmetry.)

Encourage your child to practice by folding a 9″ by 12″ piece of newsprint in half, either way. He then cuts, freehand, any enclosed shape from the fold. An enclosed shape does not cut through the top or bottom of the fold. *When he unfolds the paper, the enclosed shape should look like an island and the surrounding shape (with a hole in it) should be in one piece.*

Once he understands that, he can start making his shape more interesting. Encourage him to keep it nonobjective for now—it's easier. He'll have better luck with a wiggly blob shape or a spiked angular shape than he will with a teddy bear or a house shape.

To create a flip-flop design: fold paper (top); trace around enclosed shape (top-center); cut out shape (bottom-center); cut folded shapes in half and place positive against negative (bottom).

* * *

Now he can work smaller and with color. He selects a paper color, cuts it into a smaller size (say 5″ by 8″), and folds that in half. He cuts out an enclosed shape. (If he insists on drawing the shape against the fold before he cuts, fold the paper with the inside out so the drawn lines won't show.)

The enclosed shape that he has cut out is the positive shape, and the hole in the paper is the negative shape.

He cuts each piece of paper along the fold; this gives him four pieces to work with. Next he matches a positive half against a negative half to make his design. He has enough pieces to make two designs. Your child uses every scrap of both pieces for his Flip-Flop Design.

These designs can be done in any size. Big ones make bold collages, and small ones can be used to make postcards and invitations.

- If he is using big shapes in collage, make sure the base is strong enough. *Lightweight poster board* is a good base.

- Sometimes we cut out a wonderful shape and then can't repeat it. If this happens, have him take half of the negative shape (or use the folded negative piece) and repeat the shape by tracing against the cut line on another folded paper. Your child could even make a *lightweight poster board pattern* of the half shape.

 Remember that repetition can be a very strong design element. Your child can repeat the Flip-Flop Design on the same base, or do the same design in different colors.

Your child uses the second color he has chosen as the base. He cuts his base the same size or slightly larger than his original piece of paper.

He uses *medium-thin white vinyl glue* or *paste* as the adhesive. He puts his cutouts face down on a paper towel or piece of newspaper and brushes the glue out to the edges (no dabbing). He then puts the negative piece onto the base first, which ensures that he places it correctly. Then he lines up the positive half against the negative half.

If your child becomes frustrated with the way the glued pieces look, you can offer to use the *spray adhesive* instead

The hole in the paper (top) is the negative shape; the cut-out piece (bottom) is the positive shape.

Each enclosed shape will make two flip-flop designs.

Flip-flop designs can be used as notecards (top); postcards (center); or gift tags (bottom).

of the glue. This can be an especially important offer if his enclosed shape is so detailed that it's difficult to glue down or if he wants the glued pieces to lie absolutely flat without wrinkling.

If you decide to use the spray adhesive, take the cut pieces outside, leaving the base inside. Put the cut pieces face down on a clean sheet of newspaper and spray them lightly. Take them inside, and your child can place them on the base. **Do not let your child use spray adhesive.**

Here are a few things he could make using the Flip-Flop Design approach:

- He could make a big, going-off-the-edges collage of one shape, using different colors. The base can be *poster board* or *foam board.*

- He could glue his Flip-Flop Design onto folded *construction paper* to make a greeting card or invitation.

- He could glue his design onto *lightweight poster board* and send it as a postcard. If he makes several, he could tie them together with *yarn* and give the set as a gift.

- He could glue small designs on *construction paper* or *lightweight poster board* to make gift tags.

Collage is a laboratory of experimentation and improvisation. The only rules are that the base must support the collage, and the adhesive must support the materials used. Beyond that, encourage your child to be an explorer when he works in collage—an explorer of the ordinary but beautiful things around us. Fabric, magazines, paper, leaves, "trash"—collage lets us see these things with new eyes. They can become art.

Sample shapes for flip-flop designs

Collage Words to Use with Your Child

Collage

> montage

> appliqué

> assemblage, assemble, construct

Adhesive, glue, paste

Paint

> glaze

Color

> related colors

> monochromatic

> complementary colors

Composition

> pattern, repetition

> symmetry, asymmetry

> positive, negative

> overlap

Collage Artists to Look at with Your Child

Joseph Cornell (magical boxes)

Max Ernst (surreal constructions)

Paul Klee (combines collage with drawing)

Kurt Schwitters (texture and design found in ordinary objects)

9
Yarn Art for Children Age 6–10

Tips on Working with Yarn

Yarn is available now in many big retail stores, not only in knitting supply shops. Acrylic yarn is fairly inexpensive and comes in bright appealing colors. Build up your supply. Here are two hints about working with yarn:

- If you pull a loose end of yarn from a skein and it resists, stop pulling. Pull the other loose end.

- When you finish using the skein for the day, tag the loose end of yarn with a piece of *masking tape*. This discourages the yarn from going into a frenzy overnight and also makes the loose end easier to find next time you need it.

Yarn Art Activities

YARN FUZZ COLLAGE (6+)

This project uses very *small yarn pieces* in a collage. The pieces can be used to make a central image or to decorate a border, but they look best when clustered closely together rather than widely scattered.

Snip yarn fuzz into a plastic bag.

To cut the yarn fuzz:

Six- and seven-year-olds need some help with this, but older children might be able to manage it on their own.

- Wind one color of yarn around and around all your fingers on one hand. You could also use a piece of corrugated board as a stiff shape to wind the yarn around.

- Take away your fingers, and cut through the loop of yarn that your fingers (or the corrugated board) supported.

- Then pinch all the loose ends together where you just cut. Pinch very close to the cut ends of the yarn.

- Now snip the ends of the yarn into a *plastic bag.* Make the yarn pieces as tiny as you can without endangering your fingertips.

- Do this with as many colors as you have, but use a different plastic bag for each color.

There are several different project approaches your child could take. If she wants to use the yarn fuzz to make a central image, here are three ways of working:

1. She could draw/paint with *oil pastel* on *dark construction paper.* As part of the composition she chooses something that would look good fuzzy. It could be a kitten or a teddy bear, but it might be a tarantula or a hairy monster.

 She outlines the enclosed shape the yarn fuzz will fill.

 After she has completed her drawing/painting, she brushes *thick white vinyl glue* onto the enclosed shape. She could use *glue paint* for this. (Glue paint is white vinyl glue mixed with tempera paint.) The glue paint could be the same colors as the yarn fuzz, in which case it will cover any parts of the paper that the yarn doesn't. The glue paint could be a different color—it can be exciting to glimpse a vivid red under yellow yarn!

She masses the yarn fuzz onto the white vinyl glue shape. Then she knocks the excess yarn fuzz back into the plastic bag.

2. She could draw with *markers* on *white lightweight poster board.*

She makes her composition as detailed as possible. Again, part of the composition is something furry. She draws an enclosed shape for this.

After she has completed her drawing, she brushes *thick white vinyl glue* or *glue paint* onto the enclosed shape. She masses the yarn fuzz onto the white vinyl glue shape, then she knocks the excess yarn fuzz back into the plastic bag.

To make furry "lines," she uses white vinyl glue in a *squeeze bottle.* She squeezes out a line of glue and sprinkles the yarn fuzz onto the line. *She should do her yarn "lines" last, after the larger shapes have been completed.*

3. She could paint with *glue paint* on *corrugated board.* (Be sure to mix the glue paint with *tempera* rather than with food color—you want this paint to be opaque, not transparent.)

She could paint the corrugated board a solid color, or use various colors. When the paint has completely dried, she draws her design on the board. If she has used very dark glue paint, she can use a piece of *chalk* or a *white Stabilo pencil* to make this drawing. She could also draw/paint on this surface with *oil pastel* or draw on a very light-colored surface with *marker.*

She then brushes thick *white vinyl glue* onto the enclosed shape and pats on the yarn fuzz.

She can finish by adding fuzzy lines if she wants.

If your child is going to use the yarn fuzz to decorate a border, her working method is much the same. She waits for all paint and exposed glue on the project to dry and then brushes or squeezes *thick white vinyl glue* or glue paint onto

Sample fuzzy shapes

the border. Again, the best way to work is to press the yarn fuzz gently onto the wet glue, then tap off the excess yarn. (If she works over a piece of *foil,* she can bend the foil into an impromptu funnel when she's done, and slide all of the leftover yarn right into the plastic bag.)

If your child is decorating the border of a *Styrofoam meat tray,* she could press the glued border onto the mounded yarn fuzz. The Styrofoam border is raised and easily picks up the yarn fuzz.

I suggest that your child decorate the border after she has otherwise finished with the project. It's more logical and more practical. *The border shouldn't dictate the design; it should strengthen it.* And yarn fuzz is difficult to work around—it should come last.

WRAPPED WOOD (8+)

There is a way of working with yarn that is neither stitching, weaving, nor cutting—it is wrapping. The yarn is wound neatly and closely around a length of wood or rope. Different colors, widths, and textures of yarn can be used.

If the yarn is wrapped around a flexible base such as a rope, the wrapped length becomes sinuous—a three-dimensional "line" that can be used as part of a sculpture, for example.

An easier way to learn this wrapping procedure, though, is to begin with a stiffer base. A *3' length of ½" or ¾" wood dowel* or 1" by 1" wood can make a good base.

Your child ends up with a long colorful piece of wood that he could further decorate with feathers and streamers. He might poke an end into the earth and use the stick to decorate the garden for a while, or he could let it embellish a large container plant on the porch or in the house. Or he could tie a loop of yarn to one end of the stick and hang it from a clothes peg or hat rack. You never know when such a festive stick might come in handy!

The only trick to the wrapping is to start off and finish with a half hitch. All that means is that he pulls the loose end through a loosely wrapped loop so that the yarn won't unwrap when he's done. *You may need to help your child start and finish different colors of yarn.*

Since it is fairly hard to make the loose ends disappear by sewing them all into the wrapped yarn, I suggest that you

Cassandra displays her wrapped wood stick.

let them hang. This leads me back to a basic tenet: *not only should we avoid struggling with art materials or procedures, but also we should try to make the most of even their "weaknesses."*

In this case we can turn a weakness (loose ends) into a strength: long fluttering yarn tails. Not only can they move, which the yarn on the stick cannot, but also each tail carries a reminder of its color over the next yarn colors your child has chosen. To make this work, though, your child needs to allow at least 12″ of extra yarn at the start and finish of each new yarn piece.

I suggest that a right-hander *start at the left of the dowel and wrap his way to the right.* If he wants to stick the finished piece in the ground, he will leave the first 8″ of the

Start and finish your wrapping with a half hitch (and leave long tails for finishing).

Spacing of wraps can be even or uneven.

dowel unwrapped. He can grip this with his left hand as he begins to work.

The completed work will look more interesting if it combines perfect wrapping with some element of surprise. Here are some ways to surprise the eye.

● **Value:** In art, value means light and dark. Your child should check to make sure that all of his color values aren't the same. When he squints his eyes, he should be able to see easily the differences in value among the wrapping fibers he has selected.

● **Texture:** Some yarns are shaggier than others. Your child can look for a variety of yarns and other fibers to wrap. He might also use *twine, string, embroidery floss,* or *thread* for different textures and colors.

● **Scale:** Scale means relative size. The tendency in a project like this is to wrap 2″ of one color and 2″ of another. This can be fun to look at—it's the muffler approach! But if that's the way your child works, it should be a conscious decision, and he should make the most of it by making the wrapped units *exactly* the same. He could also come up with a color pattern: red, white, blue, white, red, white, etc. Otherwise, I suggest varying the wrapped lengths of any one color.

For example, your child might leave the first 8″ of the dowel bare, wrap the next 10″ with twine, the next 1″ with black thread, the next 4″ with red yarn, the next 2″ with red embroidery floss, the next 3″ with black yarn, and finish with 8″ more of twine. He should remember to leave long tails at the start and finish of each new selection.

Your child stops wrapping the yarn about ½″ from the top of the dowel. He could even brush a little *thick white vinyl glue* around the end of the stick to make the final wrapping more secure.

If he wants to decorate the wrapped stick further, here are some ideas:

● He could tie or wrap *feathers* onto the end of the stick.

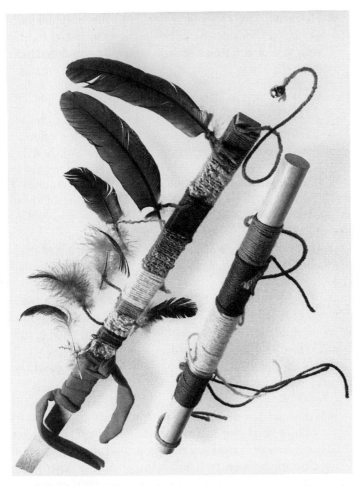

- He could tie or wrap *tissue paper streamers* to the stick. If the piece is displayed outside, the tissue colors will probably run, but the streamers will lift when the wind blows.

 Hint: When your child cuts tissue streamers, he can cut several at once. He should cut long streamers, fold them in the middle, then tie them down around the fold. This method works better than tying down individual streamers.

- Your child could cut small shapes from *felt, construction paper,* or *foil* and glue them onto the stick with *thick white vinyl glue.*

Yarn, bias tape, twine, feathers, and twigs can add interest to the finished stick.

● He could poke *twigs* or *flowers* into the wrapped yarn along the sides of the stick. If the yarn is too tightly wrapped or the stems are too green, he could tie them onto the stick.

Well, anything goes! You get the idea.

WEAVING BOARD (9+)

Your child may have stretched rubber bands across a nail-studded board in nursery school. That is one of those mesmerizing "non-projects" that children adore and grown-ups ignore.

This project starts out the same way—with a nail-studded board. But this time, your child can probably help nail the board.

I suggest a short (12"-plus) length of *board* as a base. The wood should be soft enough to pound nails easily into it. Your child starts by thoroughly *sanding* the ends of the board. Have her do this outside.

If she wants the board to be a different color from the natural wood, here's what she might do:

● She could paint the board with *glue paint.* Glue paint is white vinyl glue mixed with tempera paint. (Regular tempera won't work for this project—the dry paint will come off on sweaty hands and get on the yarn.) She paints one side of the board, lets it dry, then paints the other side.

● Instead, you could help her stain the sanded board a bright color. You first make a shallow dye bath of *rubbing alcohol* or *white vinegar* and *food color.* Spread some *newspaper* outside and gently place the sanded board into the dye bath. Turn it over. Then lift the board out and let it dry on the newspaper. Carefully pour the dye bath down the drain. If she wants this stained wood to look shiny, she can give it a coat of *medium-thin white vinyl glue.* It will dry clear.

After the board is prepared to her satisfaction, your child pounds in some nails. If she wants a neat pattern, she could pencil off 1" spaces while holding a ruler against the

side of the board. Otherwise she can just hammer the nails in at random. *It's easiest if she works her way from one end of the board to the other, though.*

Your child may need some help hammering in the nails. *Roofing nails* or *box nails* are easy to hit, but *finishing nails* are easier to weave the yarn around later.

After the board is ready, she can start playing with it. One good thing about this project is that the board can be used over and over again.

Wherever she chooses to start, she ties the end of the yarn to the base of a nail, leaving a yarn tail. (If she wants to get rid of the tail she can wind it around the nail and finish it off with a half hitch, but *if she clips the yarn end off too short at the start, the whole thing will unravel.*)

She makes any pattern she wants to out of the yarn —encourage her to think of the yarn as a line moving around the board. She can change colors and fibers. You might need to remind a perfectionist that she is making a weaving/ sculpture, not a sweater! Here are a few approaches if she needs help getting started:

Let the child help make this weaving board: finishing nail (top left); roofing nail (top right); sample weaving board (center); formal nail pattern (bottom left); random nail pattern (bottom right).

- She could begin at one corner and zigzag her way across the board. She might then start at another corner with a different color of yarn and work her way across again. Encourage her to work diagonally from time to time; we often seem to have a real resistance to diagonals.

- She could radiate her yarn "lines" out from the center. She might then create her own spiderweb, again working out from the middle of the board.

- She might weave in a more traditional way. First she works her way back and forth with the yarn across the length of the board (obviously, this works best with a formal nail pattern). This is called the "warp."

 Then she weaves the yarn (it can be a different color) across the width of the board. This is called the "weft" or (my favorite) "woof."

 She can do this second step on top of the warp, or she can use a threaded *yarn needle* to weave the yarn in and out of the warp.

When she wants to make another weaving, she can either unwind the yarn or (more likely) cut it away from the nails.

Twist the yarn in one direction
only.

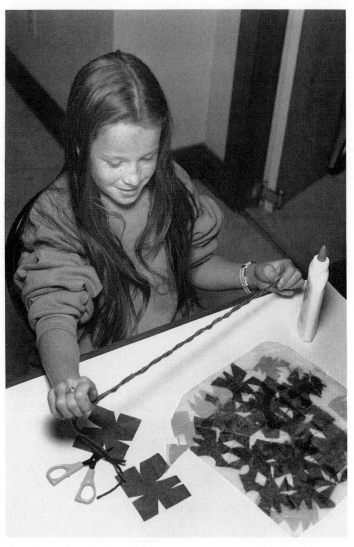

Twisted Yarn (8+)

Here is a project that is so simple that it's hard to
believe it's really a project! The finished length of twisted
yarn stays twisted and looks as if someone spent a long time
making it.

The twisted yarn caterpillar is a good project to start
with. Your child selects one color of *yarn* and cuts a 2' to
3' piece of it. *(Any twisted yarn length will end up about
one-fourth the length of the yarn your child starts with.)*

She loops the yarn once over her finger until she finds

its exact center. She does not cut the yarn at the center but loops the yarn over someone else's *finger* or a *chair leg*. *Wherever she slips the yarn, she must be able simply to slide it off when she's finished twisting.*

Holding the loose ends of the yarn, your child pinches them together and starts twisting them in one direction only. (If it's hard for her to keep her grip on the ends, she can tie them in a knot, slip a *pencil* through the loop, and twist the pencil.)

She keeps on twisting, and twisting, until she's sure she must be done, and then she should twist it some more. She twists the yarn until the length is so tightly turned that it is doubling back on itself.

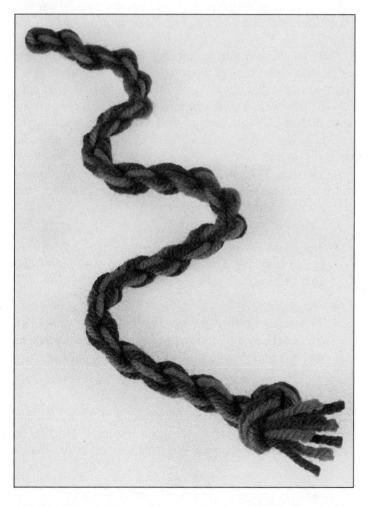

Tie a square knot 1″ down from the loose ends and then trim.

This twisted-yarn caterpillar has a topknot.

At this point the person with the yarn around his finger may be getting a little agitated, but the twister is almost done. She stretches out the yarn length, guesses where the middle of the length is, and pinches it. Then, keeping the length taut, she reaches over for the looped end of the yarn. After giving the two ends of the twisted length a final pull, lets go of them, keeping hold of the middle of the length.

The twisted yarn will jump into action and twist itself into its final pattern. It's fun to watch—it seems like magic!

To finish up the caterpillar, your child ties a tight square knot about 1" down from the loose ends of the length. (One loose end is stubby, where the yarn was looped over the finger, and the other loose end is shaggy.) Your child can tie several knots to make the caterpillar's head bigger. She cuts through both of the loose ends, but *she should leave at least ½" between the knot and where she cuts.*

Then she can fluff up the cut yarn ends—they're the caterpillar's whiskers! (I know that most caterpillars don't have whiskers, but these caterpillars do—they're part cat.)

Finally, she can glue tiny *felt* or *plastic eyes* onto the knot with *thick white vinyl glue.* To make a glowworm, she could dip the end of the tail into thick white vinyl glue and then dip it into *glitter.*

Twisting the yarn can get tedious, but if she doesn't mind it she can now try twisting more varied pieces. Here are two ideas she could try:

- She could twist two or more lengths of the same yarn together at the same time. This isn't any more work, and she ends up with a thicker length.

- She could twist more than one fiber or color together. This looks wonderful while she is twisting, but when the length finally doubles up, the "barber pole" look will be lost. It is nice to work with more than one color, though.

Your child can also twist longer lengths, which she can use in a number of ways. For these projects, I definitely suggest looping the yarn around the chair leg rather than a friend's finger.

- *Medium twisted-yarn lengths:* These can be used to hang a project; the twisted loop would be a visible and decorative part of the finished project.

 Or your child could use several pieces of yarn and twist a snake.

 She could also make a bracelet with the twisted yarn (knot, snip, and fluff both loose ends).

- *Long twisted-yarn lengths:* Your child could make a necklace or sash-type belt (knot, snip, and fluff both loose ends).

TASSELS (6+)

Six-year-olds can begin tassel-making if they have some help. Tassels can be used to adorn weavings and sculptures (including the Wrapped Wood project). They can even be used to make yarn toys or ornaments. When I was growing up it was a fad for a while to turn a large tassel into an octopus by braiding its "legs."

To make a tassel, your child needs some *corrugated board* and *yarn.* The corrugated board provides a stiff form to wind the yarn around. It is ideal because it can be cut for any size of tassel.

If your child is making a small tassel, he could use a 6″ piece of corrugated board. It doesn't need to be too wide—4″ is wide enough. A small tassel could be used to decorate another project, or it could be turned into a ghost, doorknob or window decoration, cat toy, or Christmas tree ornament.

If your child wants to make a bigger tassel, just cut the corrugated board bigger. **Parents: you need to cut the corrugated board for your child.** Do not let your child use the utility knife. A bigger tassel could be used to decorate a project or to make a bigger yarn toy.

Remember that the bigger the tassel, the more times your child needs to wind the yarn around the form. Twenty-five times around is plenty for a small tassel but would look skimpy for a bigger one. Another hint: Your child should work on a slightly longer piece of corrugated board than he thinks he should. By the time he ties up and trims the tassel it will have shrunk.

Here is a good way to proceed:

To make a tassel: wind yarn around stiff cardboard (top); tie off at top and slip tassel off cardboard (center-left); cut bottom end (center-right); tie off "neck" and trim bottom edge (bottom).

- If your child is right-handed, he holds the corrugated board in his left hand while he winds the yarn around it with his right hand. *Since it's so hard to tell how much yarn is needed, he should not cut off a length of yarn in advance.*

- He starts with the end of loose yarn on the front of the board. He can hold it down with his left thumb as he begins. He should leave a long yarn "tail" hanging off the end of the board; he can trim it later on.

- He then winds the yarn around and around the corrugated board. There's no science to figuring out how many times to wind—it's a combination of experience and common sense. If your child is using thick, fluffy yarn, he might wind it only ten or fifteen times.

- When he finishes winding, he ends with the second end of loose yarn at the bottom of the board. He cuts it, again leaving a long "tail." *Don't let him trim the tails yet.*

- Before sliding the wrapped yarn off the corrugated board, your child must tie up the very top of the tassel. (This is the part most people forget to do, which is why they only try this once.)

 Cut a length of yarn (same color) that is more than twice as long as the tassel. Work one end of it across the corrugated board, under the wrapped yarn. Pull it halfway through.

 Now your child knots the yarn length tightly at the very top of the tassel. (Children seem to look at tassels as "people"—head, neck, and so on. Tap the top of your head to show your child where he should tie this knot.) *You probably need to help your child tie this knot tightly enough; it shouldn't slip.* Make it a square knot or some other unraveling knot.

 If he wants to hang the tassel eventually, he keeps this loop apart from the rest of the tassel. If he doesn't want to hang it, he can smooth the yarn down into the rest of the tassel.

- *Only now should your child slide the tassel off the form.* He then holds it firmly at the top and clips the thick

bottom loop of yarn. Here's an easy way: He can open the *scissors* and slide the top blade down against the loop, then start to cut. This way he's sure to cut in exactly the right place.

Now comes the hard part: not trimming the shaggy yarn ends yet! But he can "comb" the yarn strands with his fingers, which is fun.

- Next he wraps the "neck" of the tassel. This could be wrapped in the same color of yarn or a different color.

Your child could wrap the "neck" in any way that works, but I think the easiest way is for him to cut a 2' length of yarn and tightly knot it at its center wherever he wants the "neck" to be. He can then wind each loose end tightly around and around the tassel in opposite directions one at a time, and finish up with a knot or a knotted bow. (Double-knot the bow as if it were a shoelace.) Then he can trim the ends of the "neck" tie.

- Finally he can trim the shaggy bottom of the tassel. He should "comb" the strands again and then pinch them with his left hand as he trims them with the scissors.

This can be a little like cutting your own bangs— by the time they're even you don't have any hair left! Your child should just get the bottom of the tassel fairly even—it won't be perfect.

Tassel ideas: ghost with felt details (top); tree ornament, hung by paper clip (center); doorknob tassel, hung by twisted yarn and decorated with felt heart (bottom)

Once the basic tassel is completed, your child could decorate it if he wants to.

Here are some tassel ideas:

- *Ghosts:* These are fun for Halloween. Your child could make a white tassel with a white neck (or a black neck for a more formal ghost). He could glue *felt, paper,* or *plastic eyes* (or one eye!) onto the "head" with *thick white vinyl glue.* He might finish by deliberately making the bottom of the tassel even shaggier.

- *Ornaments or doorknob decorations:* He could wrap one or more colors of yarn or other fibers (*non-stretchy metallic string* looks great) around the corrugated form. "Neck" wrapping usually looks best in one color, though.

For Christmas he might make a red and gold tassel and wrap the "neck" with red, gold, or green. He could hang the tassel from the top loop or from a *bent paper clip*.

For a doorknob tassel, he could work with any colors of yarn at all. He might want to decorate the "head" of this bigger tassel with felt cutouts.

A Twisted Yarn length (see earlier project this chapter) could be used to hang the tassel from the doorknob. He can use it to knot the very top of the tassel as he works. Then he can tightly knot the ends of the twisted yarn, forming a loop. After the ends have been knotted, he cuts the tips off the ends and fluffs up the yarn.

● Your child might want to hang his tassel in the window from a twisted cord. *Rhinestones* and *sequins* glued to the "head" of the tassel with *thick white vinyl glue* will reflect the sunlight as it comes through the window.

Your child will come up with other tassel ideas of his own. Maybe he won't want to make anything at all out of the tassel—after all, it already *is* something!

Simple Loom Weaving (8+)

Here is a traditional in-and-out weaving that your child can easily do at home; it involves some parent assistance at the beginning. The "loom" is part of the finished project in this case, and your child needs a piece of *corrugated board* for the loom. An 8″ by 10″ piece is fine, but the loom could be any moderate size—a 6″ by 18″ loom weaving would be interesting to see.

Parents: Cut the corrugated board with a *utility knife* or *paper cutter*. **Do not let your child use a utility knife or paper cutter.** Since your child will probably want to paint the corrugated board, you could cut up any old cardboard box.

It is important that the base be stiff enough not to bend in the slightest when the yarn "warp" is tightly strung across it. That's why I am recommending corrugated board.

Next your child takes some time to visualize the weav-

ing. What colors of *yarn* does he want to weave with? Does he want to use natural weaving materials such as *sticks* or *grasses?* How about *pipe cleaners, rag strips, ribbon, string,* or *twine?*

It is important to think about this, since the colors he will be weaving with should influence his choice of background color on the corrugated board.

For example, if your child plans to weave with brightly colored materials, he could pick one of the bright colors for a background. White or black would look good, too. If your child is planning to weave with sticks and grasses, though, a bright background color such as red or green might be too overpowering—it can be hard to mix a natural-looking green. But white, brown, or black would probably bring out the subtle beauty of the weaving materials. (Remember that natural colors change as grasses or flowers dry.)

Your child helps mix a color of *glue paint* and then paints the corrugated board. Glue paint suits this project much better than plain tempera because the color won't smudge off onto light-colored yarn or damp hands while your child is working.

Parents, you are needed for the next two steps and then your child can begin to weave. Here are your instructions:

To prepare a simple loom: slit corrugated board (top) and wrap yarn around board for warp (center). Bottom figures show two ways the back of the weaving may look.

1. When the glue paint is dry, make small slits at the top and bottom of the corrugated board. *Ask your child where the top is because he might be looking at the board differently.*)

 The slits should be only about ½" long, and about ½"–1" apart. Make the same cuts at the top and bottom of the board. It's easy to do this with a utility knife, but you could also use a sharp pair of scissors. **Do not let your child use the utility knife.**

2. Next, you probably need to help your child wrap the yarn around his board for the warp.

 He selects a color of *yarn, string,* or *twine.* Wrap it from top to bottom until the board is covered. *Leave a long "tail" of yarn when you start; you can secure the warp better that way.*

Experiment with different weaving materials: fabric, paper, yarn, pipe cleaners, twigs. Bottom drawing shows how to tie loose ends at back of work.

You could wrap the yarn in a circle on the board, tugging it through the slits, or you could simply wrap the front, pulling the yarn from one slit to the next on the back side.

End with another long tail, and knot the two tails tightly together on the back of the board. Clip the loose ends slightly more than 1″ from the knot.

The weaving is done on the front side of the loom, and the finished weaving stays on the painted corrugated board. This would be a good place to stop for the day.

Your child can weave with anything long and skinny. He could thread a *yarn needle* (he may need some help with this) and weave from side to side several times. But encourage him to weave with a variety of materials. This will never be tossed into the washer and dryer, so why not?

More advanced weavers can pay greater attention to the three design elements described earlier in this chapter (see Wrapped Wood project): value, texture, and scale. Contrast in all three of these areas can make a project more interesting to look at.

When your child has finished weaving, he may have left part of the warp exposed (unwoven). That's fine; these vertical lines are, after all, a valid part of the "composition." Let him decide when he's done.

He may or may not want to trim off any of the weaving materials that extend over the sides of the weaving. These sides aren't fences, and branch or pipe cleaner "lines" can certainly go beyond them.

Display:

Your child's weaving could simply be nestled into a bookcase or propped on a mantel for display. If he would like a little more ceremony, though, here are two ideas:

1. *Tradition!* The weaving could be displayed on the refrigerator. Your child cuts three 4″ pieces of *magnetic tape* and glues them onto the back of the weaving with *thick white vinyl glue.*

This works best if the back of the weaving has remained unwrapped. (If your tidy child is truly distressed at the informal appearance of the back of the

mained unwrapped. (If your tidy child is truly distressed at the informal appearance of the back of the board, he could cover it with a piece of *construction paper* or *lightweight poster board*. He applies thick white vinyl glue to the paper or poster board and then presses it to the back. Allow a day for the glue to dry before attempting to hang the weaving.

If your child is in a greater hurry, you could use a *hot-glue gun* to attach the poster board backing. **Do not let your child use the hot-glue gun.**

2. Your child could make a long *twisted yarn* length for a decorative way to hang the weaving. Please see the Twisted Yarn project described earlier in this chapter.

Remember how much the yarn "shrinks" during this project. If the top of your child's weaving is 9″, for example, his finished twisted yarn length should be 12″–14″. This would mean starting with a piece of yarn at least 56″ long (14″ × 4″) and twisting a 28″-length of looped yarn.

After the twisted yarn has been completed, your child knots each loose end 1″ from the end, snips the very ends, and fluffs the yarn. Then he ties the twisted yarn to the front of the weaving, knotting it around the slits at the top left and right of the weaving. *He may need some help with this.*

Your child might also be able to work a *tassel* into the weaving somewhere! (See the Tassels project, which appeared earlier in this chapter.)

With each weaving that your child makes, his skill will increase. A project such as this, with a definite beginning, middle, and end, can be especially valuable to a child who is beginning to feel a little disheartened with his drawing and painting progress.

Textile Words to Use with Your Child

Yarn

 skein

 wrapping

 tassel

 weaving

 loom

 warp, weft or woof

knots

 half hitch

 square knot

Paint

 tempera = opaque

 watercolor = transparent

 food color = transparent

Value

Texture

Scale

Composition

 border

 enclosed shape

 formal pattern, random pattern

 contrast

Textile Artists to Look at with Your Child

I suggest that you visit the textiles section when you go to the art museum. There are many beautiful things to look at from Africa, Central America, and Polynesia.

There are also contemporary artists doing exciting work in this area. Especially look for three-dimensional weavings and the use of unusual weaving materials. Visit local craft shops and fairs.

10

Sculpture for Children Age 6–10

Many of the sculpture projects your six- to ten-year-old can easily do at home are just more complicated or refined versions of the sculpture projects given in Chapter 5, Sculpture 2–5. But it is detail that makes the difference. The careful choice of materials and the "finishing touches" a project is given are very important to older children.

Sculpture Activities

LAYERED SALT JAR (6+)

Here is the project you've been waiting for, the one that *requires* you to use powdered tempera! It's a simple project. Here is what your child needs: *powdered tempera, salt, white vinyl glue, small jars,* and maybe some *glitter*. And it's a project that is fun to do with a friend—they can make several at once.

This project is done inside a very small glass jar. *Baby food jars* are perfect, but similarly sized jars are fine, too. Wash and dry the jars (and lids) you have accumulated. The glass jars are left clear, but your child may paint the lids if she wants to. She uses a small quantity of *thick white glue paint*—white vinyl glue mixed with tempera paint.

She could also brush thick white vinyl glue or glue paint

Layered salt jars

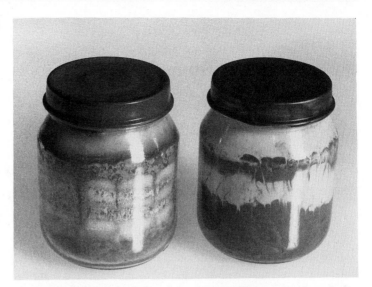

on the outside of the lid and then pour glitter over the whole thing. If she works over a piece of *foil,* she can easily funnel the excess glitter back into its container.

Or she could paint the lid with glue paint, let it dry, then squeeze a bead of thick white vinyl glue onto the lid, forming initials, a design, or a border. Then she sprinkles on the glitter.

Whenever your child uses glitter, she should be very careful not to get any of it near her eyes. Six- to eight-year-olds should have close supervision when they use glitter.

Next, get out several small bowls in which to mix the salt colors. One bowl of salt can be left white.

Your child pours some salt into each bowl and then spoons in powdered tempera and stirs it up. Don't let her add any water! (Even if you just have one color of powdered tempera, your child could alternate layers of it with the plain white salt for a successful project.)

Now your child spoons the colored salt into a clean, dry jar. She can make the surface wavy or smooth. Then she spoons a second color onto the first.

Remind her about the design elements of *value* (light and dark) and *scale* (relative size varying the width of the salt layers) that she has learned in making other projects (see Chapter 9, Wrapped Wood and Simple Loom Weaving).

She probably wants to layer the jar until the salt reaches almost to the top. She could even include a layer of glitter if she wants.

An eight- or nine-year-old might want to try something extra special before sealing up her design. She could get a *broom straw* and carefully poke it down to the bottom of the jar. She should do this right next to the glass sides so that she is able to see the broom straw inside the jar. Then she carefully pulls the straw up. This makes a wavy pattern in the layers. She can do this in several places if she wishes.

Finally your child seals the layers before snapping on the lid. This is very important and is the part most people forget. But if she forgets it, all the layers will get jumbled together before long, and she'll wonder where on earth that jar of murky salt came from.

She pours a final layer of *thick white vinyl glue* or *glue paint* into the jar. This final layer should be at least ¼" thick, and it should extend to all sides of the jar. After it has dried (the white vinyl glue will dry clear), she can snap on the lid.

This project could also be done entirely with layers of glue paint. It's a little harder to do, though; I'd suggest it for children 9 and older. These layers of glue paint won't dry since they are so thick.

Cornstarch Dough Sculpture (6+)

Cornstarch doughs are similar to the flour doughs described in Chapter 5. But cornstarch doughs are often more satisfying for older children to use for two reasons:

1. The dough has a finer texture and can be worked in greater detail. It also is less likely to blister or crack.

2. The dough is white. This means that color added to the dough shows up more vividly.

There are several good cornstarch dough recipes. Here is one that works.

1 cup cornstarch

2 cups baking soda

1+ cup water

Combine all ingredients in a saucepan and cook over medium heat until thickened. Your child can knead it as it cools. It is a little fragile when it is drying, but very hard once it has dried. See Chapter 5 for how to add color to a dough recipe.

Younger children (six- to seven-year-olds) might just want to play with the white or colored dough as they would with play dough. Here are some other activities they could try:

LITTLE LANDSCAPE (6+)

Your child could press the *white or colored dough* into a *coffee can lid* or *small Styrofoam meat tray.* He could then stud the wet dough with *sticks, rocks, tiny plastic figures,* or whatever catches his eye, to create a small world of his own.

If any of the things get knocked out of the dough when it dries, he can glue them back in with *thick white vinyl glue.*

STAMP PRINTING IN DOUGH (6+)

Your child presses the *white or colored dough* into a *Styrofoam meat tray* until it is about ½" thick. If she wants the surface to be extra smooth, she can dip her finger in *water* and slick it over the top of the dough.

She then presses a small object into the wet dough again and again. She could choose more than one object to press, but encourage her to repeat each image.

She could decide on either a formal pattern (straight lines, for example) or a random one. She could use a *pine cone, fork,* her *fingertips,* or any small object to create an impression.

SIMPLE ORNAMENTS (6+)

Your child can roll the *white cornstarch dough* out with a *rolling pin.* Make sure that the dough isn't too sticky. If it is, he might sprinkle *extra cornstarch* onto the rolling pin. He should roll the dough about ⅓" thick.

If he rolls the nonsticky dough on top of a piece of *burlap* (sprinkle the burlap with cornstarch first), his dough picks up the burlap texture.

He next dips a *cookie cutter* in some cornstarch and

cuts out some shapes. Offer simple cookie cutter shapes—he'll decorate the ornaments later.

I advise you to leave the ornaments on the burlap until they have partially dried. Just peel up the extra dough around the ornaments and use it again.

If your child wants to hang the finished ornaments on a wreath or tree, he should make a hole at the top of the ornament before the dough dries. The hole should be at least ½" from the top of the ornament, and a little bigger than seems right (it will shrink as the dough dries).

When the ornament has dried (give it a day or two), he can draw or write on the smooth side with *markers*. *Parents: If you want to keep the dried marker lines from running, you could give the ornament several light spray coats of a* clear acrylic varnish. *Use this outside, don't spray too close to the ornaments, and do not let your child use the spray acrylic (or any spray product).*

Your child might prefer to paint his ornament—he could use *watercolor* or *glue paint*. (Glue paint is tempera mixed with white vinyl glue.) Or he could squeeze a simple design of *thick white vinyl glue* from a *squeeze bottle* and douse it with *glitter*. Then he taps off the excess *glitter*. Remind him to work on *foil* so that he can funnel the extra glitter back into the jar. Any glitter work should come last.

He could also glue or paste a *small picture* or *photograph* onto a white or colored cornstarch dough ornament.

Cornstarch dough ornaments can be hung with rubber bands, paper clips, pipe cleaners, or yarn.

CORNSTARCH ORNAMENTS (8+)

Older children (8+) will probably enjoy the previous three projects too. But if your child would like to try a smaller, more detailed cornstarch dough project, this is a good one.

She begins by making the *basic cornstarch dough recipe*. She then divides the dough into several small bowls and covers each with *plastic wrap*.

She squeezes a few drops of *food color* onto each portion of dough, mashes it into the dough with a *fork*, then kneads it in evenly with her *fingers*.

If she wants a pale color of dough, she uses less food color. She can add more food color for more vivid dough colors. Refer to the Color Wheel (see page 247) for color mixing ideas, which work even with food color.

She does this with all the bowls, leaving one dough white, though.

She works with very small quantities of dough, but these will be very small sculptures! The idea is to have the color already mixed into the dough rather than to try to paint color onto the tiny finished projects later. The finished projects will probably be used to make pins, charms, or refrigerator magnets, so she will keep them very small—under 2″.

Once all her chosen colors have been mixed, she can start to model with the dough. She should work on *waxed paper* or *aluminum foil.*

She can make anything from the different-colored doughs. If she needs some inspiration, here are some ideas to get her started:

- She could make a yellow flower and poke down its red center with a *toothpick* "dot."

- She could make a white clown face, "draw" (poke) its eyes and mouth with a toothpick, roll a red nose, and use a *garlic press* to squeeze out purple hair.

- She could make a small yellow car silhouette and poke on green wheels.

- She could create a small monster entirely out of garlic-pressed dough and little eyes.

- She could form a small Christmas tree and poke on multicolored balls.

- She could flatten a white Easter egg shape and poke on stripes and polka dots.

- She could model a white ghost for Halloween and poke on red eyes.

Once she gets warmed up, she won't need anyone else's ideas.

Working with dough that will harden for the finished product is a little like working with real clay that could be fired:

- Any attachments must be firmly attached to the dough underneath. Poking them on usually works; so does

scratching the tiny surfaces with a toothpick. Even just licking the little attachment sometimes helps.

But if something falls off when the dough is drying, you can always help your child glue it back on later with *thick white vinyl glue.*

- No dough piece should be thicker than about ½"– ¾". If your child rolls large balls of dough, for example, they probably will crack as they dry.

- If your child wants to hang her tiny sculpture as a charm, she could carefully poke a *paper clip* into the top of the damp dough so that just the top loop of wire is exposed. *Parents, you may need to help with this.*

Once your child's small cornstarch dough ornaments have completely dried—allow several days, depending on the weather—you may help her glue a mounting to the back of the piece. She uses thick white vinyl glue for this. *Parents: You might use the* hot-glue gun *instead. Squeeze the hot glue onto the flat back of the sculpture, not onto the tiny backing you are holding.* **Do not let your child use the hot-glue gun.**

If your child wants to make refrigerator magnets, which are always welcome as gifts, she uses *small magnets* or pieces of *magnetic tape* for the backing. Magnetic tape is light, simple to cut, and glues down easily.

If she wants to wear her small sculpture, she could thread a length of *yarn* or a colorful new *shoelace* through the paper-clip loop exposed at the top of the dough piece.

To prepare the sculpture as a pin, I suggest buying inexpensive jewelry *pin backing mounts* at a craft store.

If those aren't available, you can help her stitch the straight side of a *safety pin* onto a tiny piece of *felt,* and glue the felt to the back of the sculpture. She can then pin the piece to her sweater.

Any of these cornstarch dough pieces can be given a shiny finish by brushing on a layer of *thin white vinyl glue* (uncolored) after the dough has completely dried.

Foil Sculpture Activities

This is probably the easiest kind of sculpture to do at home since all your child needs is *aluminum foil.* There are

several ideas in Chapter 5, Foil Sculpture about modeling, painting, and displaying the finished pieces.

Your eight- to ten-year-old may be frustrated now at not being able to model the foil in greater detail. (For these sculptures to work, they must be modeled from a single piece of foil; otherwise, the extra parts soon fall off.)

The way around this limitation is to learn where to cut the foil before crumpling it. Your child won't have to cut any pieces away from the foil length. Instead, he learns to make slits here and there. *(Parents: You may need to help younger children cut the foil.)*

ANIMAL (8+)

An easy way to prepare the foil for an all-purpose tailed creature, from kitten to tyrannosaurus rex, is to slit the foil two times at the top and two times at the bottom. Next your child squeezes the foil in the middle, then bends the ends into legs, a head, and a tail. Your child can experiment with foil lengths and how long to cut the slits.

PEOPLE (8+)

People don't have tails, so to model a person your child only needs to make three cuts in the foil—two at the top and one at the bottom. Then your child squeezes the foil in the middle and models the arms, legs, and head. These foil figures can be very loosely crumpled or the foil can be tightly compressed.

As was described in Chapter 5, Foil Sculpture, these figures can be flattened or mounted upright. Encourage your older children to make several foil sculptures and use them together in a composition.

You might also buy a special roll of *heavy-duty aluminum foil* just for sculpture work. It is wider, and your child will be able to model bigger, sturdier pieces.

SPIDER (9+)

If your child wants to model a spider (the ultimate in legs!), he starts with a square of foil, which he has cut in diagonally about 3″ at each corner and in about 3″ in the center of each side. Then he squeezes each "leg" tight and

forms the center. Finally, he does the detailed modeling and bending of the legs.

He could make a whole flock of spiders for the front porch, paint them with *glue paint* (white vinyl glue mixed with tempera), and glue on little *pompons* for the eyes. *Plastic eyes* would work, too.

The same cuts would work if your child wanted to model a sun. He could paint it with glue paint and sprinkle *glitter* onto the wet glue paint. **He should be very careful not to get the glitter near his eyes.**

Treasure Chest (8+)

Before beginning this project, please read the Advice to Parents section on page 97.

Here is an activity that combines painting, collage, sculpture, and greed in one project! Your child creates a box heaped with "treasure" that she can gloat over in private.

There are several parts to this project, and your child won't do them all in one day. I strongly encourage you to promote these more complex activities for your older children from time to time.

- It's good for them to remember what they have recently done and to visualize what they will do next.

- It's also good to learn to wait for things, and not only learn to endure the anticipation but also enjoy it.

The Chest:

Your child needs a sturdy *shoe box* (or slightly smaller box) for this project. She begins the project by painting the inside of the box. I suggest *black glue paint* (white vinyl glue mixed with tempera) or another dark color. The treasure will look more impressive against a dark background. If she wants a lid for her treasure chest, she can also paint the inside of the lid at this time.

Your child could either paint the outside of the box another vivid color of glue paint or give it the "antiqued" finish of a long-lost treasure chest. Here is a way to do this:

- Your child tears off a long-enough piece of *aluminum foil* to wrap around all four sides of the box, allowing

Press the crumpled foil to the box; keep the long edge of the foil against the table.

an extra 6″. Most foil is 12″ wide, so it will be much wider than the box.

● Next she crumples the length of foil—not into a ball, but just enough to wrinkle it all over.

● Now she flattens the foil out again—not trying to erase the wrinkles but to pound them flat.

● To glue the long foil to the sides of the shoe box, she may want to cut the crumpled length in half—a shorter length is easier to work with.

 She starts the gluing by brushing *thick white vinyl glue* to one of the two long sides of the box. Then she presses the foil to the glue with the long edge of the foil length against the table. (The extra foil pokes up above the top of the box.)

 To make the outside corners extra neat, she could leave an extra 1″ of foil to bend and glue over each corner.

● She works her way around the four sides of the box. She can leave the bottom of the box bare. (If that ends up bothering her, she could paint the bottom with glue paint or glue crumpled foil to the bottom later on.)

● Now she can trim the extra foil from the top of the box.

● To cover the outside of the lid to the treasure chest, your child tears off, wrinkles, and flattens a length of foil.

 Then she glues the foil to the top of the lid. After she has done that, she bends and glues the foil to the two long outside edges of the lid.

 She then makes four small cuts right along the four outside corners of the lid, glues down the foil onto the two short outside edges, and trims off all the excess foil. *Parents: you may need to help her make the cuts and finish off the edges.* This would be a good place to stop for the day.

To make the outside of the chest look old:

 Your child may want to leave the wrinkled foil surface of the box as is. That's fine. If she's interested in making the surface look older, though, she could try an "antiquing" process.

Hint: have her try this process on a scrap of wrinkled foil to make sure she really likes the way it looks. Here is a simple antiquing process:

● Help her mix a *very thin wash of black tempera*. She needs to add several drops of *liquid detergent* to the wash so it won't "resist" the foil. If she is mixing powdered tempera, remember to start with the tempera, add a small amount of water to make a paste, then thin it further with water.
Do not add white vinyl glue to this antiquing wash—it should just be tempera, water, and liquid detergent.

● Now she brushes the very thin wash over the foil surface of the box. She can just slosh it on with a big brush.

● When the wash has dried, she gets some *damp paper towels* and rubs some of the dried tempera wash from the foil. The paper towels pick up the paint only from the top of the crinkled foil surface, leaving the black wash in the wrinkles.

She can wipe off a little or a lot of the dried wash, depending on how she wants it to look. (If she has accidentally mixed white vinyl glue into the wash, she won't be able to wipe off any of the paint. But she could test that out on a scrap, too, and she may prefer it. This is another good stopping place.)

The Treasure:

Now that the chest itself has been completed, your child may decide that's enough—forget the treasure! No problem. An extra box will always be useful to her. Do not insist that she finish this second part of the project—making the treasure. She can always come back to it later.

But if she's ready to make some treasure, here is a way to begin.

The Big Stuff:

To make this Treasure Chest look really lavish, it's a good idea to start with some big objects at the bottom. That way the smaller loot can be mounded on top.

Your child can wad up large pieces of *aluminum foil*

to fit either snugly into the corners or as individual big
lumps. Next, before gluing them to the inside of the box,
she can paint them with *thin glue paint.* She works on
newspaper.

- Mix white vinyl glue with *food color* or a little *tempera.*
 Add a few drops of *liquid detergent* and thin the mix
 with water. The idea is for the silver foil to glint
 through the color.

- If she adds yellow color to the glue, the painted foil will
 look golden. Other colors can make the foil look gem-
 like: red can be rubies, green can be emeralds, etc.

- While the glue paint is still wet, your child can drift
 glitter across the foil surface for extra glamour.
 She should work over a piece of foil when she uses
 glitter. That way she can funnel the extra glitter back
 into the bottle.
 **She should be very careful not to get the glitter
 near her eyes. Six- and seven-year-olds might need
 supervision when using glitter.**

- Your child could also wrap *rocks* in foil for "the big
 stuff," but that would make the chest pretty heavy.
 Some old *blocks* could be wrapped and painted to
 make gold ingots, though.

- She can glue these large treasures to the bottom of the
 chest with *thick white vinyl glue.*

The Small Stuff:
 There are a lot of small things your child could heap
onto the bigger treasures underneath. For example, she
could make large *foil "coins"* (taking balls of foil and stomp-
ing them flat) or even toss in a handful of real *pennies.* You
might as well store them there as anywhere!
 If you have any unusable colorful *costume jewelry*
stashed away, let her add it to the treasure chest—or you can
hunt for some costume jewelry at yard sales.
 She can also throw in some old *fake money* from games
or buy an inexpensive packet of it at the toy store. Anything
that she thinks of as treasure can go into the chest. Stop here
for the day.

The Map:

If she decides to hide the treasure chest away somewhere, she should probably make a map so she can find it again. It's fun for a child to make maps, even of things that we wouldn't think needed one, such as the inside of the house or her own bedroom. Making a map involves imagining a space from an unusual viewpoint—it's a good exercise in abstraction and visualization.

Your child can draw her map with *markers* on *light-colored construction paper,* or she might prefer it to look more old-fashioned. In that case she could work with *pencil* and *watercolor* on *typing paper.* When she's done she can roll it up and tie it with a *ribbon.*

Making maps can be so engrossing that your child may want to skip the Treasure Chest altogether and just make the map!

Another Kind of Treasure Chest (10+)

Before beginning this project, please read the Advice to Parents section on page 97.

There is another kind of treasure chest that an older, more sedate child would enjoy making: the Decoupage Treasure Chest. *Decoupage* is a word that means detailed cutouts, and these require a fairly high degree of skill with scissors. *(Hint: Let your older child try small scissors, even manicure scissors.)*

For this project I suggest that your child prepare the inside of the box *(dark glue paint)* and the outside of the box *(antiqued crumpled foil)* the same as for the Treasure Chest described earlier. But instead of heaping loot inside the box, your child glues cut-out *magazine pictures* of things he treasures to the interior.

It can be hard to accumulate enough pictures to paper the entire box interior, and especially hard to cut around all those edges. But he won't have to accumulate so many pictures—that's one reason he has prepainted the inside of the box. The dark glue paint will showcase the pictures he does select.

Here are a few hints for this project:

• Your child should wait for the glue paint to dry before he glues down his trimmed pictures.

- He should cut as carefully as he can; it's the detailed cutting of contours that makes this project look so good.

- The box is more interesting to look at (and easier to decorate) if he has two or three large pictures to combine with his smaller selections. I suggest that he spend one day hunting for pictures to use before continuing with the project. Don't rush it.

When it's time to glue down the cutouts, he uses *thin to medium white vinyl glue* (it dries clear) or *thinned paste.* Here are some things that can make his work easier:

- He can start by gluing down the larger cutouts.

- If he is using white vinyl glue as his adhesive, he can brush it right on the interior of the box and then press the picture onto it. (But paste won't disappear when it dries as the glue will.)

- Encourage him to overlap pictures.

- Help him precrease the pictures so that they can "turn corners." This makes the interior collage look especially complex.

- Suggest that he allow some pictures to jut past the top of the box. Help him trim them off when the glue has dried.

He can use this box to hold his own small treasured objects or just to look at and enjoy some rainy afternoon. He may even find more pictures to add some day.

Assemblage (6+)

Once upon a time your child made a junk sculpture. Now he makes an assemblage!

Whatever he calls it, it's still fun. Your six- to ten-year-old will make more complex sculptures and spend a longer time on them in one sitting. He will also be better able to work on them over a period of time—he could do part one day, part the next. Finally, these assemblage projects offer your child a good opportunity to explore mixed media.

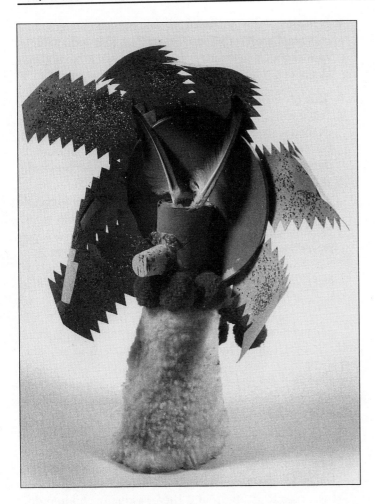

Mixed media is an art term that means that the artist (in this case, your child) has used a combination of materials in one art work. This might mean that he drew on a sculpture or he painted on a collage, for example. I think that working this way is almost a "state of mind." What does it mean when we are able to work this way? Why is it so valuable?

Here are a few of the things that mixing media quietly teaches us:

- *It helps us to think and act with flexibility.* More things are possible—we aren't stuck with something just because we "planned it that way."

- *It lets us throw out artificial boundaries that get constructed between different art media.* Is it a drawing, a painting, or a sculpture? Well, why can't it be all three at once? Don't worry about violating "art laws."

- *Mixing media encourages us to relate "unrelated" things*—to let our intuition (or whimsy) toss various elements together in one work. This can be a way of triumphing over the mass of stimuli that surrounds each of us today. We can refocus by celebrating individual parts of our surroundings.

 For example, your child might eye the empty *oatmeal container* as he finishes his breakfast. He could paint it with *glue paint,* leaving the beaming face unpainted. Later he could glue a *cotton ball* or *yarn fuzz* beard to the face's chin and perhaps write his initials in *glitter* (pressed onto *thick white vinyl glue*) on the back.

Mixing media gives us the means to evolve our personal aesthetic by giving us the freedom to express it in any way that works.

This is the key to successful assemblage projects: do them any way that works! Here are a few basic guidelines:

- *Start with the big things and work to the small ones.* For example, your child might start with a woodworking project, then paint it, then glue small objects on top. But if he glues the small objects onto the wood and then tries to paint around them, as many children do, he will become frustrated.

- *Start with the sturdy or heavy things and work to lighter ones.* If your child tries to glue a brick onto a sheet of construction paper, it will stick, but so what? Remember that a base should be able to support the things glued on to it.

- *Be patient and logical when creating large assemblages.* (Parents: This is where you come in!)

 Your child will have already learned that bulky things fall right off the sides of a cardboard box if he tries to glue them down. So, obviously, he has to work on one side (face up) at a time and allow plenty of time for each side to dry before continuing.

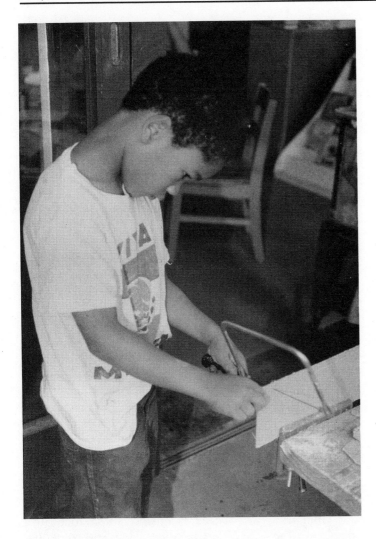

A child starts an assemblage project.

And when your child paints a large three-dimensional object, he obviously has to wait for the top and sides to dry before he can paint the bottom.

Parents: You may need to remind him of these "obvious" things that we all already know but sometimes forget in the heat of creation. Give your child a protected area to store his project in until he can continue his work, and then give him the time to continue the project.

If your child requests your assistance in attaching bulky or awkward assemblage parts, give it.

- Remember to use *thick white vinyl glue* or *glue paint* (tempera mixed with white vinyl glue). Thinner glue is for thinner collage materials only.

- If you decide to use the *hot-glue gun* to speed things up, remember that this is still your child's assemblage. Let him point to the exact spot he wants something attached, and you can try your best to attach it. If it doesn't work, it doesn't work; let your child discover it for himself. **Do not let your child use the hot-glue gun.**

Display:

As I explained in Chapter 3, Doodad Collage, sometimes the best way to display a lightweight assemblage is to hang it from the ceiling in your child's room. Beware of falling objects, though—use your own judgment.

Small assemblages can go on the kitchen table, the mantel, or the front porch—at least for a while.

If you have an instant *camera,* give your child the treat of a packet of his own *film.* He can take close-up photographs of his assemblage outside. With the cat sitting on it, with plastic dinosaurs creeping over it—what possibilities!

PAPIER-MÂCHÉ TOWN (6+)

Before beginning this project, please read the Advice to Parents section on page 97.

Working with papier-mâché (say "paper mashay") can be simple or complicated. We'll take the simple approach!

Papier-mâché means "paper pulp," but in this project your child uses *paste-soaked newspaper strips* to form a "skin" over the base of her building. Then she paints her sculpture and finishes up with some collage. So obviously *this is a mixed media project that will be done over a period of time, and not all in one day.*

She could do this project alone or with a sister, brother, or neighbor. These buildings fit together well, yet each can stand on its own. Each child constructs a building on a separate small base. That way they can turn their individual projects as they work.

The Base:

Papier-mâché is just a "skin." Your child needs "bones and muscle" underneath to form the base, the foundation.

In papier-mâché work, your child always needs to build up as much detail on the base as she can before proceeding with the actual paste and paper. Parents: You may need to prepare impatient children for this. Encourage your child to look at the base-building as a sculpture project and the papier-mâché as "the frosting on the cake."

I suggest a small square, rectangle, or triangle of *corrugated board* as the support for your child's building. Parents: Do not cut it down to size until your child has selected the primary box itself. Your child does not paint the base until much later. The corrugated board base should be at least a few inches bigger than the building on all sides. Parents: Cut the corrugated board with a utility knife. **Do not let your child use the utility knife.**

There are lots of things your child could select for the basic shape of the building. Here are a few ideas:

- *Oatmeal carton:* This would make a good cylindrical building. She could glue *paper towel* or *toilet paper cylinders* to its side to create a futuristic structure.

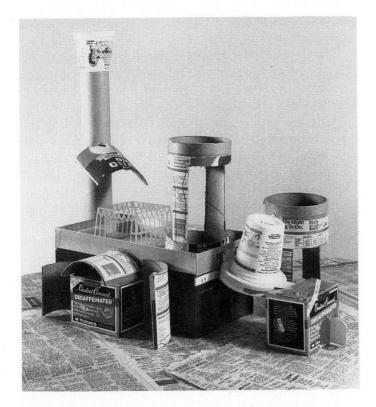

Almost anything can be used as a papier-mâché base.

- *Shoe box:* This would be good for either a low-lying building (open side down) or a tall building. For a tall building, your child either tapes a piece of *lightweight poster board* to the open side (any color—it will be covered up) or tapes the shoe box lid tightly onto the box.

 She could even leave the side of the shoe box open and cover it with *plastic wrap* for "glass." She covers this at the very end, after painting.

- *Cereal box:* This would be a good choice for a sky-scraper.

 If your child would rather make a house, she can select a *gift box* and tape a gabled roof on top before beginning with the papier-mâché. Instructions for this follow shortly.

In any multipart project like this, discourage your child from beginning with a fixed idea of what the finished project "should" look like. Not only is this image hard to duplicate, which sabotages the failure-proof approach, but it keeps her from taking advantage of materials or ideas that might pop up as she works.

It is better, for example, for her to think simply "house" rather than "my house" or "the White House." This way she can turn the project into a haunted house, fun house, or mouse house if she feels like it.

It's also better if she thinks "skyscraper" rather than "the Empire State Building." By thinking "skyscraper," she can glue some cylinders to its side if she wants to. She can always plunk a stuffed-animal gorilla on top when she's finished!

Encourage your child to hunt for smaller boxes or other lightweight objects that she can use. She can glue them to the top or sides of her primary box before beginning with the papier-mâché.

She securely tapes any loose box flaps down with *masking tape.* She can then tape any smaller boxes to the primary box. *Parents: You need to help attach the smaller boxes.* If it is too tricky to tape them on, you can attach them with a *hot-glue gun.* Have your child point to where she wants the small boxes attached. **Do not let your child use the hot-glue gun.**

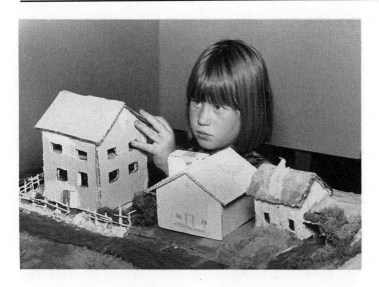

Make sure the base and all primary parts are secure before adding papier-mâché.

Next, she glues the primary box to its corrugated board base. She can use *thick white vinyl glue* for this. *Parents: You could glue the primary box to its base with the hot-glue gun.*

Now your child takes some time to look at the "building." If there's anything big she wants to add, now is the time to glue it to the base.

For instance, your child could glue an *animal-cracker box* to the side of a shoe box to create a smaller "wing." She could stack *small gift boxes* on top of an oatmeal carton for rooftop decoration. She could also cut out a lightweight poster board roof.

For a flat roof she just cuts a piece of poster board slightly larger than the building itself. To make a gabled roof, I suggest fashioning it out of one piece of poster board. Here's how:

● Your child starts with a piece of poster board that she has cut a little larger than she thinks necessary.

● *Parents: You need to help her "score" the poster board to create the pitch.*

Find the middle of the board and hold a *ruler* or straightedge there with one hand. Then open a pair of *scissors* and "draw" an incised scissors "line" against the edge of the ruler. The poster board will then bend crisply, making a satisfactory roof. To attach the roof to the base, glue little poster board hinges to the inside

To make a gabled roof: score poster board (top); fold poster board (center); attach roof to box with poster board hinges (bottom).

of the roof. (Parents: Use thick white vinyl glue or the hot-glue gun for this.)

If the roof is too big, she can trim down the edges.

This makes a much sturdier roof than if your child tries to tape two pieces of poster board together.

Parents: The final thing you will need to do before your child begins to use papier-mâché is to hold a building inspection! You must make sure that the building is firmly attached to its base and that everything else is firmly attached to the primary box or the base. Nothing should wiggle.

Now is the only time you can do this; later will be too late. This is also a good place to stop for the day.

Papier-mâché Strips:

After the building has passed inspection, your child can mix up some *flour* and *water paste* for dipping the newspaper strips. This is really done "by feel," but here is a rough idea of what she needs.

Dipping Paste

- She pours *1 cup of water* into a bowl.

- Next she trickles about *¾ cup of flour* into the water while mixing with her other hand.

- The finished paste should have the consistency of a thin milk-shake.

- She shouldn't make extra paste. It's better to make it up fresh each time it's needed.

- She dips the strip, then squeezes off a little of the excess paste before applying the strip to her building.

Many children like the feel of this paste, but some prefer using *liquid starch* to dip the strips. If your child prefers this, or if you just have some handy, use it full-strength; *do not dilute it with water.*

Tearing the *newspaper strips* is easy as long as your child tears them in the right direction. If she tears several pages at a time from the top of the page to its bottom, the strips will be long and even. But if she tries to tear horizontally, across the page, she will only be able to tear off little pieces. The strips should be about 1″ wide.

Your child probably wants to dip the full-length strips in the paste, but encourage her to tear or cut her 1" wide strips into 4"– 6" lengths. These are much easier for her to work with.

Finally comes the fun part! Your child dips the newspaper strips into the paste and slaps them onto her building. *The best place to begin is at the juncture of the box and corrugated board base. She should press the middle of a strip into that angle.* She makes the structure stronger when she does this.

It's a good idea for her to do this at every single join. If she has attached small things to her primary box, she needs smaller strips—about ½" wide and 2" long, or even shorter. *Parents: You may need to help six- or seven-year-olds tear these small strips.*

After the joins have all been reinforced with at least one layer of glued newspaper, all that remains is for your child to cover the rest of the structure (and the base if she likes) with newspaper strips. And here's the beauty of this particular papier-mâché project: The preliminary structure is already so stiff that your child needs to paste on only one or two layers of newspaper in any one place.

If your child needs to stop working for a day or a week, she can come back to the project even after it has dried. She can just apply the new wet strips right on top of the dry ones. When she finishes each pasting session, it's a good idea for her to go over the whole thing with a pasty finger, checking that all of the paper has been given enough paste.

When the project is put aside to dry, make sure that air can circulate freely around it. Otherwise, mold can form on the damp strips. The project must be completely dry before your child can paint it. You can tell when it's dry: It does not feel cool to the touch and looks lighter than it did when it was wet.

Painting:

During the day or so that it takes your child's project to dry (longer in damp weather or seemingly longer if she is particularly impatient), she can be planning the colors to use on her building. She uses *tempera paint* or *glue paint* (white vinyl glue mixed with tempera paint) for most of her colors. Other colors can be supplied by various collage materials after the paint has dried.

In the Assemblage project described earlier in this chapter, I suggest that your child "start with the big things and work to the small ones." The same advice applies to painting: *Your child should try to paint in layers, starting with the biggest color areas.* (This isn't so obvious as it sounds: the temptation is to start with the windows and then paint around them! And that's hard.)

If your child selects glue paint for her preliminary color, she is able to paint on top of it when it has dried without its "bleeding" into the other colors. Please refer to the Color Wheel for color mixing ideas, but be sure to mix up enough of any color—it is very hard to match mixed colors of tempera.

Remember that white vinyl glue dries clear, so any mixed color of glue paint will look lighter wet than dry. For instance if your child mixes red tempera with white glue paint, it will look pink when wet but will dry red. (If she *wants* pink, she has to add white tempera to the glue paint mixture.)

She needs to wait for one layer of paint to dry before painting another color, unless she wants the colors to mix and look "soft." (If she *does* want the colors to blend together, I suggest that she use regular mixed tempera rather than glue paint. Glue paint is tacky as it dries, and it can be hard to do a lot of color blending on large, quickly drying areas.)

There's no reason that these buildings have to be realistic, although they can be. Here are some examples of ways to paint fantasy buildings:

- The building can be blue, and fluffy white clouds can be dabbed onto its sides.

- The base of the building can be deep rose, which *blends* to pale pink at the top of the building.

- Each side of the building can be painted a different bright color.

- The entire building can be *splatter-painted* on top of a white undercoat. (See Chapter 7, Action Painting, for how to neatly do this.)

After all the paint has dried, she is ready to move on the final part of this mixed-media project.

Collage:

This is a good time for you to help your child review all the various types of collage that she is now probably familiar with—especially if she has done many of the projects in Chapter 8. Your child, especially your eight, nine, or ten-year-old, can apply that knowledge to this project. First, though, let's take a look at the easy collage work a six- or seven-year-old could try.

Windows and doors:

Windows and doors can be cut out of *construction paper, Fadeless art paper,* or *aluminum foil*—a little harder to work with, but effective. Your child can attach these with *medium-thick white vinyl glue* or *paste.*

Your child could also cut "real" windows from *magazine pictures*—a skyscraper could be a lot more endearing with only three or four houselike windows on each side.

She might decorate the painted corrugated board base with some *small rocks,* or she might make a *dyed-macaroni* fence . . . the Pasta Security System! (See Chapter 3, Mosaic, for how to dye dry pasta.)

She could also sprinkle *dirt* or *sand* onto *white vinyl glue* for "ground" or sprinkle *green yarn fuzz* onto white vinyl glue for "grass." (See Chapter 9, Yarn Fuzz Collage, for how to cut yarn fuzz.)

She may want to glue *small plastic figures* (people, monsters, or farm animals) to the base. This is a good idea—these tiny toys are easy to buy but often just trickle to the bottom of the toy box. More than many other collage material, tiny toys give your child's building the scale she intended. So before you say "no!" when she asks if she can glue a small toy to her sculpture, ask yourself "why not?"

She can use *thick white vinyl glue* to attach the figures to the base. But if the base is too bumpy or the figures just keep toppling, you can attach the figures with a *hot-glue gun.* **Parents: Do not squeeze the hot-glue onto the small figures; squeeze it onto the base. Do not let your child use the hot-glue gun.**

The hot-glue gun is also helpful in making fantasies come true:

- A giant plastic spider might crawl up the side of a building.

- A line of small dinosaurs may be trudging down the front of a skyscraper.

- A super-hero could crouch under an eave while the bad guys cluster on the lawn.

Older children (8+) might enjoy using one of those ideas as a starting point for their own use of collage. Here are some additional collage ideas.

Montage:

Your child may find many uses for *magazine pictures* in her sculpture. I mentioned windows already, but here are a few more ideas:

- Cut-out trees could be glued to the side of the building.

- A large cut-out person might be glued to the side of a small building, immediately changing the scale. Is it a giant person or a very small building?

- Big eyes could be cut from magazine ads and either peer from the windows or even serve as the windows.

- Underwater photographs could be cut up and glued to the base. This, too, changes everything at the last minute.

Any of these pictures would bring an element of *surrealism* into the sculpture. Your child needs to be able to "see" the humor in these things before using them, however. Many children are more reality-bound, at least for a while, and to any of these montage ideas might say "Well that's dumb. Who ever heard of that?" These children will get much more satisfaction out of making their structure as "real" as possible and may branch into surrealism or fantasy only later. Don't push it.

Appliqué:

The collage-with-*fabric* approach can be used in this project. Realists might cut up a length of *ribbon* for windows—it's easy to control sizes this way. A piece of green *felt* could be pieced around the building for "grass."

Surrealists might want red felt grass, *corduroy* windows,

or big *calico* polka dots on the sides of the building. Or maybe there could be a great big *bow* tied around the entire structure. *Hint: If your child is trying to attach thin or synthetic fabrics to a surface,* paste *works better than white vinyl glue.* Paste doesn't soak through the fabric as the glue does.

Assemblage:

Three-dimensional collage is fun to add to these structures, and the use of small plastic figures mentioned earlier is an example of this. Here are a few others:

- Instead of the painted clouds described earlier, your child might want to glue *cotton ball* "clouds" to the sides of her building.

- A *broken watch* could be hung on the side of the building as a surreal timepiece.

- Old *costume jewelry* might be draped from the eaves.

- A *stuffed animal* could perch on the roof.

- *Yarn fuzz* could creep up the sides of the building. Maybe it's moss, or maybe it's just a hairy building!

Parents: If *thick white vinyl glue* doesn't hold a larger object, you can try using the *hot-glue gun.* **Do not let your child use the hot-glue gun.**

Your child might well work on one building over a period of a week or two. After all, this project is really several projects in one: sculpture, papier-mâché, painting, and collage. It's worth the effort. She will have a deserved feeling of accomplishment when she's done. She's really been through something and seen something through.

Encourage her to repeat the project after a period of recuperation and reflection. The "let's try everything once" approach to art denies your child the opportunity to learn from her experience—to learn through repetition.

The next time she tries the project she will be more familiar, less tentative, with the materials and the process. She'll be better able to deal with frustrations or opportunities that arise as she works. She'll be able to have more fun.

And as the individual bases nestle together on her dresser, a papier-mâché town will begin.

Sculpture Words to Use with Your Child

Sculpture

> three-dimensional
>
> construct, assemble, model
>
> dough, impression
>
> papier-mâché

Composition

> overlap
>
> vertical, horizontal
>
> contrast, value
>
> formal pattern, random pattern
>
> scale

Mixed media

> decoupage
>
> cut, score
>
> tempera, wash

Realism

Surrealism

Fantasy

Sculptors to Look at with Your Child

Christo (huge wrapped natural environments, probably can just see photographs)

Alberto Giacometti (exaggerated sculpture of people, faintly similar to foil sculpture)

Claes Oldenburg (big, funny sculpture of familiar objects)

Surrealism and Fantasy

Salvador Dali

Max Ernst

M. C. Escher

Afterword to Part Two

The five chapters in Part Two contain detailed step-by-step instructions to specific art projects. But don't get too tangled up in the details or the instructions.

The most important art your six- to ten-year-old will make is when he or she is "messing around"—doodling, experimenting, playing with art materials. Don't fall into the trap of telling your child to save the materials for "real" art.

Why bother with specific projects then? For one reason, your child will probably take these projects more seriously than his or her own inventions—after all, they're in a book! And for another, your child is more likely to be pleased with the way the projects look when he or she is done. Your child is more apt to show them off, to display them.

But another reason to bother is that I have found that detailed instructions help quell art panic. And once your child has gone step-by-step a few times into a project, I hope that familiarity with the steps leads him or her to apply them to his or her own inventions.

So think of these projects not as icons, the beginning and end of your child's art at home, but as tools, as a means for him or her to keep on making art. And then let your child go.

In Closing

This book is intended to be used as a tool, a means of facilitating your children's own natural creativity. Always remember that your children are already creative—they don't need a book, teacher, or class to make them so. But a creative environment will surely help.

The best creative environment for children is relaxed and noncritical. The best creative environment encourages children to be playful or silly, to be alone or bored sometimes, to explore or even fail sometimes. It's home.

Parents (and teachers) have often said to me, "I think my child is gifted in art!" (Or sometimes, "I don't think she's gifted, but she likes to do it anyway.") They say this even about very young children.

Why do we feel that we need to label children this way? This young? Do we think that only "gifted" children should make art?

And who is "gifted," anyway? It is the child who is neat, who draws things *we* can identify, who likes the projects we dream up, who doesn't argue? Or might it be the child in the corner, the sloppy one, the one who won't stop what he's doing, who insists on doing things his way? It could be either.

I hope that, having read *Encouraging the Artist in Your Child,* you will throw out the idea of "giftedness" as some kind of entitlement or criterion necessary to allow your

231

children to make art. **Give your children the frequent opportunity to experience freely a variety of art activities at home. Then let your children do them again and again.**

That's the only kind of giftedness we should concern ourselves with for our children. And it's a gift that only we, as parents, can give. Our children will take it from there.

The visual arts are only one area of creativity, but strengthening our creativity in even one area can't help but enhance our lives in other ways. It's like muscles: Strengthening your arm muscles may improve your tennis game, sure. But it will help you out with any activity that needs arms, as well as increasing your general well-being.

Children may or may not choose to "go on with art" as they grow older, but it will always be part of their life. **The most valuable things they get from art—the flexibility, the decision-making abilities, the confidence in their intuition, the feeling of celebration—they will bring to any creative endeavor.**

Parents, I invite you to review the history of your own art life. If you feel any nostalgia or regret at what has been "lost," I think that those feelings are your own creativity just looking for a place to happen! Your creativity is still there.

It's not too late for you to regain some of the joy and satisfaction that you have seen your children experience making art at home. I promise.

Appendix 1

List of Art Materials

Here are the art materials, organized by type of project and age range, that you'll need to do the activities in this book.

Drawing

Two- to three-year-olds

Draw on: 12″ by 18″ or 18″ by 24″ paper (try taping down the corners)

computer paper (unfold to larger size)

newsprint

construction paper (light colors)

Draw with: big crayons or markers (dark or vivid colors)

Three- to four-year-olds

Draw on: 12″ by 18″ paper; begin 9″ by 12″

computer paper

newsprint

construction paper (light and dark colors, with chalks)

Draw with: big crayons and markers (begin to offer smaller ones)

FOUR- TO FIVE-YEAR-OLDS

Remember QUANTITY!

Draw on: 20-lb. typing paper (don't buy erasable paper)

roll of plain white shelf paper

unlined 3″ by 5″ cards

all scrap paper

newsprint or computer paper (for rubbings)

lightweight poster board (for crayon etching and resist)

Draw with: fluorescent crayons for special projects such as crayon etching and resist

skinny crayons and markers (unscented)

Occasionally offer chalks, charcoal, and oil pastels.

SIX- TO SEVEN-YEAR-OLDS

Remember QUANTITY!

Draw on: same as for ages four–five

Draw with: same as for ages four–five

Add black Flair or Pilot pens for more detailed drawings.

EIGHT- TO TEN-YEAR-OLDS

Draw on: same as for ages four–seven

Offer 16-lb. typing paper for tracing.

Also offer inexpensive notepads and self-adhesive labels.

For special projects: heavyweight poster board; mat board; cold-press illustration board

Draw with: same as for ages four–seven

Painting

TWO- TO THREE-YEAR-OLDS

Paint on: 12″ by 18″ computer paper or construction paper (do not use newsprint)

Paint with: tempera (also sold as "poster paint"). Buy liquid (mixed) tempera if possible; colors are much brighter.

Dry (powder) tempera can also be used.

1 or 2 primary colors of tempera

liquid starch

fingers

1″-plus brush

big brush or roller for painting with water outside

FOUR- TO FIVE-YEAR-OLDS

Paint on: same as for ages two–three; may begin to work 9″ by 12″

Paint with: primary colors, white and black glue paint (with help)

small set of watercolors

narrow brushes

food color (with parents only)

Six- to seven-year-olds

Paint on: same as for ages two–five

Offer more three-dimensional surfaces to paint on.

Offer a large quantity of 20-lb. typing paper for more extensive watercolor work.

Paint with: same as for ages two–five

Encourage color-blending with oil pastels on dark paper.

Eight- to ten-year-olds

Paint on: same as for ages two–seven

For special projects: lightweight or heavyweight

poster board, 90-lb. cold-press watercolor paper

Paint with: same as for ages two–seven

Offer more colors for watercolor or tempera work.

food color (with parents only)

bleach (used by parent only)

Collage

Base

Computer paper or construction paper (very light-weight collage)

Lightweight poster board (medium-weight collage)

Styrofoam tray (heavy or bulky small collage)

Corrugated board (heavy or bulky large collage)

ADHESIVE

Liquid starch (tissue collage only)

Paste (lightweight paper or fabric collage)

White vinyl glue (everything else)

> thin: tissue collage (older children)
>
> medium: paper, fabric
>
> thick: heavy or bulky collage, assemblage,
>
> wood projects

TWO- TO THREE-YEAR-OLDS

use paste, with fingers

acid brush

glue stick

liquid starch

Acid brushes are small, stiff-bristled, very cheap brushes that are good to use with glue or paste; they are available at paint supply stores or hardware stores.

Look for strong contrast in value and texture when selecting collage materials.

Don't offer glitter, sequins, or small Styrofoam pieces for collage.

FOUR- TO FIVE-YEAR-OLDS

You may start to offer white vinyl glue, but always use acid brush or glue stick—most children hate it when the glue dries on their fingers.

Begin tissue collage.

Offer smaller collage materials if you feel it's safe.

Parents: If you want to dye dry pasta or unvarnished wood scraps, make a dye bath of rubbing alcohol or white vinegar, and add food color to it.

Six- to ten-year-olds

same as for ages two–five

Older children use thin white vinyl glue for tissue collage.

They use waxed paper and Fadeless art paper in collage work.

For special projects: doilies, velour paper, metallic paper, pompons, pipe cleaners, glitter (velour paper and metallic paper are available by the sheet at many art-supply stores)

Parents: You may wish to use spray adhesive (outside only) or a hot-glue gun in helping your child with a project. Do not let your two- to ten-year-old use either.

Yarn

Two- to three-year-olds

Work on: construction paper

 lightweight poster board

 stiff paper plate

 Styrofoam tray

Work with: 1 or 2 colors of yarn

 white vinyl glue, single hole punch

Four- to five-year-olds

Work on: same as for ages two–three; add berry basket

Work with: same as for ages two–three; may add additional colors of yarn

 yarn needle

SIX- TO TEN-YEAR-OLDS

Work on: same as for ages two–five, add corrugated board

 ½"–¾" dowels

 length of 1" by 1"; pine board

Work with: same as for ages two–five

 Vary fiber thicknesses and textures.

For special projects: embroidery floss, metallic threads, fancy yarns, bias tape, knotted rag strips

Sculpture

TWO- TO THREE-YEAR-OLDS

uncooked and cooked doughs in one color

no tools or kits

Parents: To make the doughs, you need flour, salt, cooking oil, and cream of tartar.

FOUR- TO FIVE-YEAR-OLDS

Child may help prepare dough.

Mix two dough colors together.

Use simple tools with the dough.

other sculpture materials: stiff paper plates, dried beans, white vinyl glue, tissue paper, crepe paper, paper bags, aluminum foil, lightweight poster board, popsicle sticks, fabric scraps, clean old socks, wood scraps

spring tension rod for puppet stage

Parents: To make Slime, you need cornstarch.

To dye dry pasta or unvarnished wood scraps, make a dye bath of rubbing alcohol or white vinegar, and add food color.

Six- to ten-year-olds

same as for ages two–five

For the Layered Salt Jar project, you need a baby food jar, salt, powdered tempera, and white vinyl glue.

For the Cornstarch Dough projects, you need cornstarch and baking soda.

For the papier-mâché project, you need either liquid starch or a flour-and-water paste.

For special projects: Styrofoam shapes, wooden boxes

Where to Buy Art Materials

Supermarket

flour

salt

cornstarch

baking soda

cooking oil

cream of tartar

dry beans, dry pasta, fruit, vegetables

white vinegar

rubbing alcohol

food color

liquid starch

liquid detergent

stiff paper plates

aluminum foil

waxed paper

plain paper bags

plastic storage bags

doilies

cotton balls

sponges

shoelaces

plastic basin

Many supermarkets also have a school supplies section
where you might find the following:

watercolor markers (never use permanent markers with
children)

crayons

watercolor sets

9″ by 12″ packages construction paper

9″ by 12″ packages newsprint

small packets of lightweight poster board

Pharmacy

eyedroppers

Stationery or Office Supply Store

20-lb. typing paper for drawing (don't buy erasable
typing paper)

16-lb. typing paper for tracing

large sheets of lightweight poster board

12″ by 18″ construction paper

small white notepads

unlined 3″ by 5″ cards

white vinyl glue (buy the largest size you can; it may
be worth a trip to a discount store to buy an
extra-large container)

paste

rubber cement (for adult use only)

spray adhesive (for adult use only)

2B, 4B pencils

Flair and Pilot pens (black)

good scissors

stars, stickers

tape, masking tape

hole punch

rubber bands

2″ by 4″ self-adhesive labels

Artgum eraser

photocopy machine

Hardware Store and Lumberyard

hot-glue gun, glue cartridges (for adult use only)

utility knife and blades (for adult use only)

acid brushes

paintbrushes and rollers

twine, string

sandpaper

dowels (½″, ¾″)

1″ by 1″ lengths of wood

Masonite

wood scraps

white vinyl glue

roofing nails, finishing nails

spring tension rod

Fabric Store

yarn

yarn needles

oilcloth

felt

fabric

Craft Store

pompons

pipe cleaners

popsicle sticks

plastic eyes

yarn needles

glitter, sequins

magnetic tape, small magnets

pin backing mounts

Art Supply Store

12″ by 18″ packages construction paper

12″ by 18″ packages Fadeless art paper

12″ by 18″ packages tissue paper (you should buy the best tissue you can for the Patterned Tissue project; for general collage work, you can use the cheaper tissue that is sold in one-color packets)

12″ by 18″ packages newsprint

corrugated board in large sheets

lightweight poster board

heavyweight poster board

cold-press illustration board

mat board

foam board

90-lb. cold-press watercolor paper

velour paper (by the sheet)

metallic paper (by the sheet)

Lucite box frames

white vinyl glue

paste

spray adhesive (for adult use only)

good brushes

good scissors

tempera paint (buy liquid tempera if possible—the colors are brighter)

watercolor markers

crayons

oil pastels

watercolors

colored pencils

chalks, pastels

oil pastels

charcoal sticks

Household Items to Save for Art Projects

big cardboard boxes (cut them up for corrugated board, or use the boxes as assemblage bases)

other boxes

Styrofoam trays

plastic berry baskets

computer paper

newspaper, magazines

greeting cards

glass jars, baby food jars

coffee cans

old cookie sheet

simple cookie cutters

old towels and washcloths

fabric scraps

felt scraps

clean old (or odd) socks

spools, buttons

Catalogs

The following art supply firms publish catalogs from which you can order by mail:

Dick Blick Art Materials
P.O. Box 1267
Galesburg, IL 61401
(309) 343-6181
 Fadeless art paper (in sheets)
 construction paper
 tissue paper
 velour paper
 cold pressed illustration board
 tempera paint
 fabric paint
 glitter, pipe cleaners

Daniel Smith Inc.
4130 First Avenue South
Seattle, WA 98134
(206) 223-9599
 watercolor paper
 cold pressed illustration board
 white canvas covered sketchbooks (for Scrapbook
 project)
 foam board
 gesso (acrylic)
 fabric paint
 brushes
 color pencils, charcoal

S & S Arts and Crafts
Colchester, CT 06415
(203) 537-3451
Buy the basic materials offered in this catalog, rather than the kits.
 construction paper
 tissue paper
 white drawing paper
 velour paper, metallic paper
 tempera paint
 brushes
 pipe cleaners, plastic eyes, felt, synthetic fur, pompons,
 yarn needles, magnetic tape

Appendix 2

The Color Wheel

Primary Colors
 Red

 Blue

 Yellow

Secondary Colors
 Violet

 Green

 Orange

Intermediate Colors
 Red-Orange

 Red-Violet

 Blue-Violet

 Blue-Green

 Yellow-Green

 Yellow-Orange

Color wheel

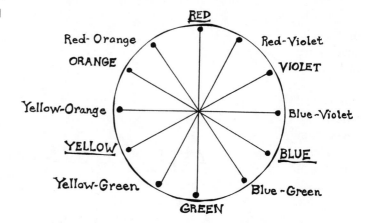

The color wheel is a tool that is helpful in several ways. Any two mixed **primary colors** make a **secondary color.** For example:

red + blue = violet

blue + yellow = green

yellow + red = orange

Any **intermediate color** is mixed from the colors on either side of it.

red-violet = red + violet

red-orange = red + orange

blue-violet = blue + violet

blue-green = blue + green

yellow-green = yellow + green

yellow-orange = yellow + orange

Colors next to each other on the color wheel are called **related colors.** For example:

red + red-violet + violet

yellow + yellow-orange + orange

blue + blue-green + green

With tempera paint, a **tint** of any of the twelve colors on the color wheel is made by adding white to the color. A **shade** is made by adding black to the color. With watercolor or food color, a tint is made by adding water to the color.

To make any of the twelve colors on the wheel less intense, add a little of the color opposite it on the color wheel. Colors opposite one another on the color wheel are called **complementary colors**.

Here are some art projects that use **related color** schemes or any two primary colors.

FINGER-PAINTING OR COLOR MIXING (PAGE 28)

red + blue

blue + blue-green

orange + red-orange

SWIRLED STAMP PAD (PAGE 29)

green + yellow = yellow-green

blue + violet = blue-violet

WATERCOLOR: SIMPLE COLOR MIXING (PAGE 31)

blue + green = blue-green

red + violet = red-violet

orange + water = tints of orange

MIXED PLAYDOUGH COLORS (PAGE 60)

red dough + orange dough = red-orange dough

OIL PASTELS: BLENDED (PAGE 142)

blue + violet = blue-violet

TISSUE COLLAGE (PAGE 154)

blue tissue on green tissue = blue-green

red tissue on orange tissue = red-orange

These color combinations are a good choice for any project where the colors will be mixed. Remember, if you mix complementary colors together (or colors that are almost complementary), you get a very dull color. But if your child wants to mix red and green, for example, let her—that's how we learn. And she might like it!

Complementary colors look great in many projects, though, especially in collage work. Paintings also look wonderful mounted on complementary colors. Here are examples of complementary color schemes:

> red + green (Christmas!)
>
> red-orange + blue-green
>
> orange + blue
>
> yellow-orange + blue-violet
>
> yellow + violet
>
> yellow-green + red-violet

These are exciting color combinations, and children love them.

If you buy only one color of tempera, start with your child's favorite color. Then buy more when possible, using the color wheel as your guide.

Appendix 3

How to Save Your Child's Art

Children grow up quickly, although it doesn't seem like it at the time! Their art is one of the few physical things we have left to remind us of their earliest years. It is a treasure.

Here are some ways you can save favorite two-dimensional pieces for everyone's future enjoyment.

1. *Label the art.* If you have more than one child, I guarantee you'll get their art mixed up eventually. Print each child's name in the corner of each piece.

2. *Title each piece if you can.* Often, children will tell you what the title is ("Squeaky Little Monster" or "My Teddy Bear"). If they don't title it, put a brief comment in parentheses. Years later, you may be glad to have a clue. (He went to a birthday party that day.) (She was a princess for Halloween.)

3. *Always put either the age of your child or a simplified date (12/89) on the art.* Again, you'll be glad you did.

4. *Make a portfolio.* Most of your child's two-dimensional home art projects will be 12″ by 18″ or smaller and will fit neatly into a simple portfolio. Make the portfolio bigger than the art so that the edges of the art won't get ragged. For example, you could make the portfolio 16″ by 24″.

Simple homemade portfolio

Before you start, call a nearby art store and price the cheapest portfolios. Art stores usually carry inexpensive cardboard ones, and you may decide to go ahead and buy one.

Making the portfolio

If you decide to make a portfolio, you need stiff board for the two sides. I suggest either corrugated board (this is the cheapest) or foam board.

Corrugated board

Parents, you can cut a large cardboard box into pieces using a utility knife. You need two pieces the same size for the portfolio. You can also buy a large sheet of corrugated board at most art supply stores.

Foam Board

Foam board can be bought at most art supply stores. Again, you need to cut two same-sized pieces.

Assembling the portfolio

The two pieces of board must be attached at the bottom. I suggest using duct tape, package tape, or colorful wide cloth tape. Put the boards on top of one another, and carefully attach them with precut tape pieces. If you want to, poke two holes at the top of each board, and tie the tops together with string.

Storing the portfolio:

Everything will last longer if you can store the portfolio flat. Slip it under a sofa or bed.

If necessary, the portfolio can be stored upright. In that case, be sure to tie it tightly shut at the top or tie the whole portfolio shut. Otherwise, the art will get crumpled.

Taking the time to preserve some of your child's art might seem like a nuisance, but it pays off. Years later, when you go through this portfolio with your grown child, it will feel like a vacation—in childhood!

Bibliography

The following six books are favorites of mine; I feel that they provide valuable insights into children and art. Most of the books that are out of print can be found in the library. The material in quotation marks is from the actual book.

ROBERT HENRI, *The Art Spirit.* New York: J. B. Lippincott, 1923, and Harper & Row, 1984.

"Feel the dignity of a child. Do not feel superior for him, for you are not" (p. 281).

HERBERT READ, *The Contrary Experience: The Autobiography of Herbert Read.* Bountiful, UT: Horizon Publishers, 1974 (currently in print).

". . . to establish one's individuality is perhaps the only possible protest" (p. 12, preface). I especially recommend "Part One: The Innocent Eye," in which the author vividly remembers his childhood.

CAROL BLY, *Letters From the Country.* New York: Penguin Books, 1981, and Harper & Row, 1988.

The chapter entitled "A Gentle Education for Us All" stresses that, among other things, all children have a right to schools that take music and art programs seriously.

DAVID ELKIND, *The Hurried Child* and *Growing Up Too Fast Too Soon.* Reading, MA: Addison-Wesley Publishing Co., 1981. Addison-Wesley Publishing Co.

Chapter nine of *The Hurried Child* is called "Helping Hurried Children." In it, the author emphasizes the dignity of children. He tells us of the value of play as an antidote to hurrying, and reminds us of the playful side of art.

GARETH B. MATTHEWS, *Philosophy and the Young Child.* Cambridge, Mass.: Harvard University Press, 1980.

In this fascinating book, the author demonstrates his respect for children, and provides a glimpse into the way they perceive the world.

ROLLO MAY, *The Courage to Create.* New York: Bantam Books, 1975 (currently in print).

Chapter two is called "The Nature of Creativity." Especially interesting is the author's exploration of the important distinction between talent and creativity.

The following books were mentioned in *Encouraging the Artist in Your Child.* These books are about drawing and cover a variety of approaches.

KIMON NICOLAIDES, *The Natural Way to Draw: A Working Plan for Art Study.* New York: Houghton Mifflin Company, 1941 (currently in print).

This book is for adults, as I stated in Chapter 6. It is still available—because it is a classic.

BETTY EDWARDS, *Drawing on the Right Side of the Brain.* Los Angeles: J.P. Tarcher, Inc., 1979.

"The sequence of exercises in this book . . . can be used with ten-year-olds" (page 198). This popular book is still available.

MARJORIE AND BRENT WILSON, *Teaching Children to Draw: A Guide for Teachers and Parents.* Englewood Cliffs, NJ: Prentice-Hall, Inc., 1982.

This book contains many drawing activities and games for children. It encourages a more active role for teachers and

parents in a child's drawing development. It provides descriptions and explanations of children's drawings, and gives suggested responses a teacher or parent might make. This is an especially valuable book for parents of children aged six to ten.

Each of the following two authors has a series of popular books that many children love:

ED E. EMBERLEY, Little, Brown and Co.

Ed Emberley's cartooning books are fun and easy to follow. He even has a whole book about making fingerprint cartoons!

SUSAN STRIKER, *Anti-Coloring Book* series.

(Some of these books were written with Edward Kimmel.) H. Holt & Co. These books give older children imaginative ideas of things to draw, such as "What do you look like in the fun-house mirror?" and "How many different things can circles be?"

Project Index